FINDING

A catalogue record for this book is available from the British Library.

First Edition 2023
First published in Great Britain in 2023 by Carpet Bombing Culture.
An imprint of Pro-actif Communications
www.carpetbombingculture.com
Email: books@carpetbombingculture.co.uk
©Carpet Bombing Culture. Pro-actif Communications
ISBN: 978-1-908211-93-4
Printed in China

Photography by: Kamal X

www.carpetbombingculture.com

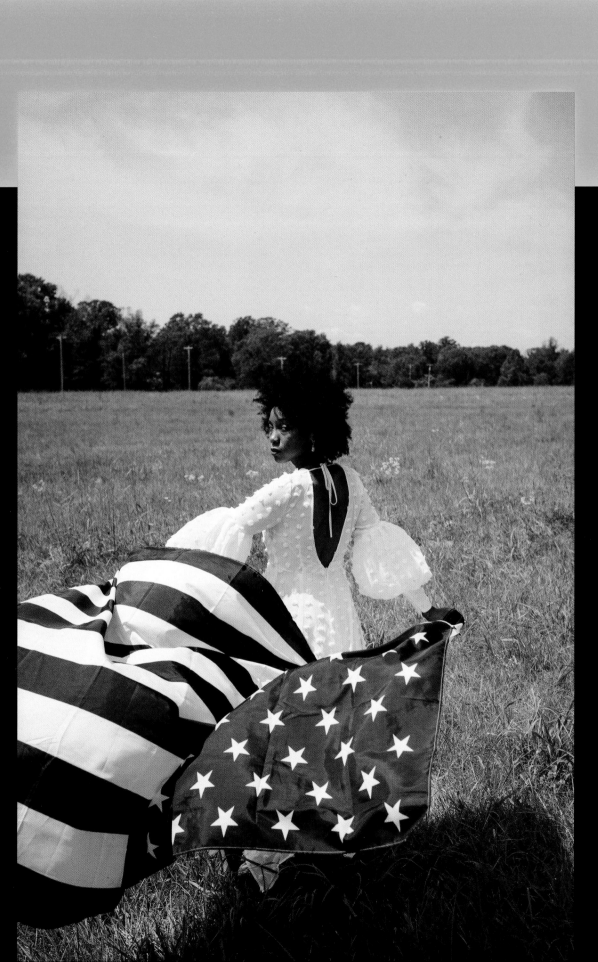

THE BEAUTIFUL.

FORGIVENESS

When I was younger, I thought I knew what forgiveness was: it meant letting go of negative feelings toward people and forgetting that they had hurt you. But something happened during my senior year of high school in 2003 that changed my life and made me realize there was more to forgiveness that I hadn't yet understood.

I'd been invited to model in a fashion show in Orange, New Jersey, but during my drive there with a friend, I got a call that it had been cancelled. Looking down at my phone, I realized the battery was low and decided to go to my girlfriend Nicole's house to charge it. As we rolled up to her house, I saw her ex-boyfriend, a gang member, in the front yard. We'd had a couple of tense encounters, but nothing serious. I didn't like him, especially after I heard that he'd pushed Nicole during an argument, but I wasn't interested in fighting. Still, just the sight of him told me things were not going to be good. I learned later that he had come to her house that day to confront her brothers over a personal issue.

I threw the car's gearshift into park and opened the door as he walked into the street, staring me down. Suddenly another car drove up, and three more guys poured out. As all four circled around me, one of them raised some kind of weapon. Before I even realized what it was, he had hit me in the head.

The next thing I knew, I was lying under a car. I felt something wet on my face and tasted blood. I saw blurry legs, shoes, tires, the edge of a curb, the sky. My shirt was soaking wet against my skin. I tried to stand up, but my left leg wouldn't move. Someone helped me up and leaned me against the car as I screamed out in pain.

I blacked out and woke up again and again. It was surreal. I heard sirens, and then I was being loaded into an ambulance.

When I opened my eyes, I saw a guy seated beside me. There was a sensation that we were moving. I was freezing cold, but I couldn't speak.

"*Don't fall asleep, man!*" the stranger yelled. "*Stay with me, Kamal. We'll be at the hospital soon. Hang in there!*" He sounded so concerned, almost like he was worried for my life.

Is my life at risk? I wondered. The way he talked and looked at me said this was more serious than I'd realized. My eyelids felt thick and heavy, but I tried as hard as I could to stay awake.

A short while later, I was in a waiting area at a hospital in Newark while nurses and other staff did tests and gathered information about me. Meanwhile, I was shaking and going crazy with pain. Finally they gave me something that calmed me down. Before I went into surgery, I saw my mom. My mom had always reacted dramatically to the risks I took, warning me that something bad would happen if I kept running around with the wrong crowd. So I expected her to be hysterical. But she had the calmest look on her face. The lack of emotion caught me off guard; I didn't know what that meant. Then I was whisked off to an MRI and then surgery, and the night became a blur.

I heard different voices around me. Some of them sounded familiar as I took in broken pieces of their overlapping conversations.

"*...a fractured skull.*"
"*...never saw so much blood.*"
"*...lucky to be alive.*"

Finally, after what had seemed like a long time, I tried to open my eyes again.

The swelling only allowed me to peer through tiny slits. Everything was blurry, as if I were looking through a glass of water.

"*Kamal!*"

"*Oh, God! He's awake!*" "*Go get the doctor! Hurry!*"

I had no concept of time, and no idea where I was or what had happened to cause all the commotion. It irritated me that I couldn't open my eyes all the way or make my mouth work. Gradually my mind separated the voices. I tried to swallow. My mouth felt dry and swollen, as if it no longer fit my face. My arms and legs were like useless lead weights that I couldn't lift.

"*You're in the hospital...lost a lot of blood...detached ear...transfusions...so lucky to be alive...*"

My head hurt like there was a jackhammer inside it, but the voices kept talking. "*You were in surgery yesterday.*"

Surgery? I thought. For what? Why?

"*Thank God!*" the voices continued.
"*A miracle! A true miracle!*"

What miracle? I thought. Finally it became too hard to focus. Just listening was exhausting. I let go and drifted again.

Over the next few days, I found out why I was in so much pain. I had been hit repeatedly with a car jack and had several skull fractures. Surgeons had put a plate in my head to hold the broken bone together. I was lucky to be alive. Nicole's brother was the original target of the attack, but when I dropped by unexpectedly, they had turned on me instead.

The doctors were amazed at how quickly my healing progressed, and I was released from the hospital in about a week. For a while my days were a mix of pain, dizzy spells, queasiness, headaches, and fatigue. Beneath the external wounds, I had a lot going on internally. I had always believed in God, but after what I'd survived, I began to appreciate Him even more. There was no doubt in my mind that He had saved me.

My mom was incredible and never once cried in front of me. She showed so much strength from the start, through all the choices she had to make on my behalf, including the decision to put a plate in my skull. She had kept the faith and knew in her heart that I would be okay.

But in addition to the gratitude, I struggled with anger over the attack, grief over what I had lost, and fear that I would never be the same again. I wasn't the same person I'd been before. Gone was the confident, sociable guy who loved to play basketball and hang out with his friends. It was like he'd been beaten out of me, and only a twisted shell was left. When I returned to school, I struggled to pay attention. Going to class didn't seem to matter anymore, and at the end of the year I barely graduated.

Meanwhile, charges were filed against my attackers, and they ultimately paid my hospital bills. One who had priors ended up going to prison. Justice was carried out, but the real conflict that had to be resolved was in my heart.

A few months after the attack, I ran into my attackers at a festival. That encounter could have gone in a much different direction than it did. But I told my friends to let it go, and we left. I knew I had to forgive them so that nothing more would come of it. If I held onto it, my friends would have held onto it too, and the situation would have escalated. I don't know if I would still be here today if we had retaliated.

But that wasn't the end of it. Forgiveness is a process. It took several years for me to heal. Forgiving someone for trying to take my life was one of the hardest things I've had to do.

As with so many other issues, first I had to look at myself. That process was tough. I shed a lot of tears as I examined my life and saw things as they really were. I realized that the first step in overcoming my anger was to forgive myself for making a mistake. For so long, I had agonized over why I'd put myself in that dangerous situation.

Why did I stop at Nicole's house? Why did I get out of the car? Why was I dating someone who was involved with a gang member in the first place? The past was in the past. I'd done the best I could at the time. Making mistakes is only human.

Examining myself gave me the tools to understand that the challenge of forgiveness was bigger than just this situation. When we forgive ourselves, it frees us to extend that same level of acceptance to others. If we want peace in our hearts, forgiveness for ourselves and forgiveness for others have to go together.

I also realized that this event had changed me for the better. Of course there have been times when I've wondered what might have been or how things could have gone differently. But in the end, the experience has benefited me in many ways. Now I have no problem saying no to situations that don't serve me. I understand that life is not a game. At the same time, I'm no longer afraid. I'm alive and lucky to be here, and I'm not going to waste the time I have by keeping silent or worrying about what other people think.

Basically, the attack forced me to make a choice: either I could shut down and hold onto the hurt, or I could open my heart back up and be willing to receive what life has to offer. Today I'm stronger for the pain I went through.

The date November 23 is a big day for me every year. Instead of feeling anger, I feel gratitude. The events of that day put my life in a different perspective. My survival and recovery made me feel like I was here for a reason, and even if the reason wasn't clear, I knew someone was looking out for me. There was something in me that I needed to recognize and discover.

Let my story stand as a reminder that even in our darkest moments we can still choose love over the allure of hate. We will never reach our greatest potential if we allow the weight of damaging circumstances to hold us back from taking off into the limitlessness of the great unknown. Dreams require facing parts of yourself and the world that are uncomfortable. Sitting in that discomfort and ultimately letting go creates a new frame of mind. When I think back to how afraid and lost I was at that time in my life, I never would have imagined that by deciding to not give up on myself, I would lead the life that I am so thankful for today. For many of us finding forgiveness will serve as our most important step towards manifesting our own freedom.

Kamal X

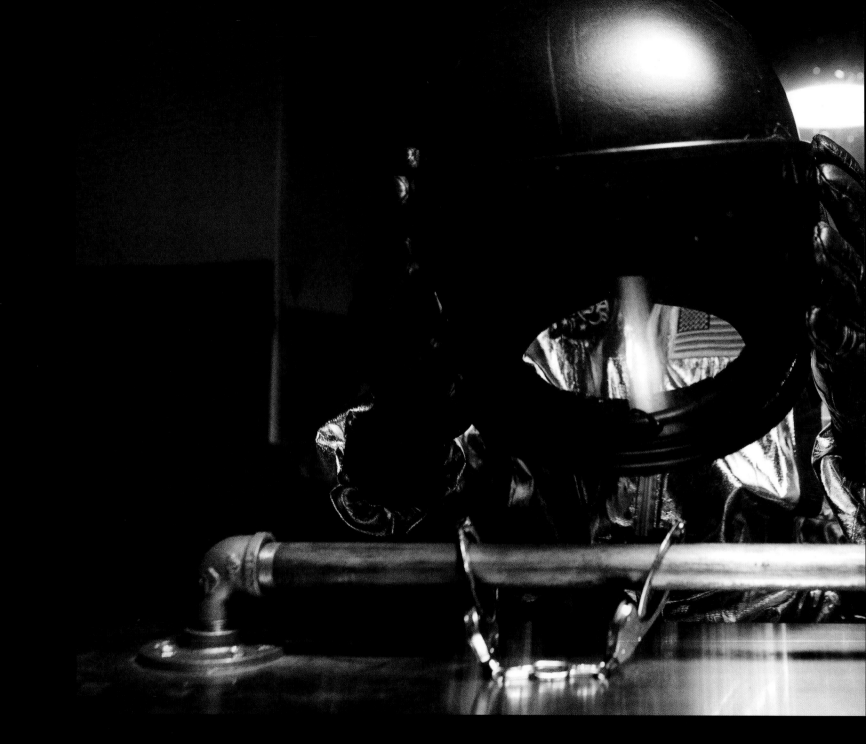

FINDING X

When Covid-19 made its way to the U.S. in February of 2020, we couldn't imagine the plight we would soon face as a country. A worldwide pandemic quickly became the backdrop to a civil uprising, one that had been brewing since our nation's inception. As we watched George Floyd's life stolen, one gasp of breath at a time, I found myself at a life-defining crossroads. My fear of Covid-19 was debilitating, yet I felt an innate need to document this momentous time in our history. I had an obligation to the legacy of George Floyd and every African American who'd lost their life to racism and police brutality. I wanted to bring light to the darkness I saw reported—the news stories that captured the rage but not the people and the voices behind it. As I left the clean, safe air of my apartment in Oakland and ventured out into what now felt like an unknown abyss, I became the BLACK ASTRONAUT.

While documenting various viewpoints within this spiraling revolution, I was constantly confronted by my fear of death. I had no choice but to envision a shield of protection, an invisible suit of armor, which gave me the peace of mind necessary to keep going and uncover truths behind this deafening cry for change. Pushing myself beyond these limits transformed my fears into an infinite source of power, reshaping my entire world. The fight for social justice and equality evolved into a supernatural passage toward self-discovery and triumph. This led me to a vision of optimism that inspired me to explore additional voices fighting for their own stake in the quest for freedom and equality. This decision opened my eyes to the complexity and interconnectedness beaming through every new experience I encountered. Regardless of how far I ventured into each realm, every cause was united by the need for change.

The BLACK ASTRONAUT represents the undying spirit within ourselves that fights for what is right, no matter the circumstance. Worries of consequence are silenced by our responsibility to answer the call of duty. From the bright lights in the night sky to the 50 formations on the American flag, we must always remember that the stars belong to the people. Finding X is our mission to discover what lies within us that moves us to become the change we wish to see in the world. No matter how impossible the mission may seem, never underestimate the power of you.

The stories revealed in the following chapters took place in 13 cities and 9 states over the course of 120 weeks. I am forever thankful to have the opportunity to share these moments in history. Creating this project required every part of me. I hope this intergalactic journey through the diverse realms of fury and compassion gives you an opportunity to reimagine and expand your understanding of this time in American history.

OAKLAND, CA
VENICE BEACH, CA
ATLANTA, GA
NASHVILLE, TN
NEWARK, NJ
NEW YORK, NJ

MOTHERSHIP

STAY HOME

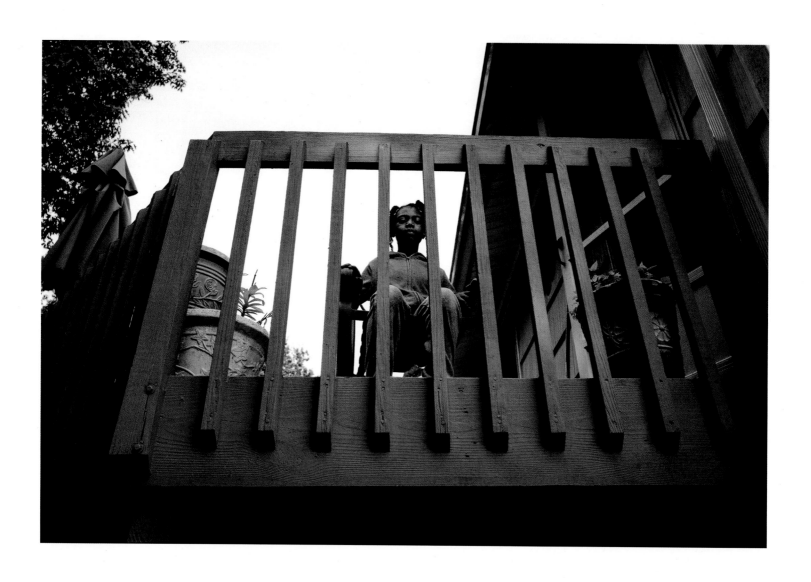

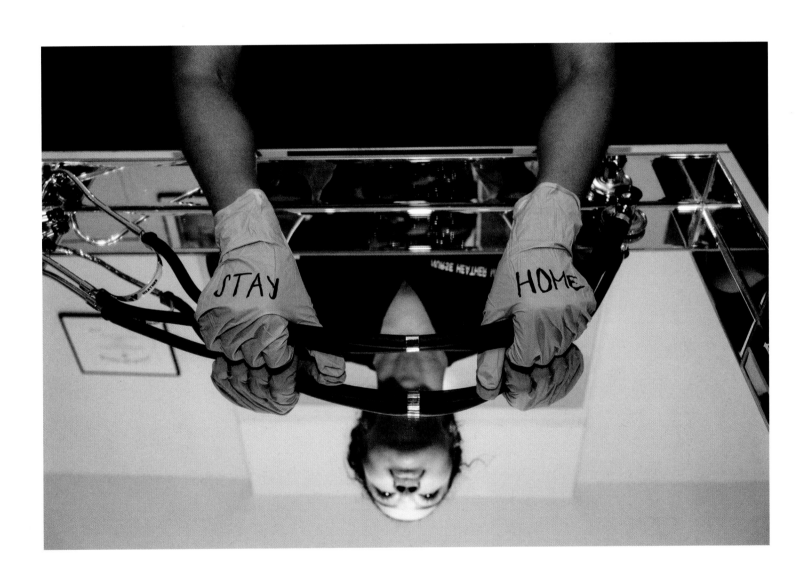

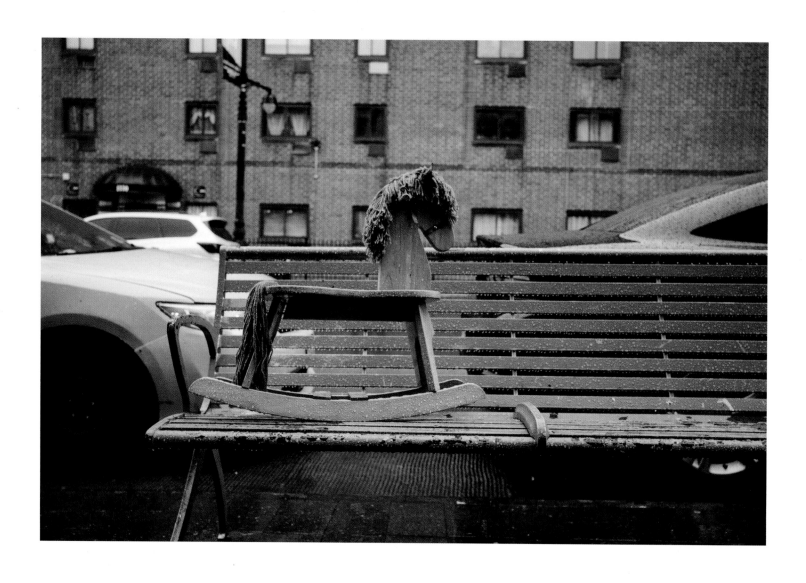

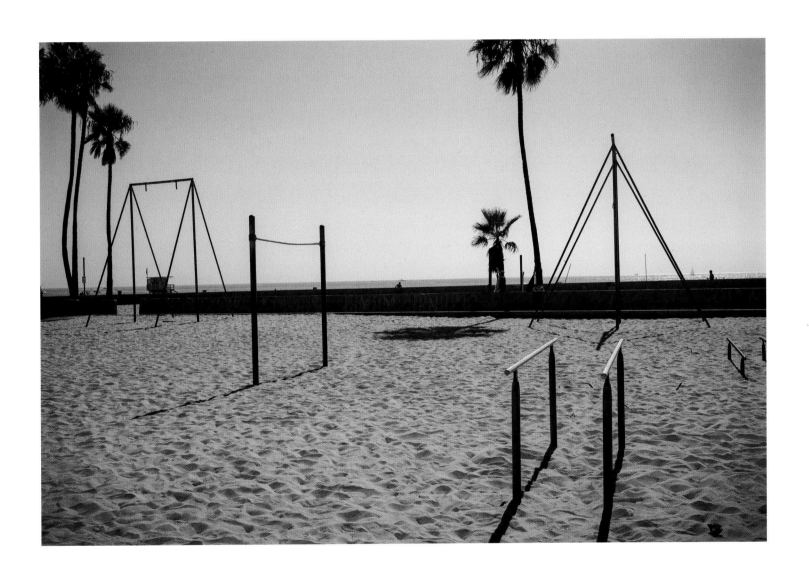

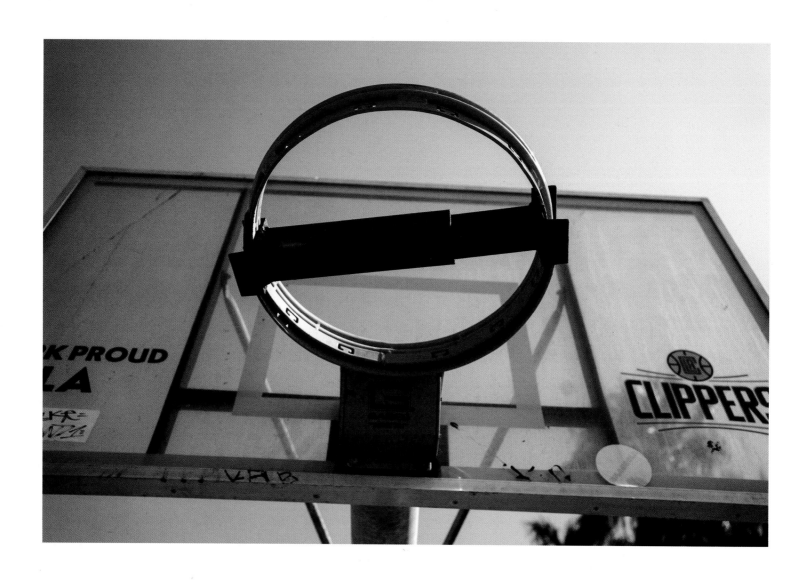

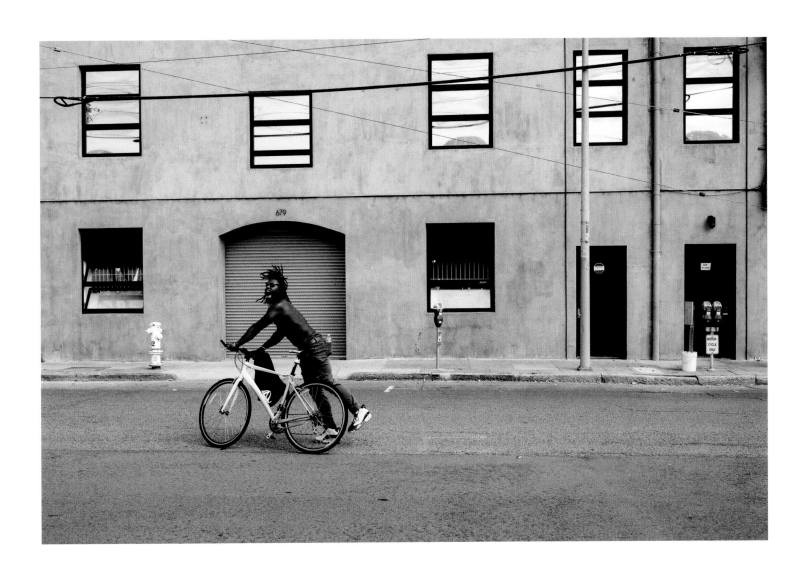

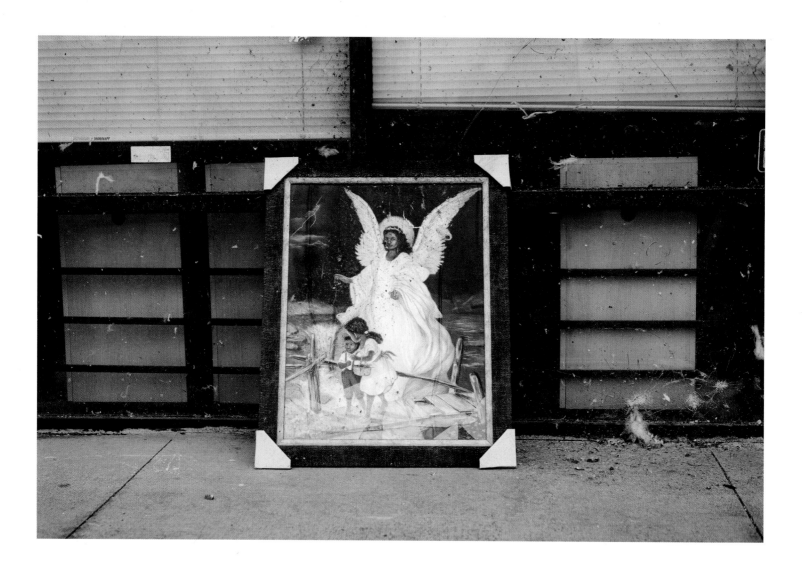

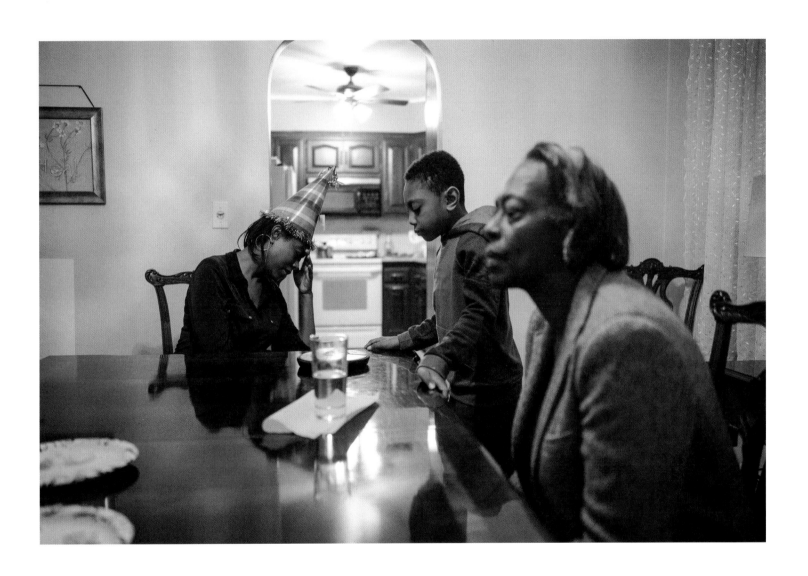

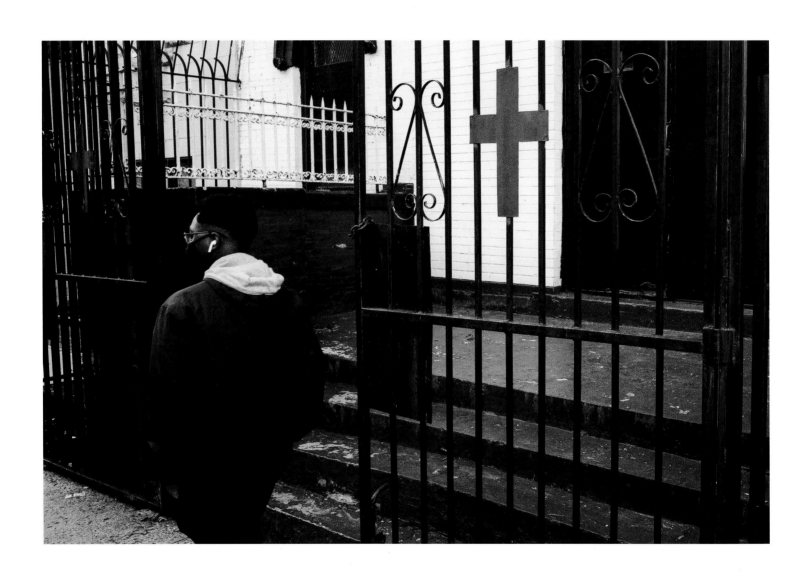

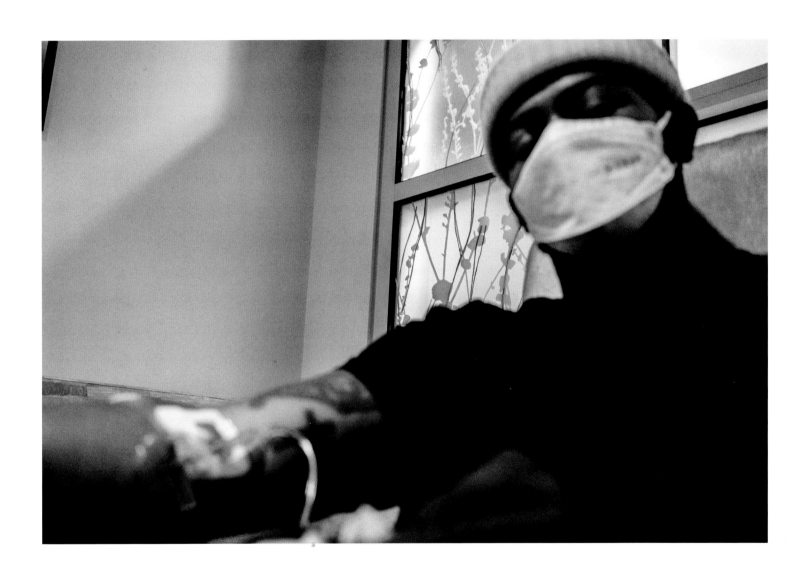

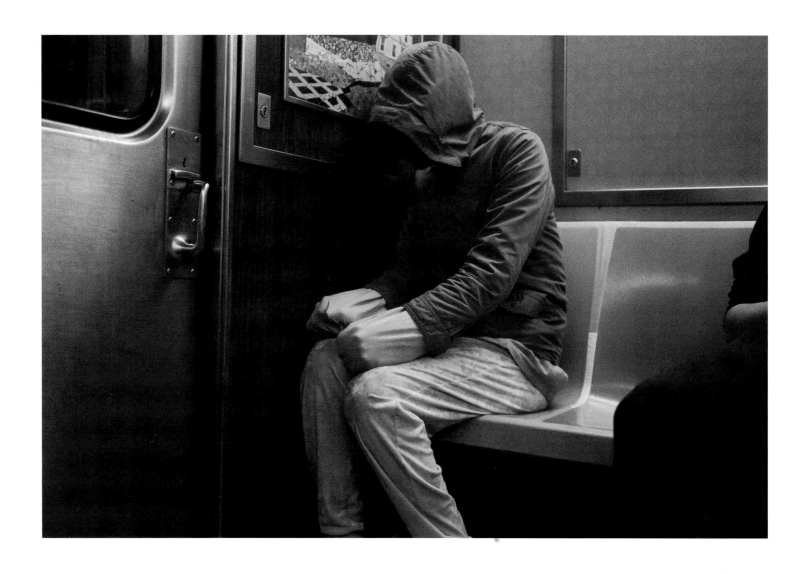

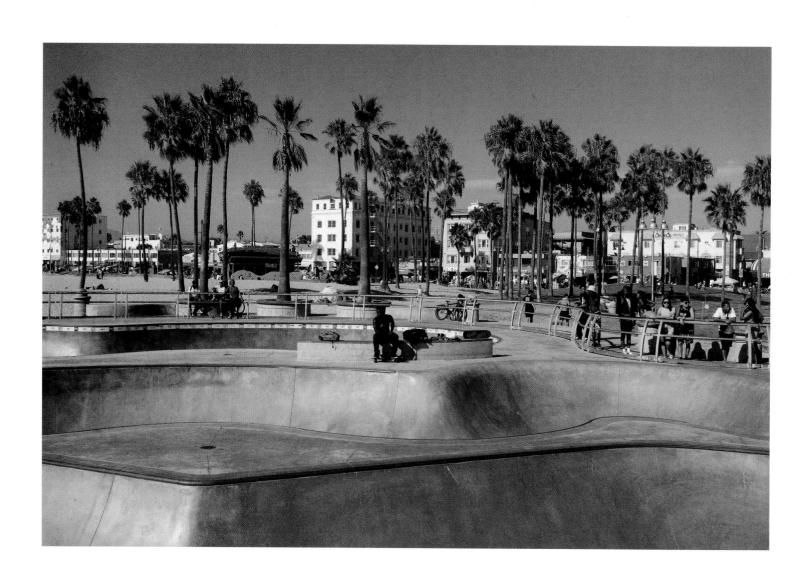

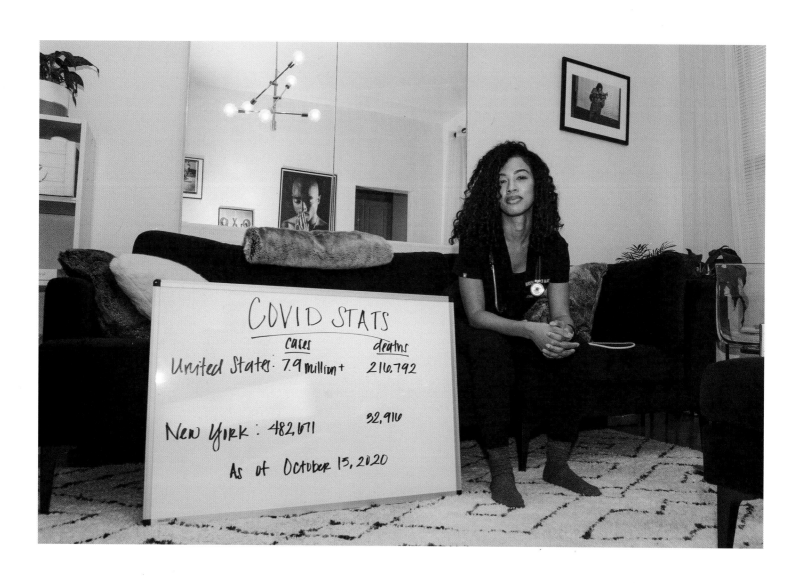

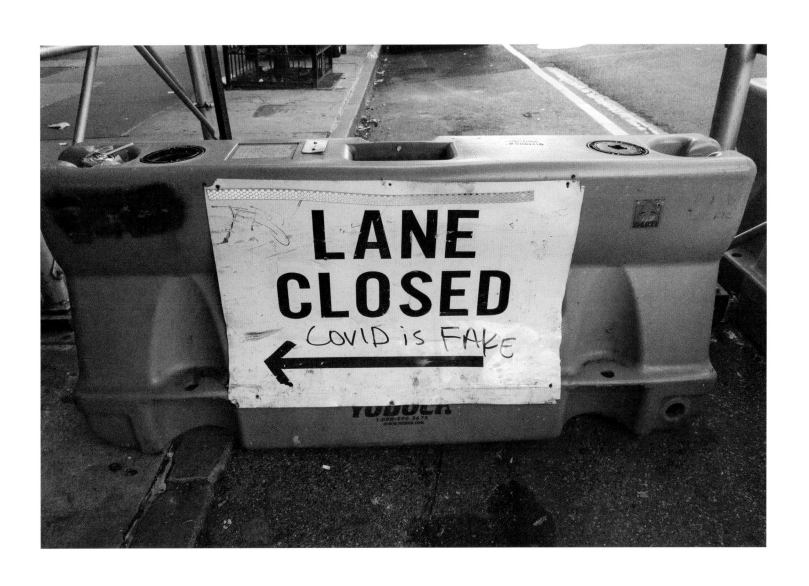

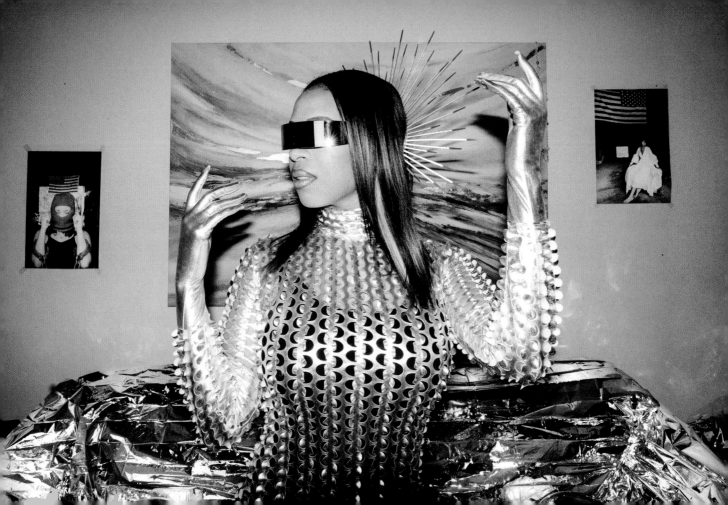

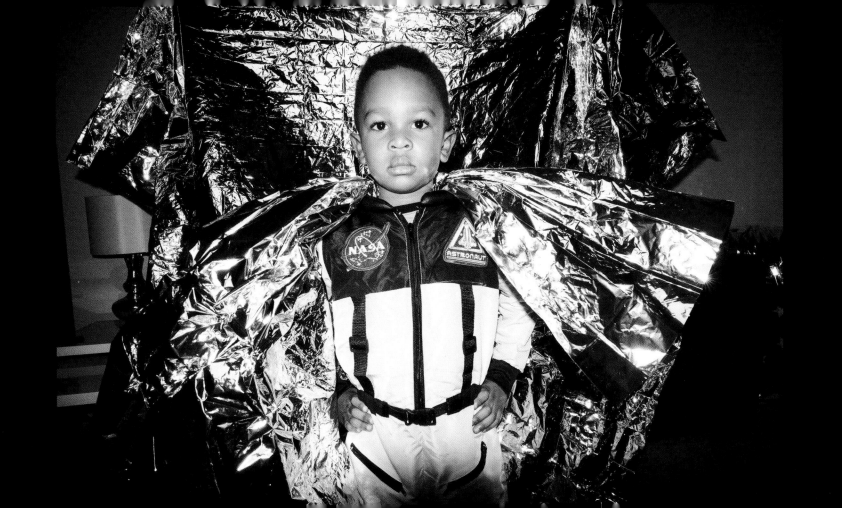

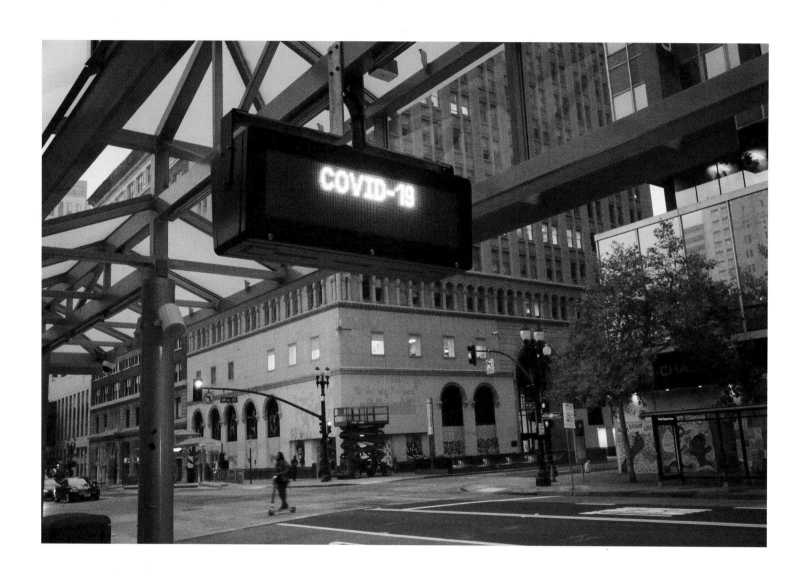

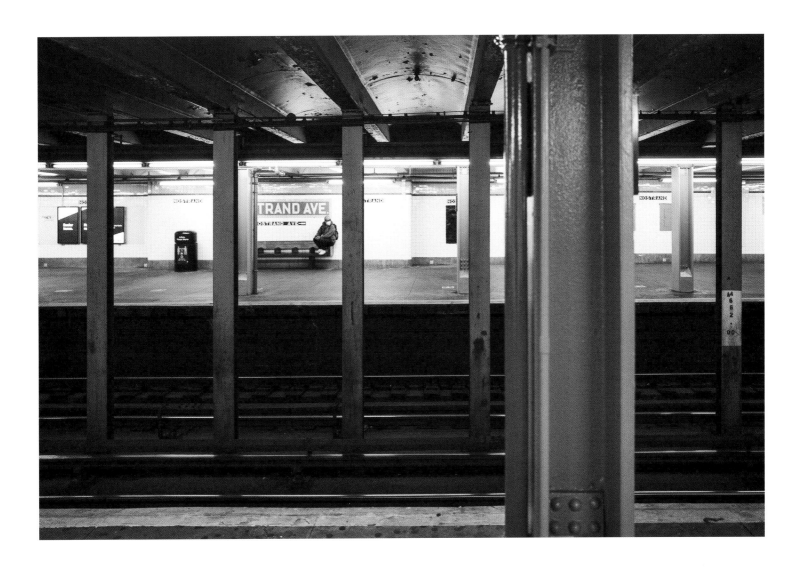

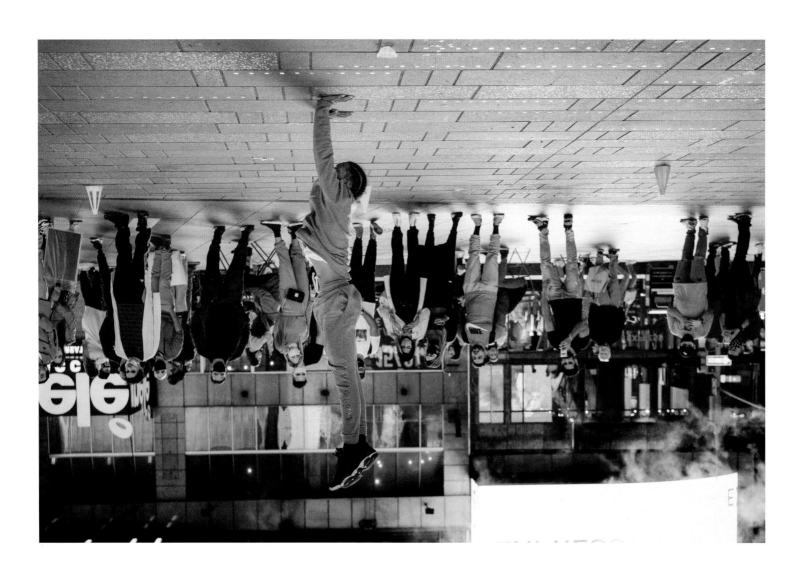

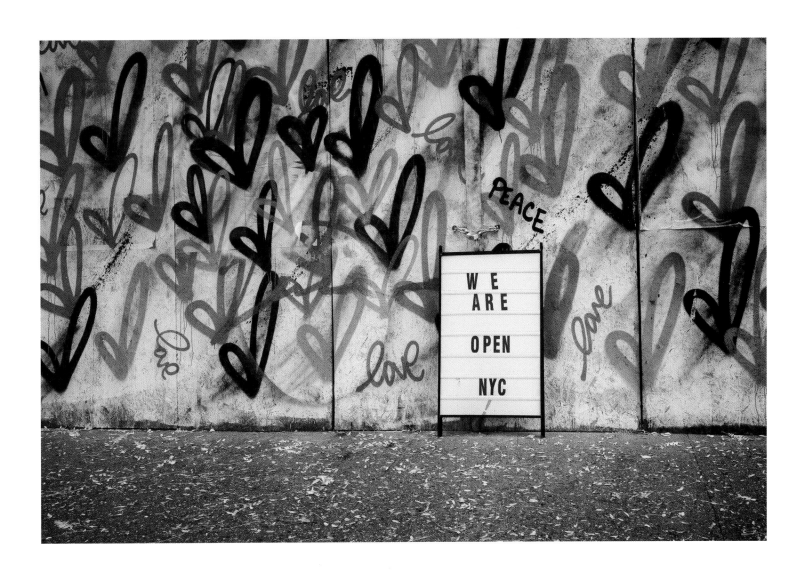

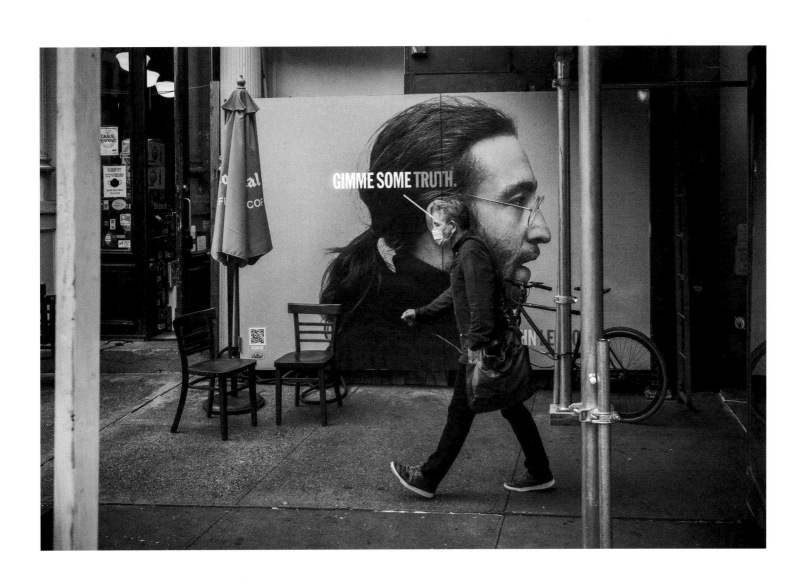

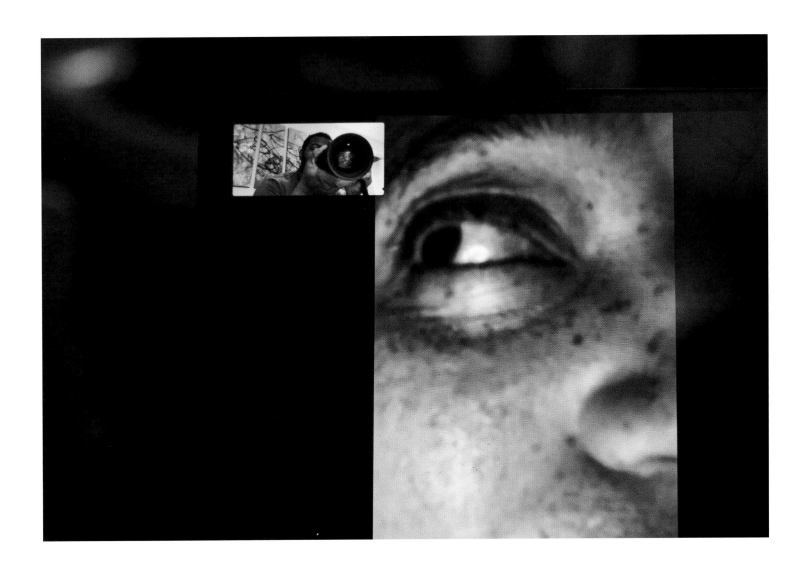

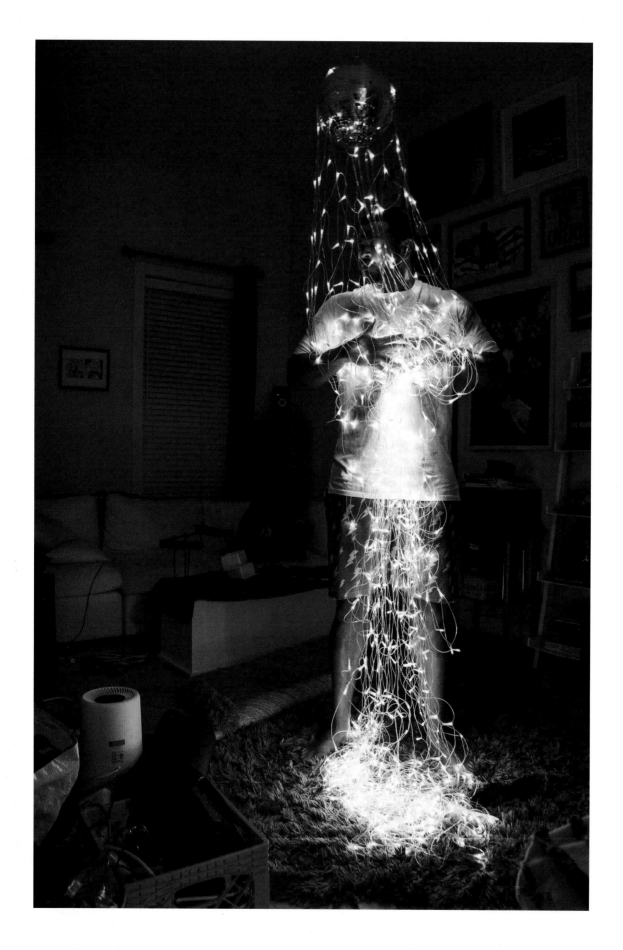

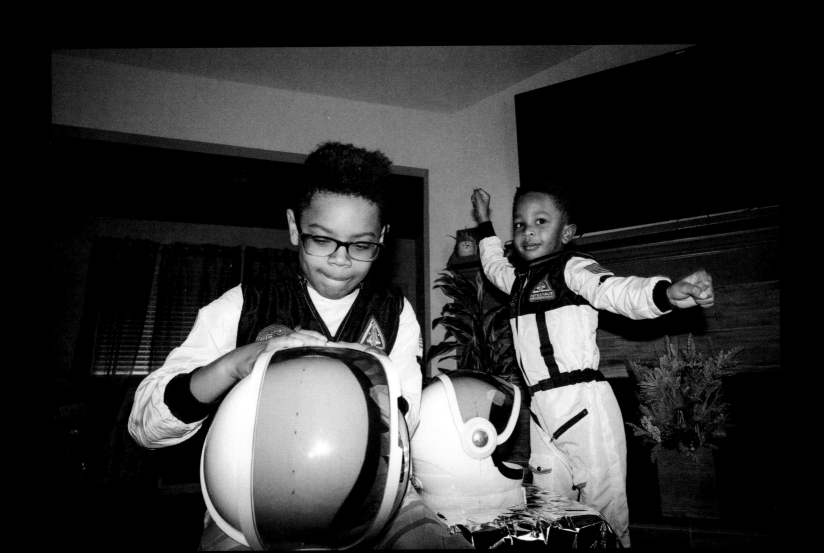

OAKLAND, CA
WASHINGTON, D.C.
ATLANTA, GA

THE BIG BANG

HIGHER POWER

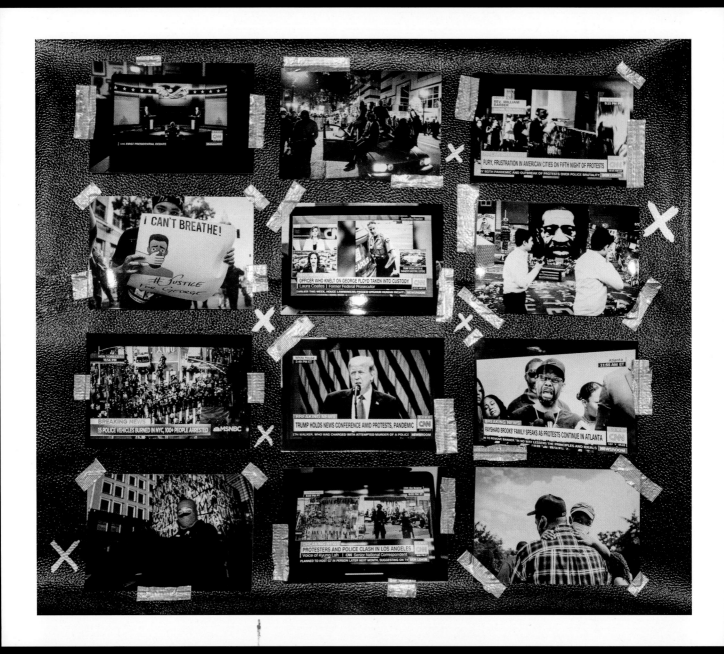

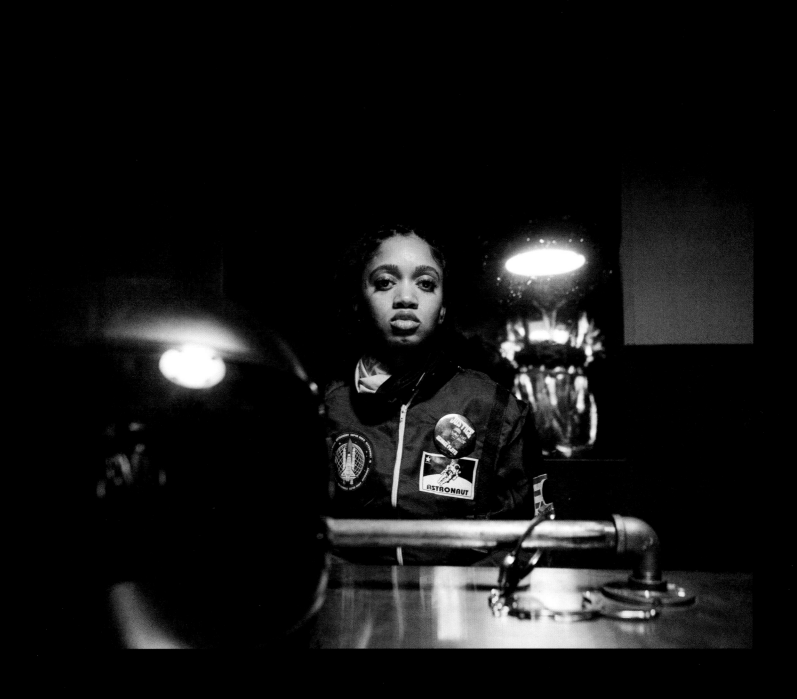

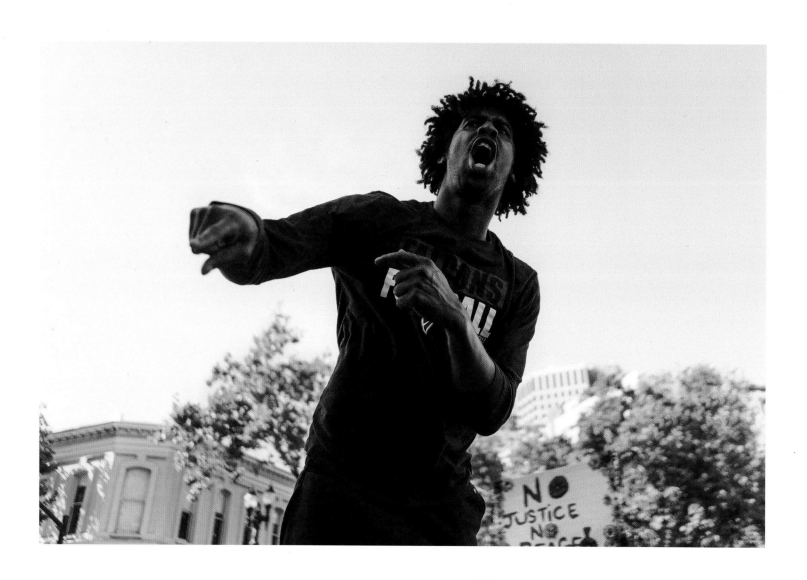

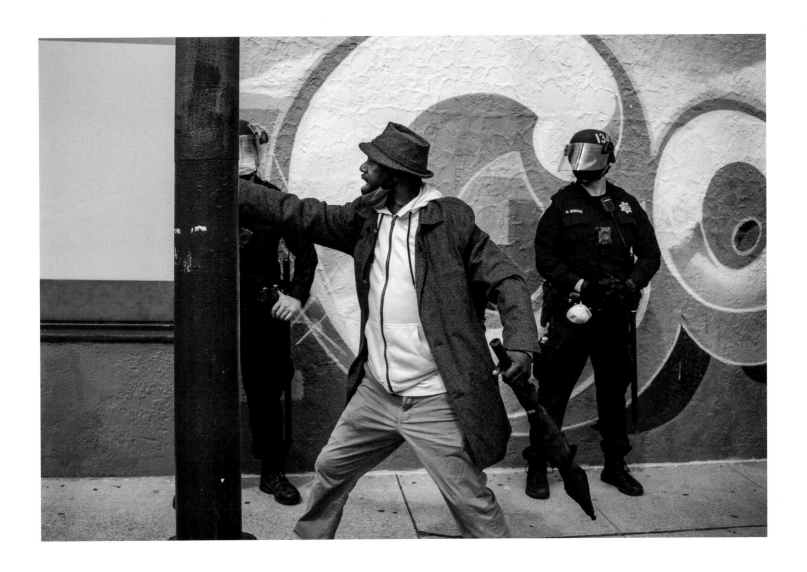

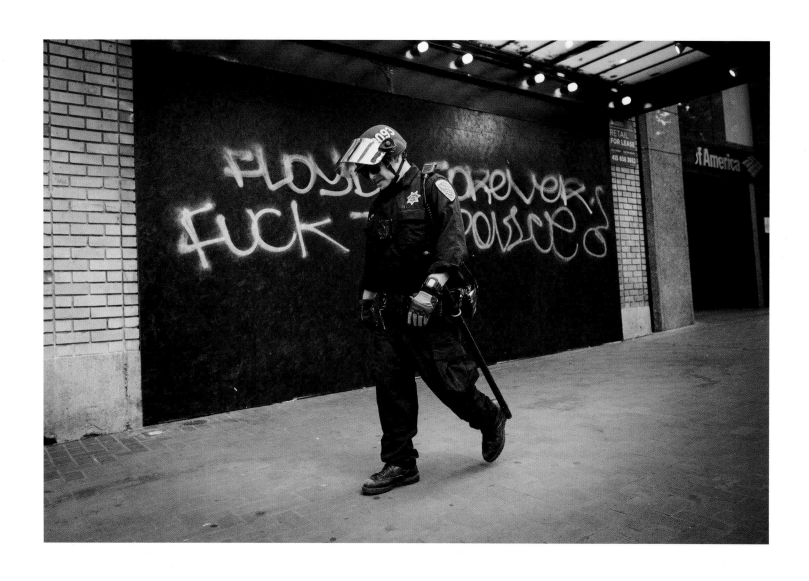

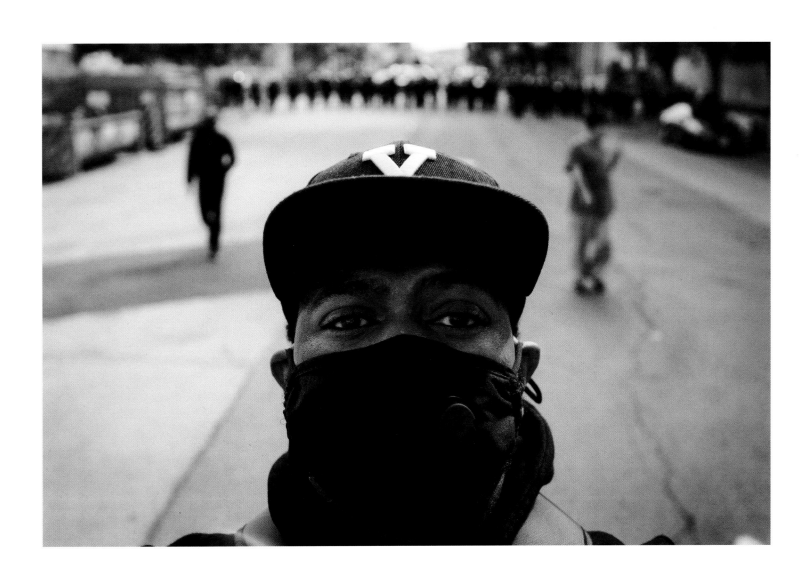

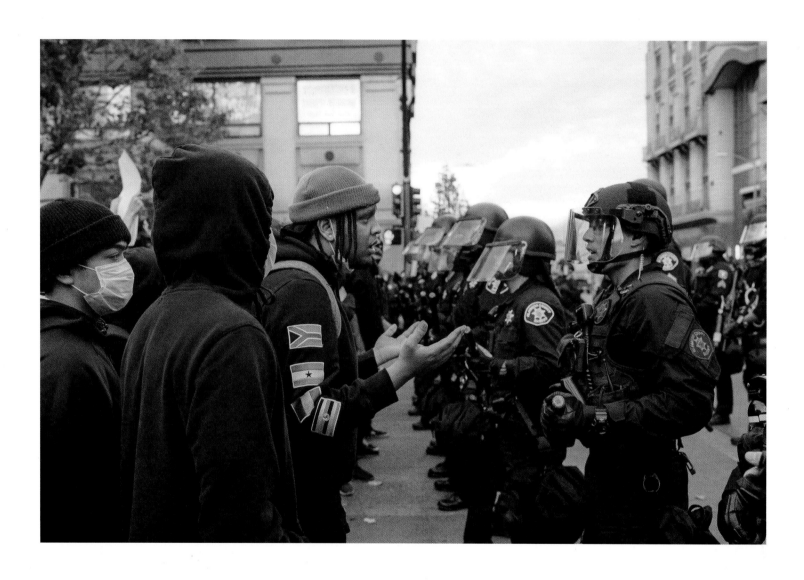

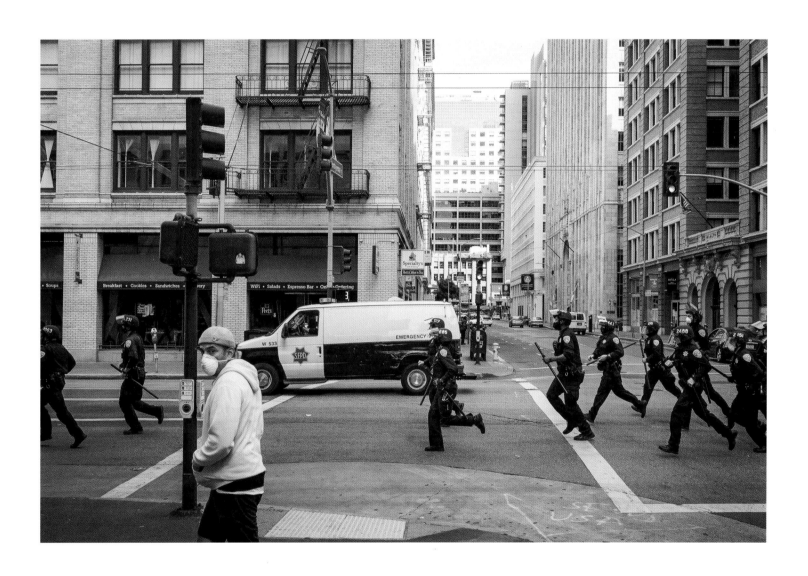

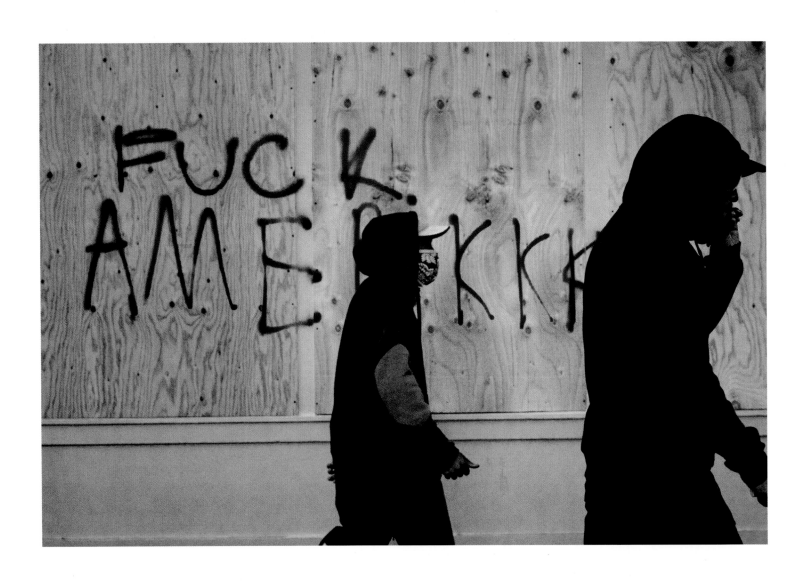

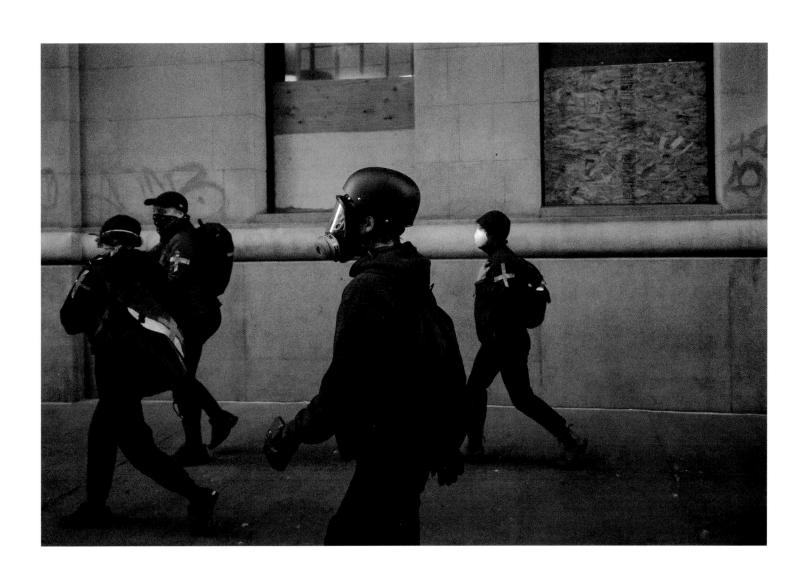

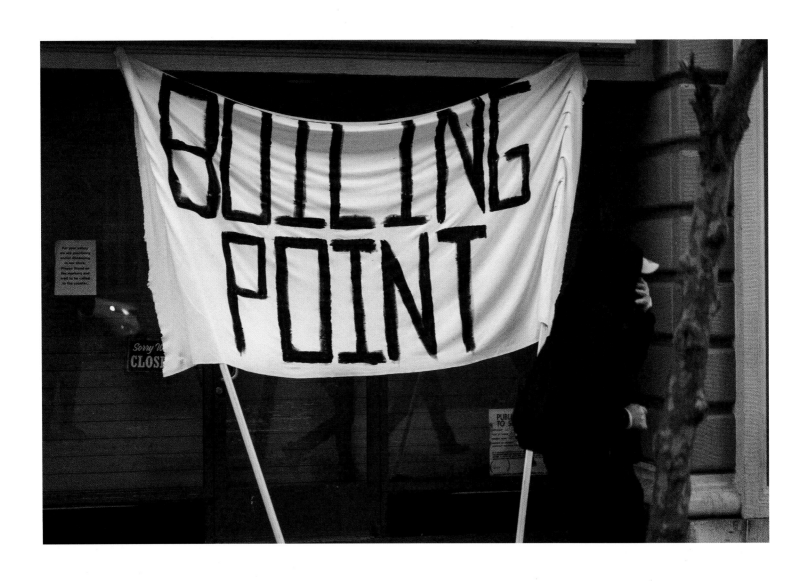

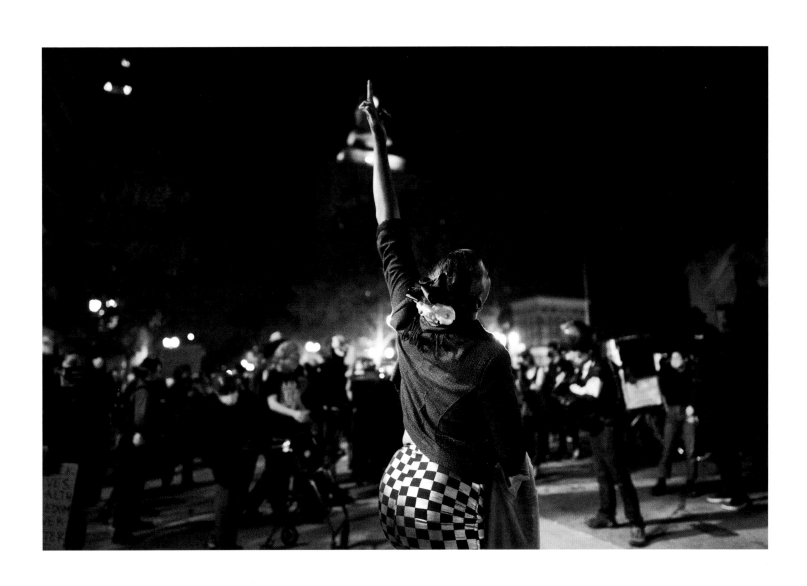

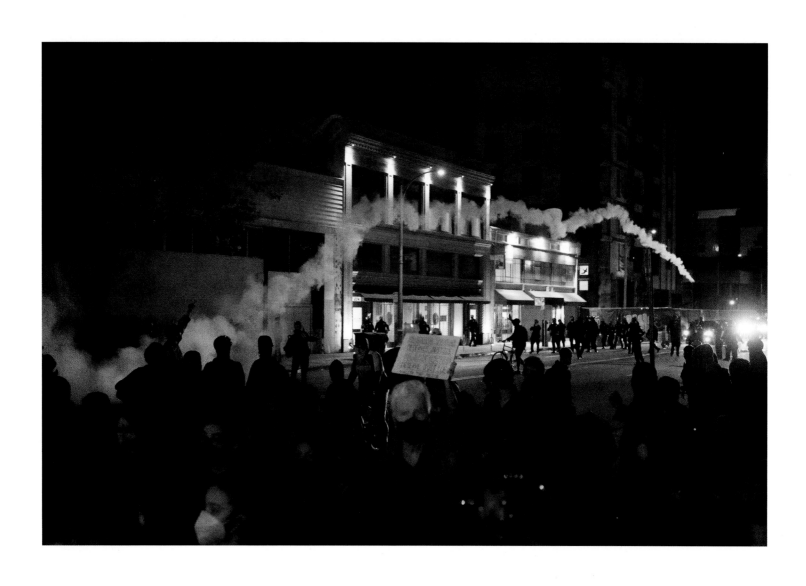

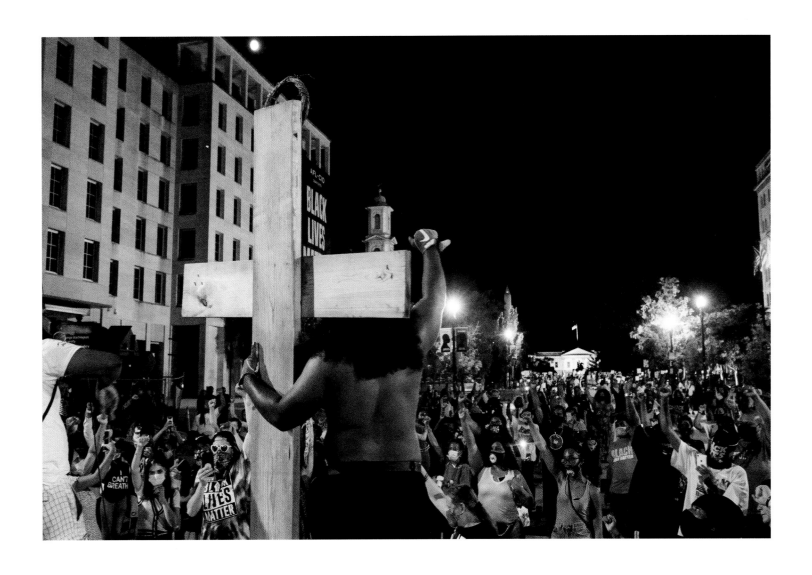

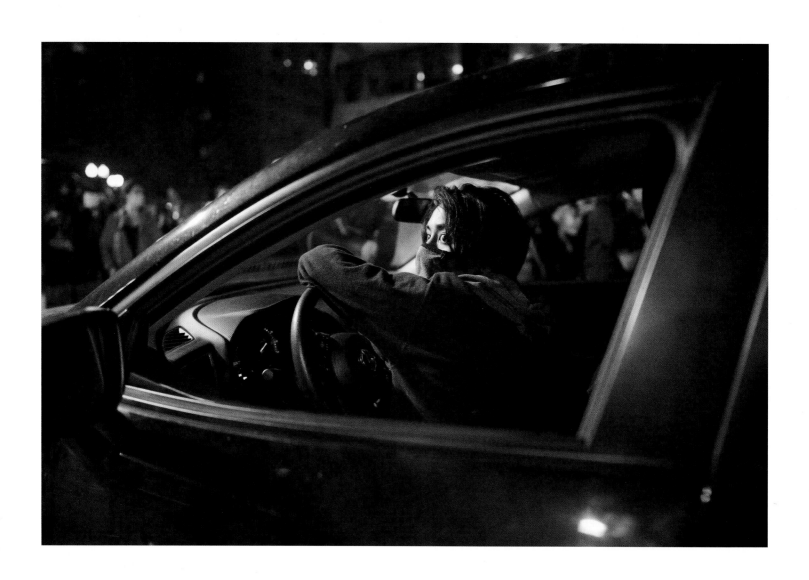

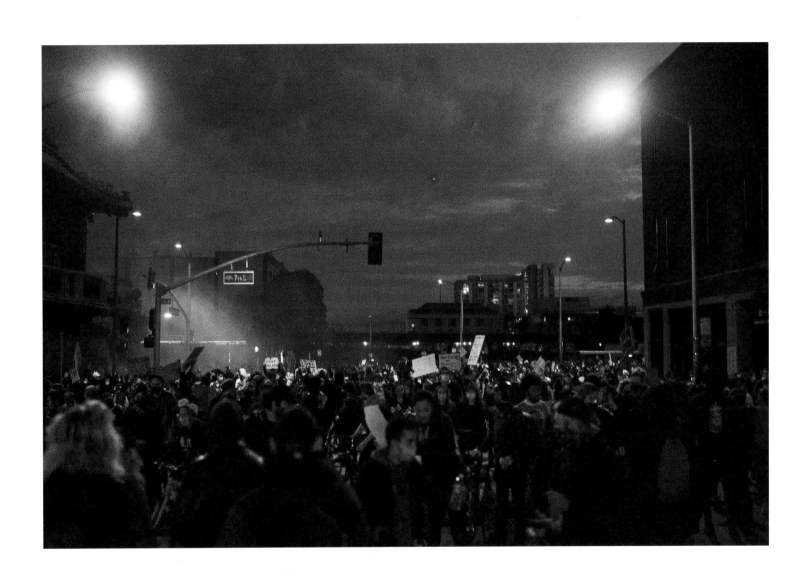

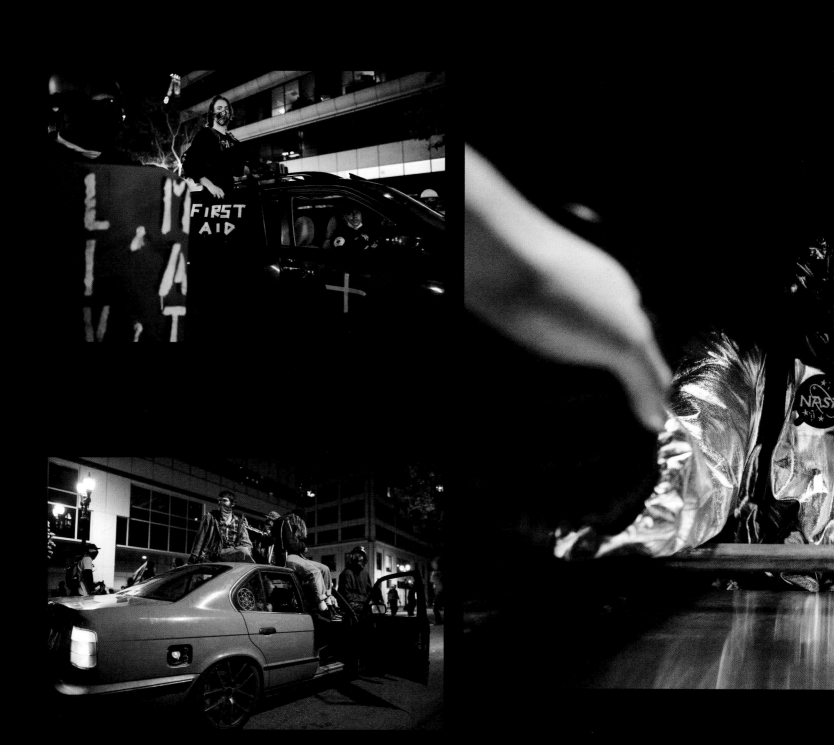

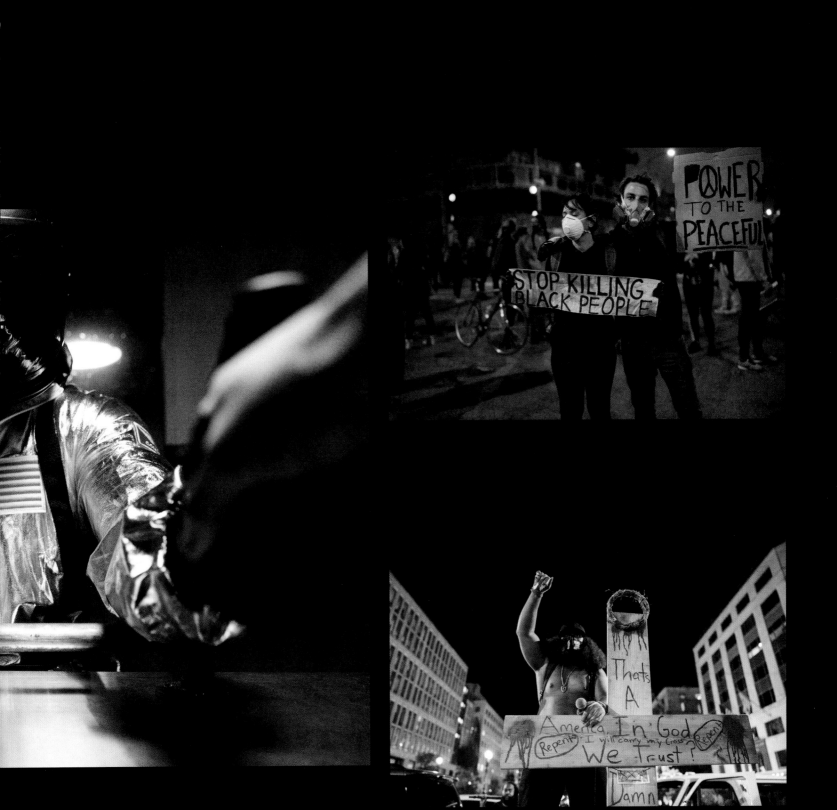

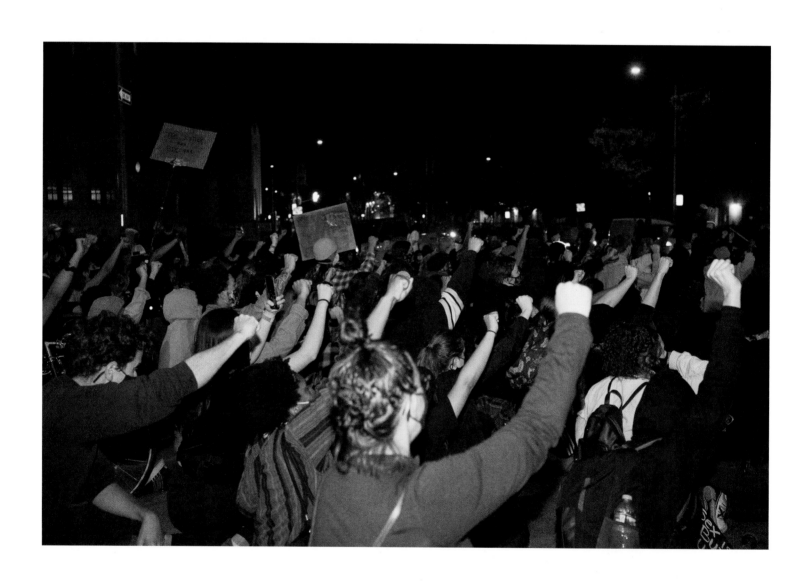

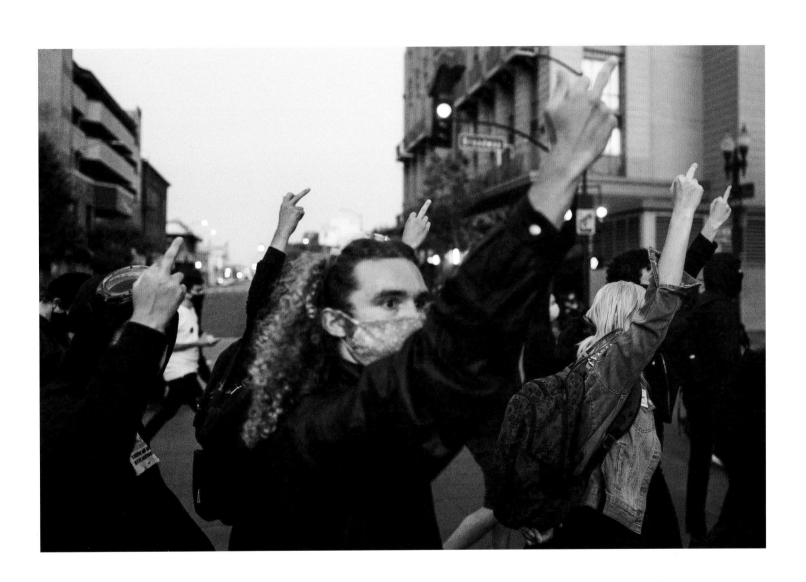

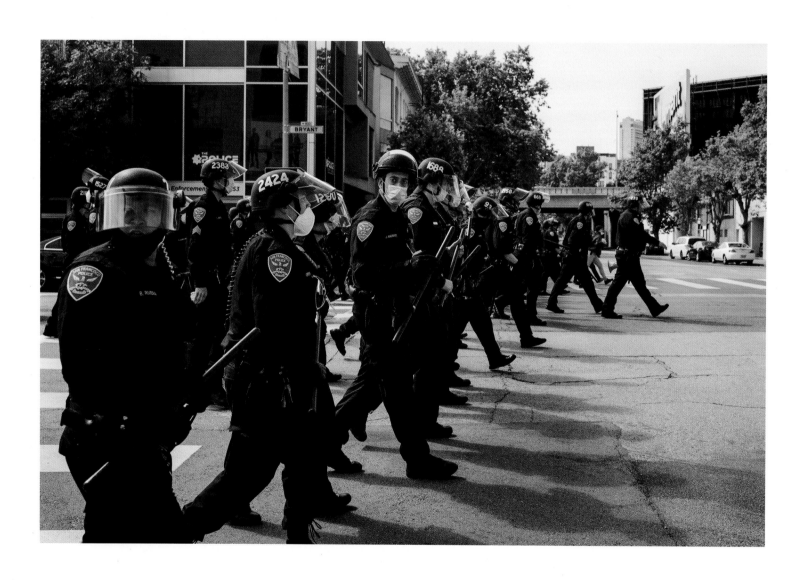

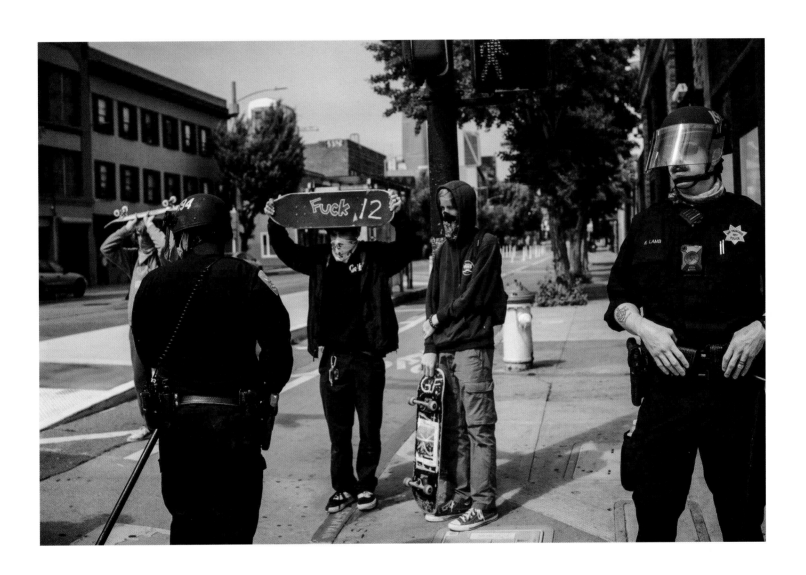

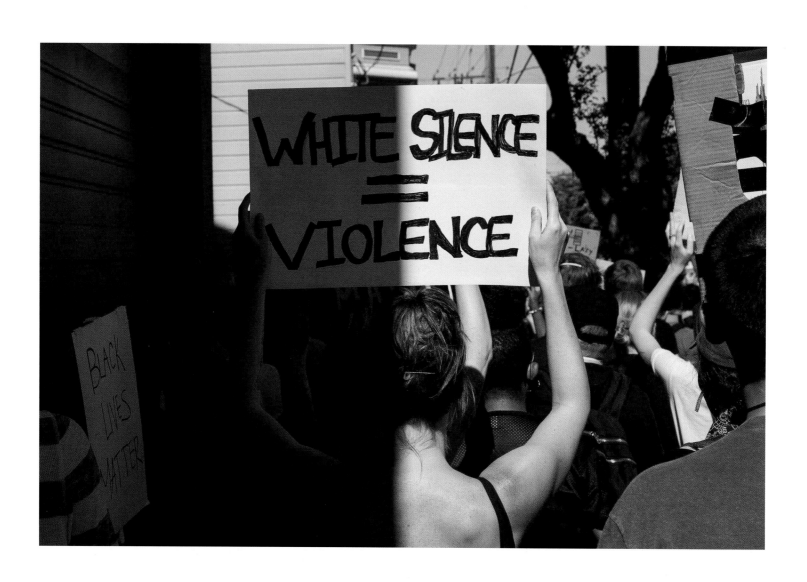

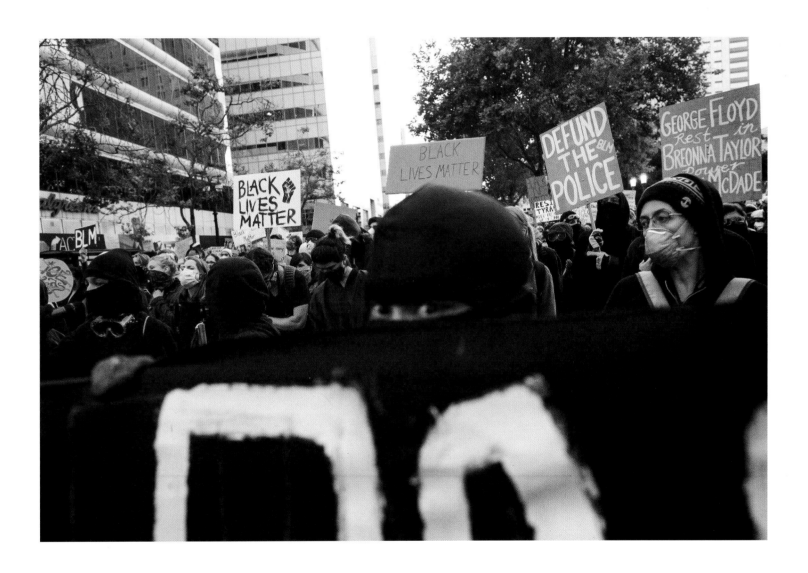

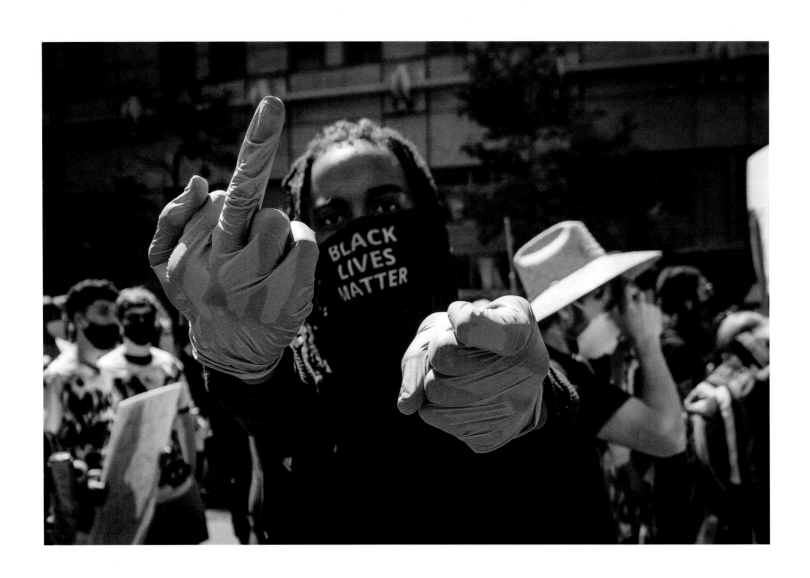

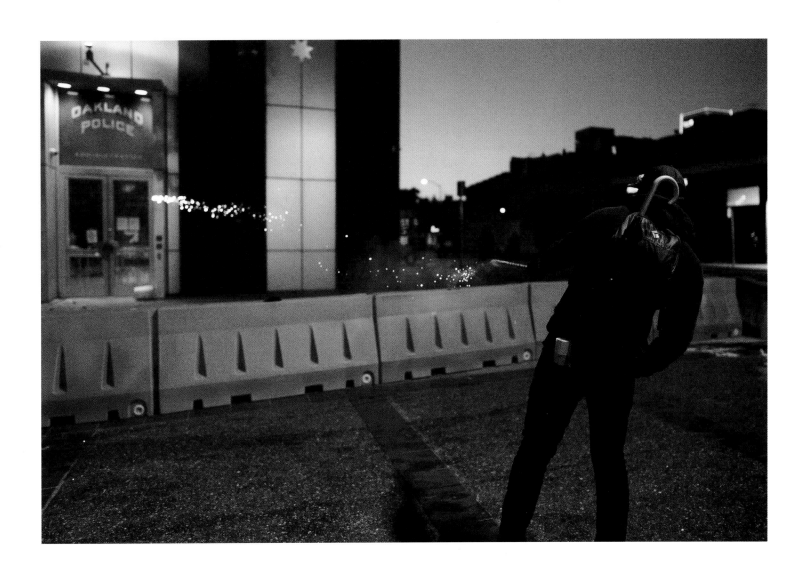

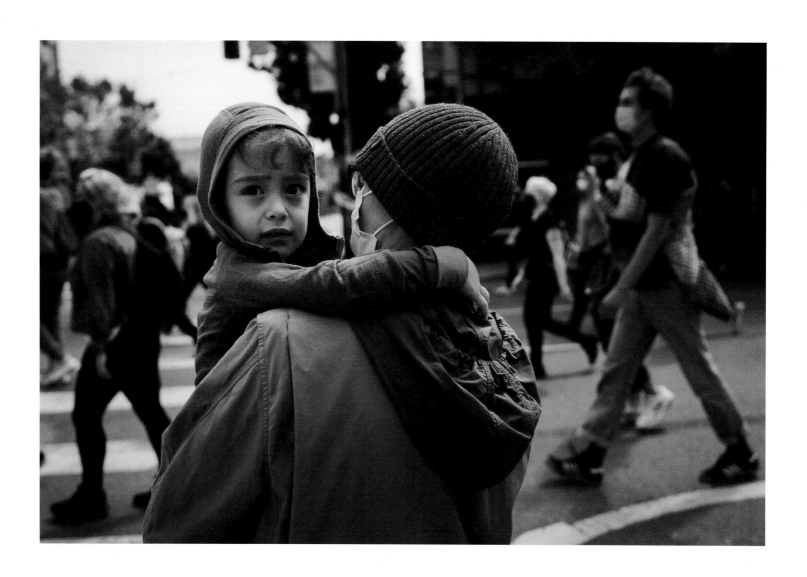

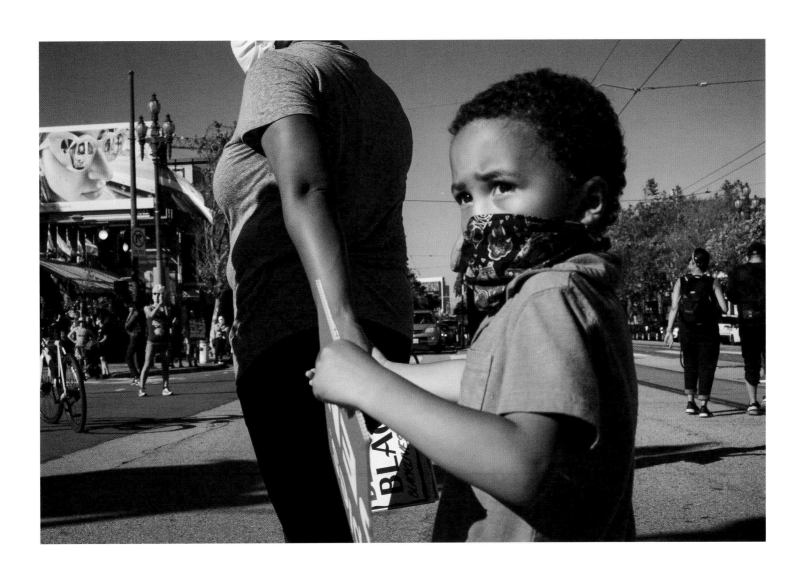

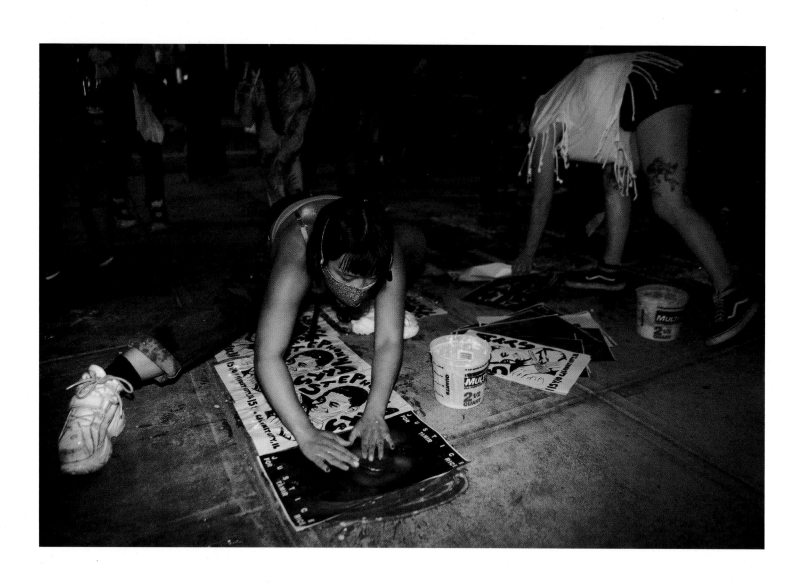

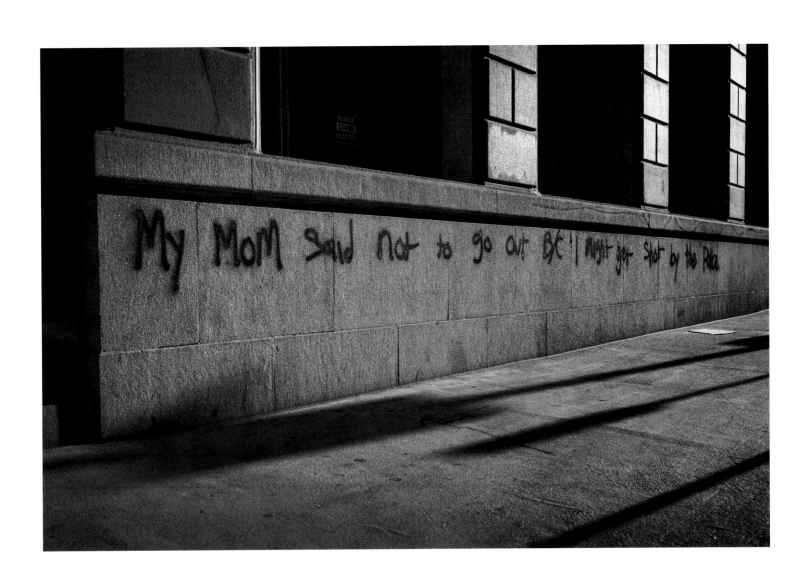

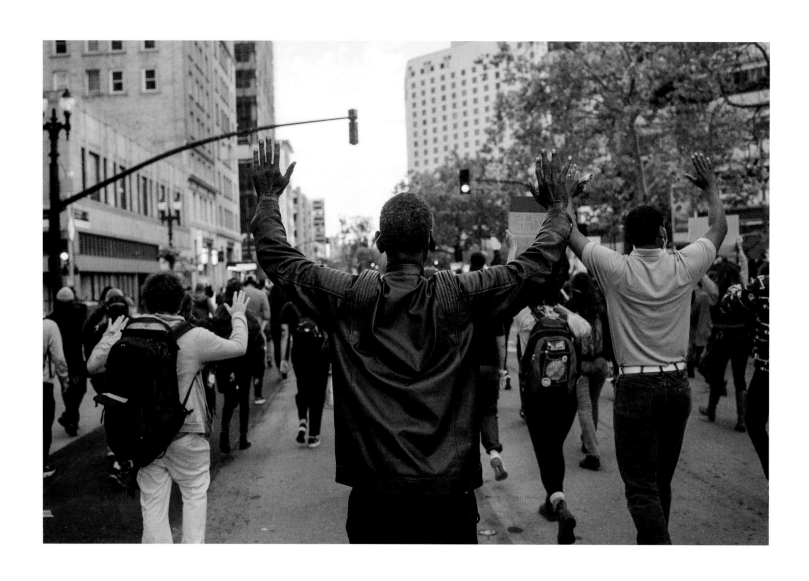

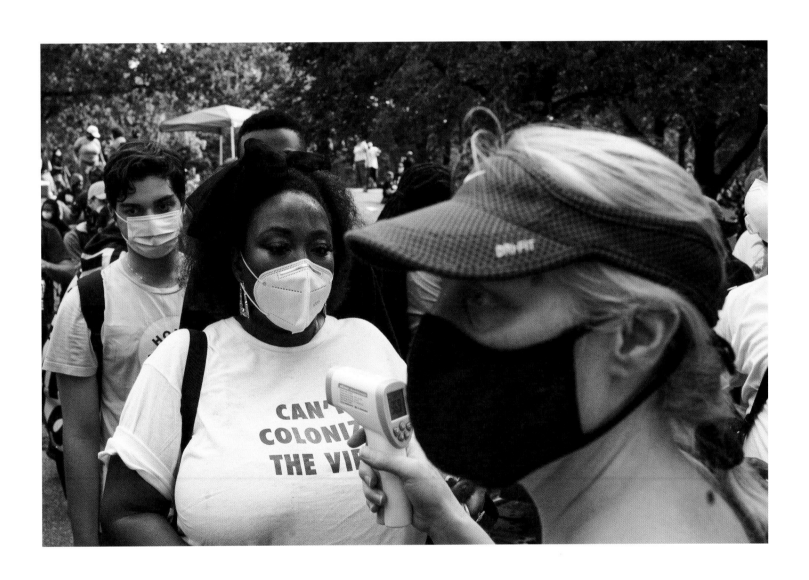

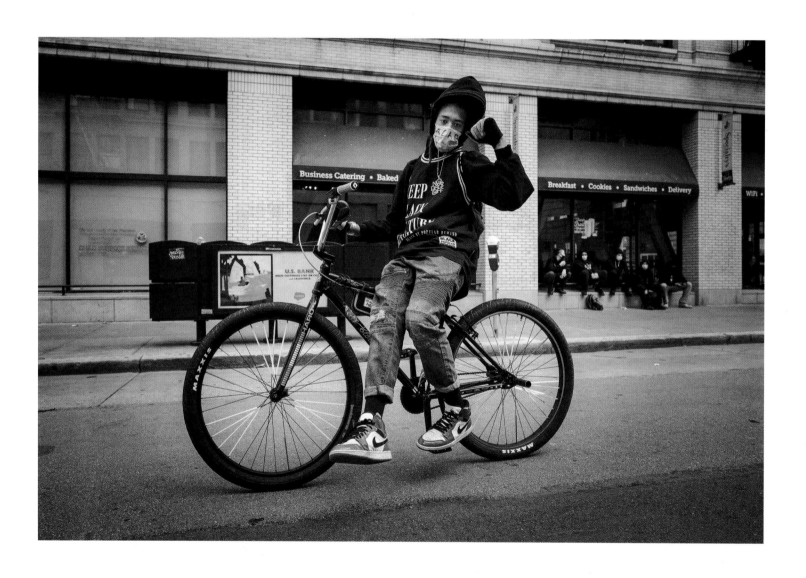

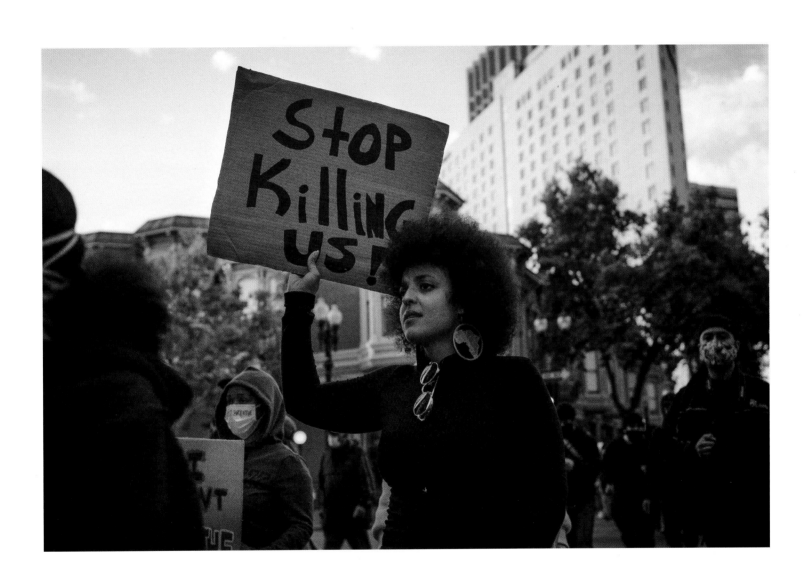

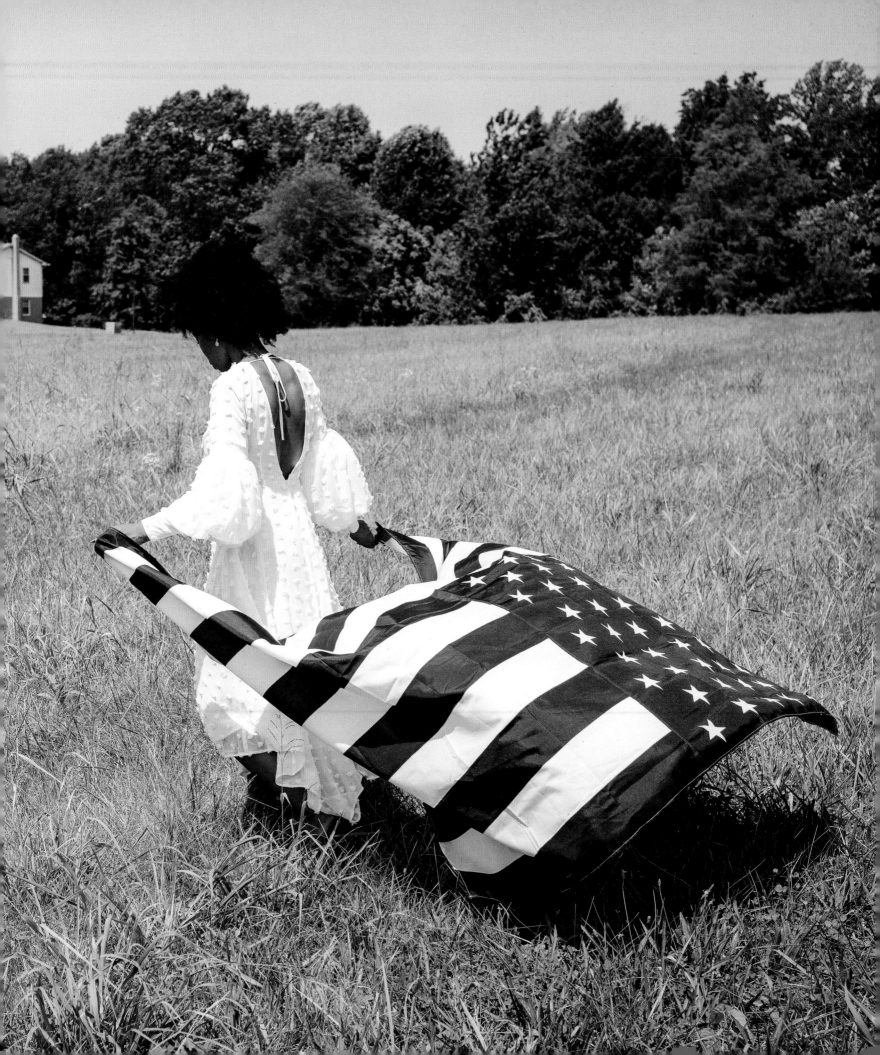

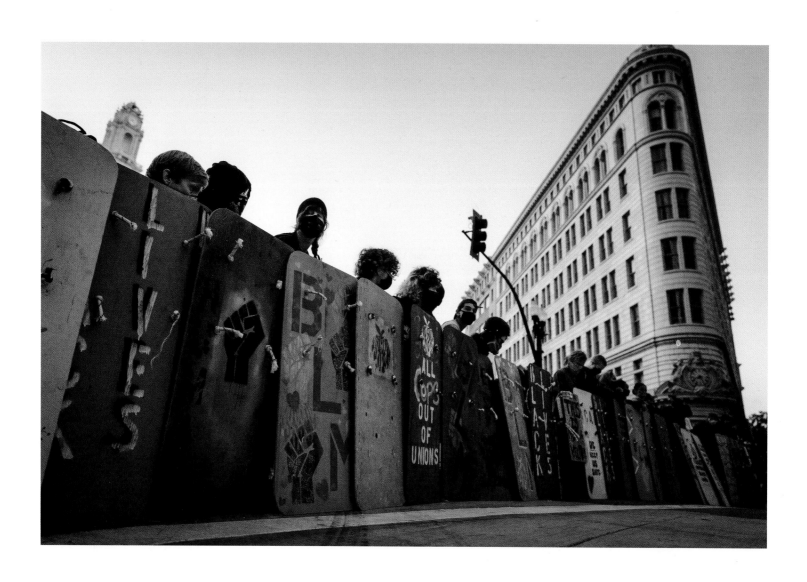

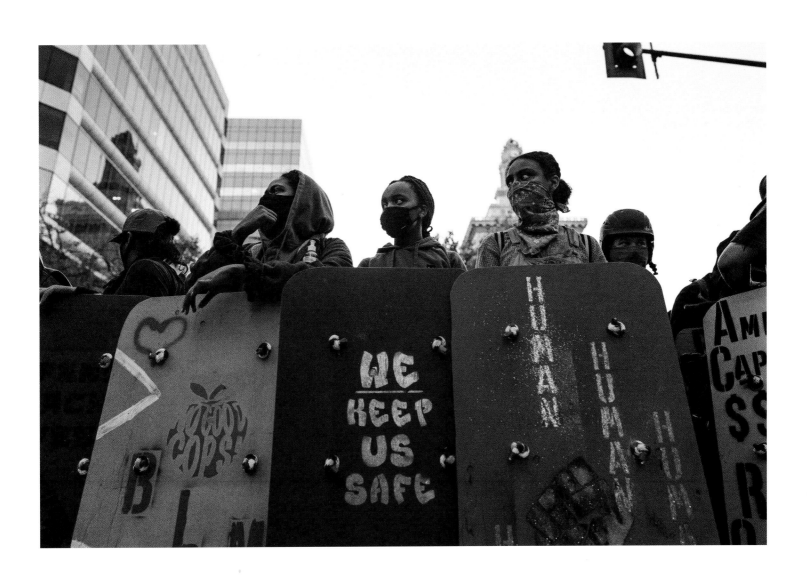

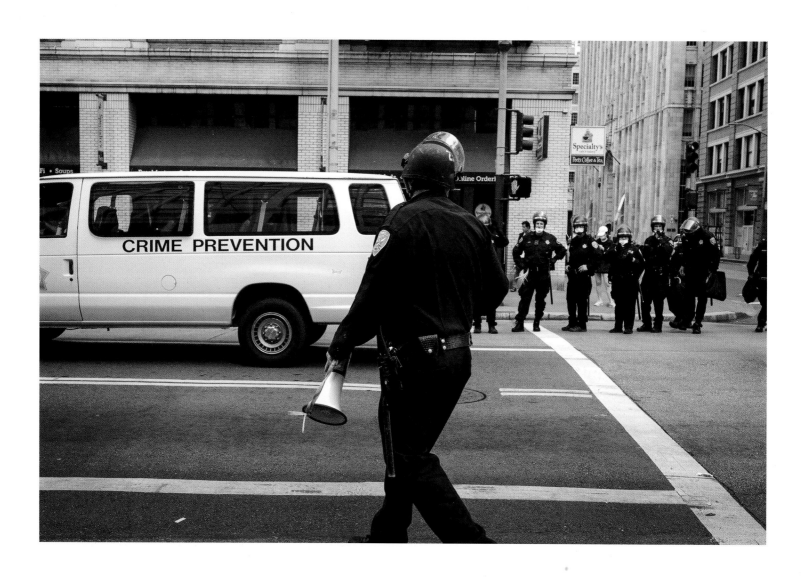

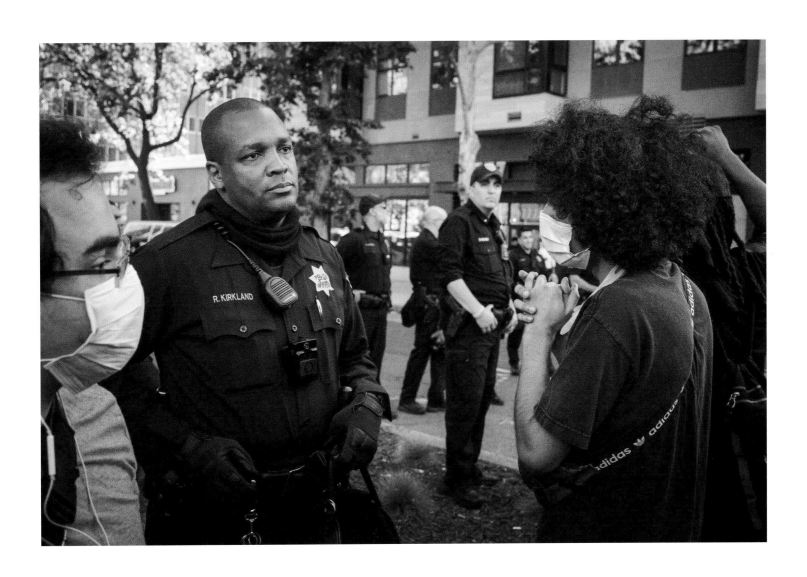

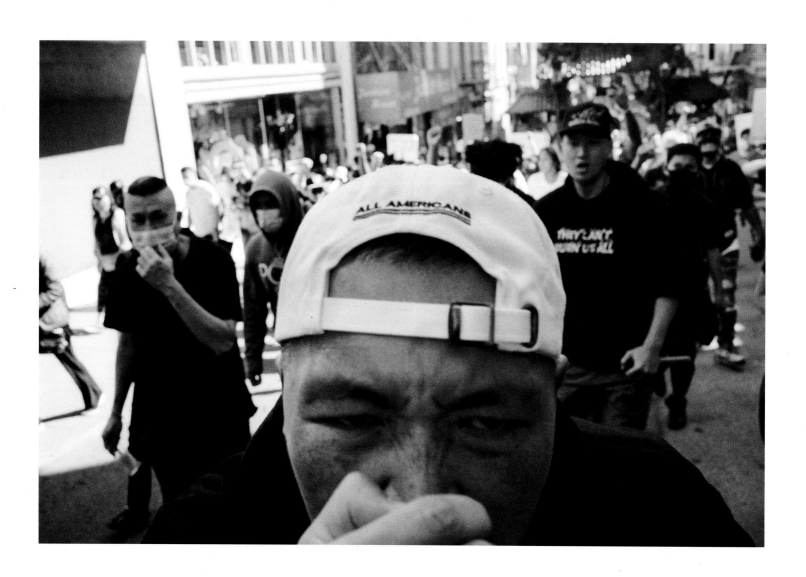

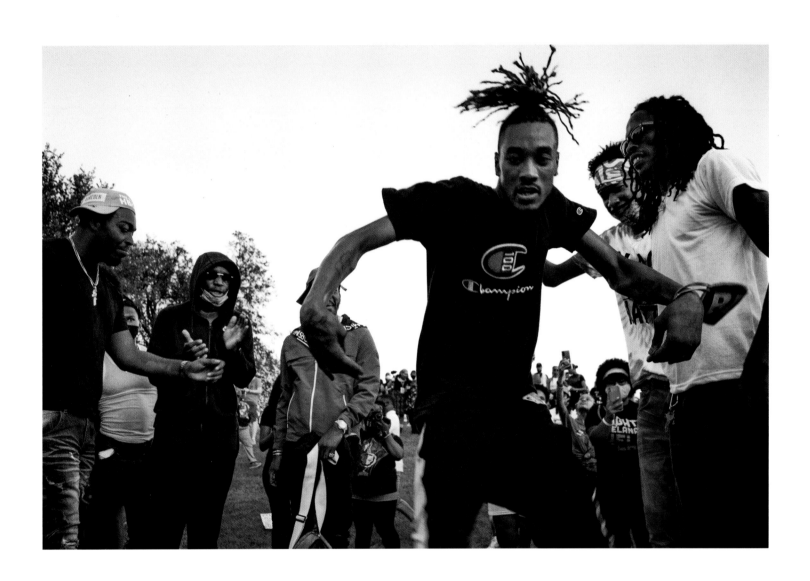

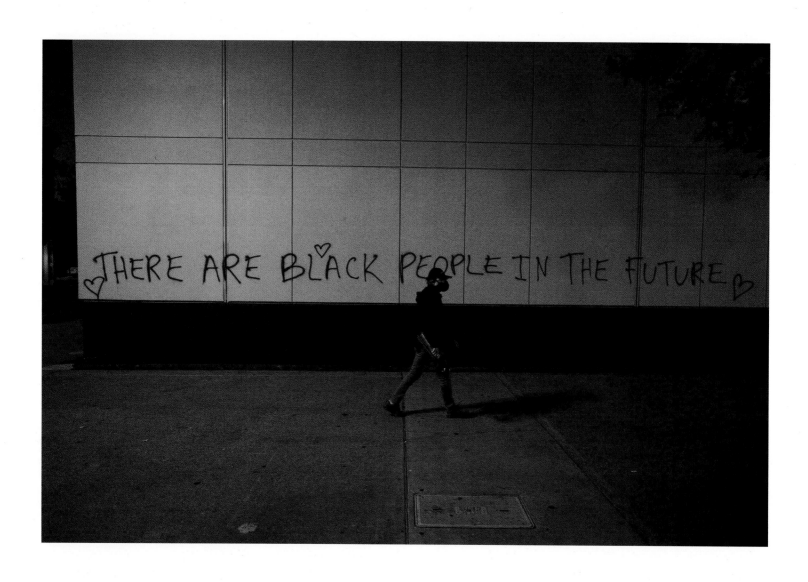

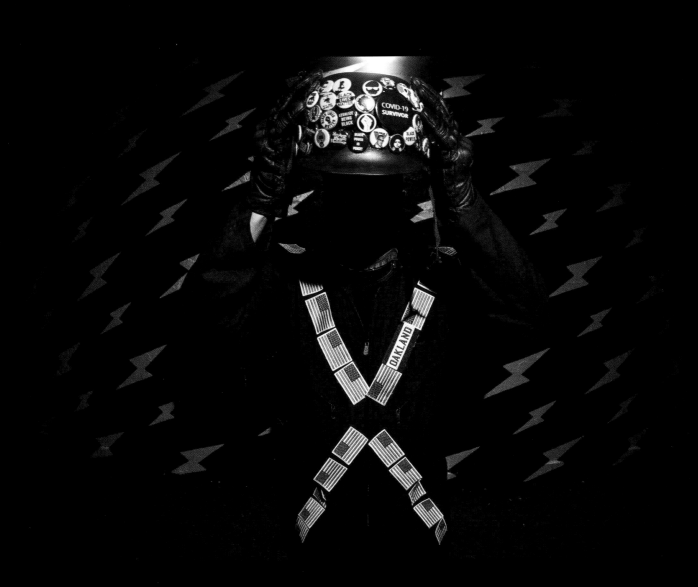

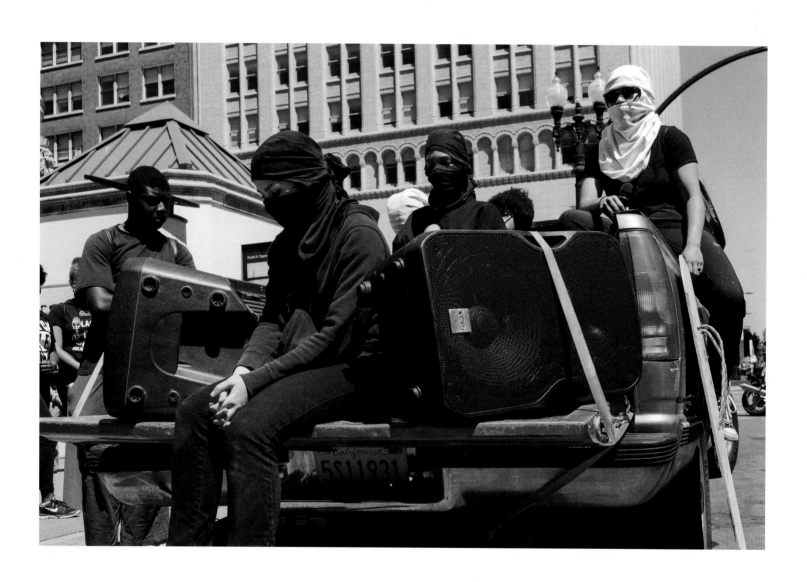

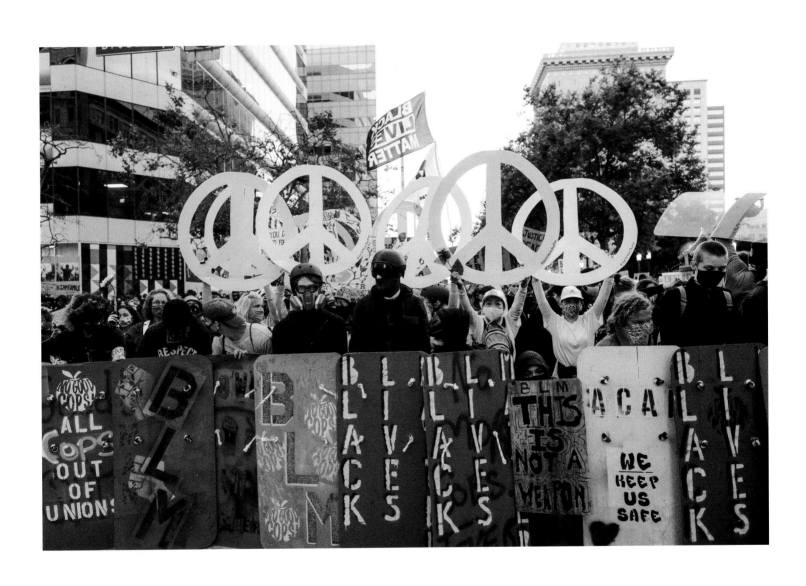

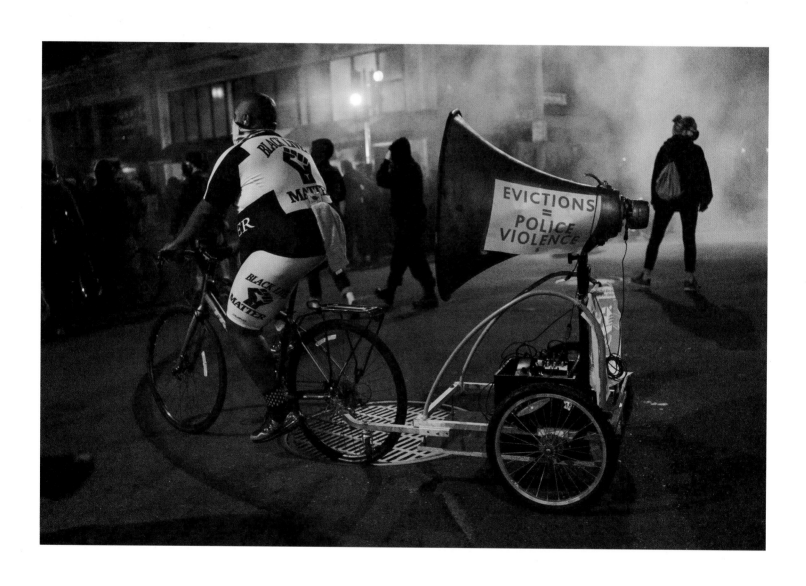

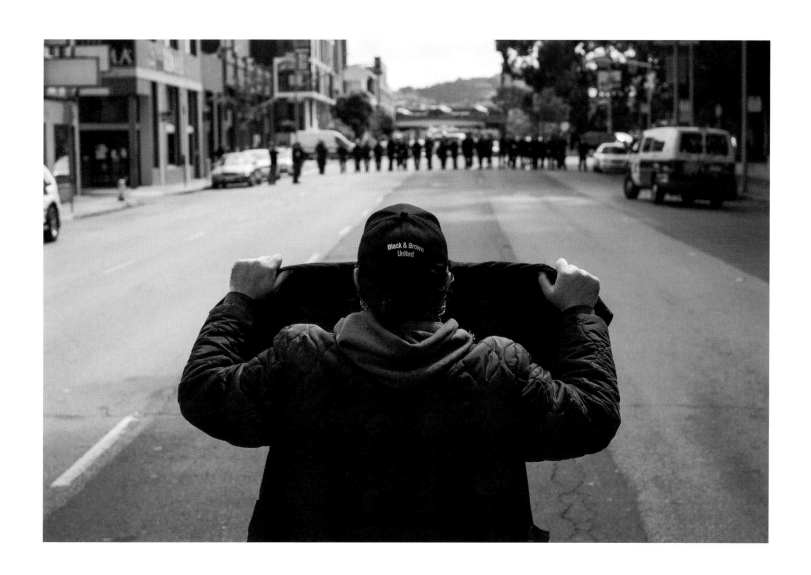

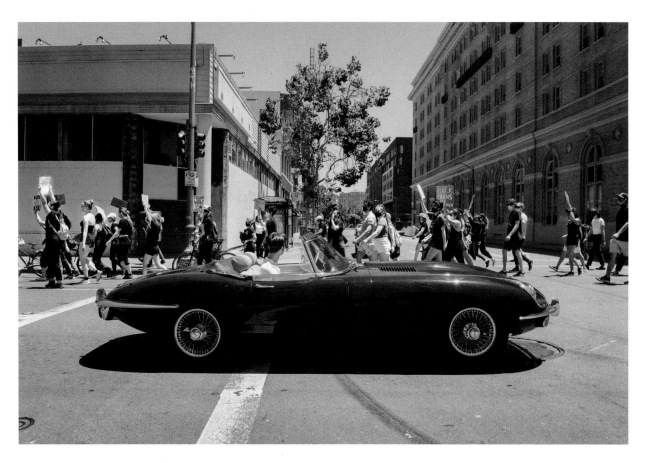

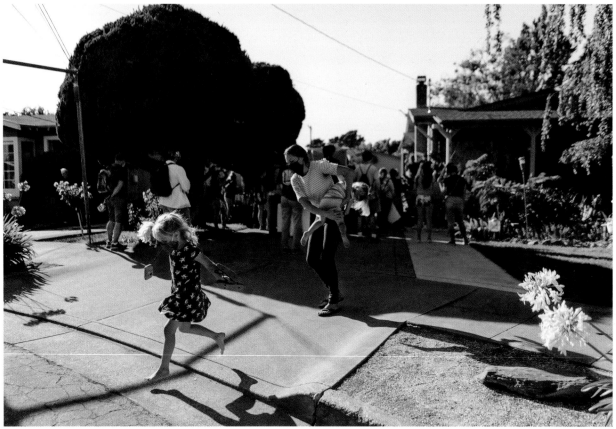

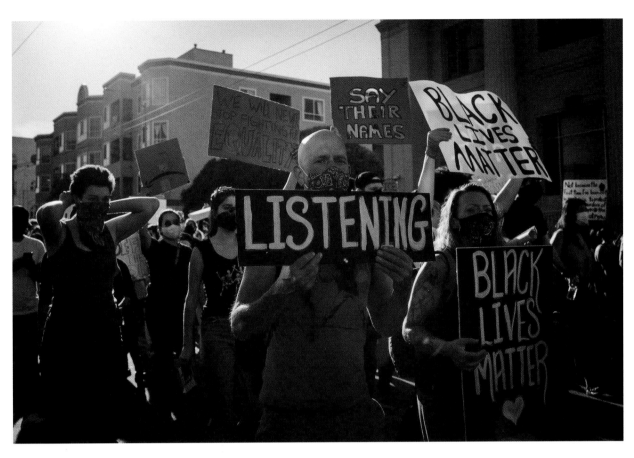

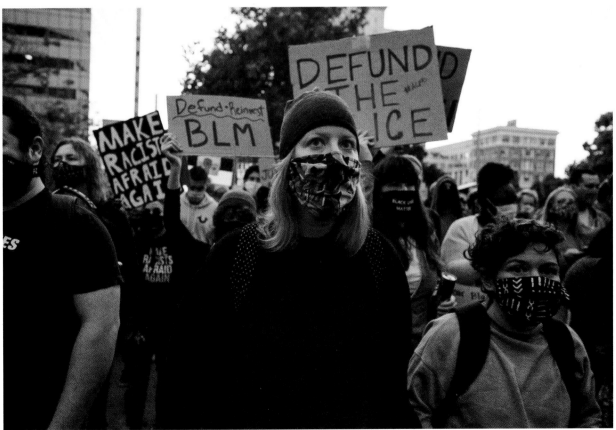

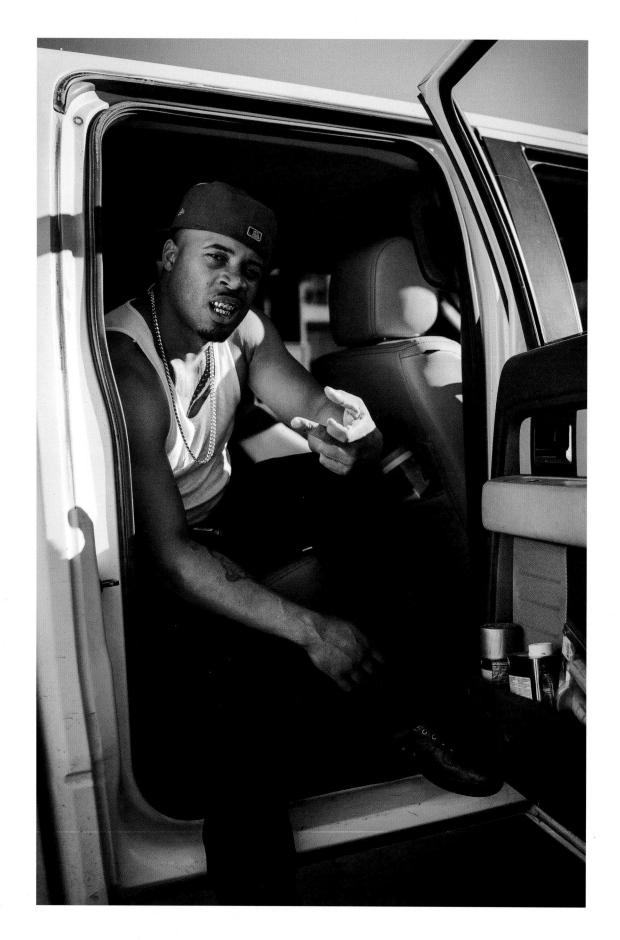

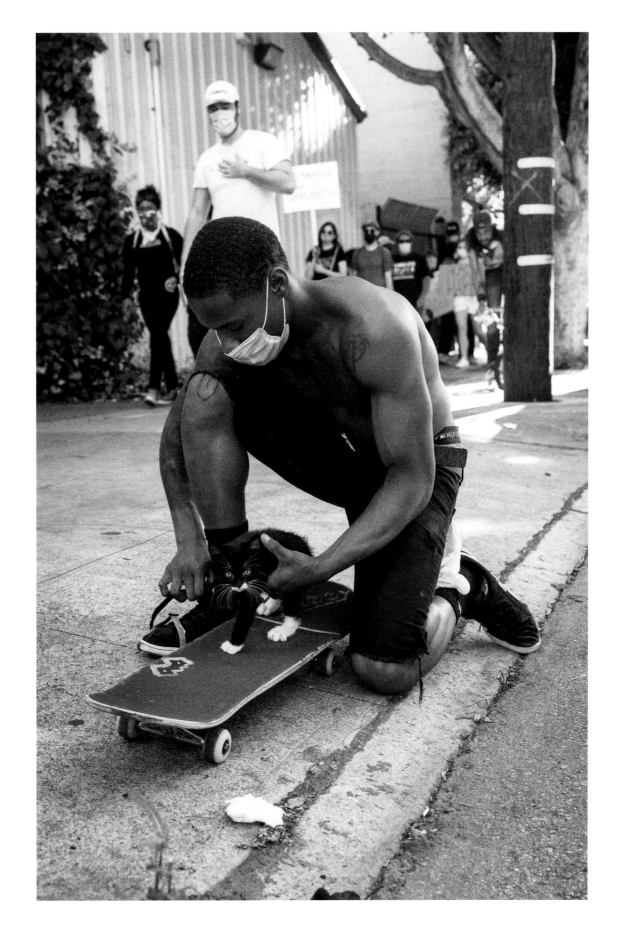

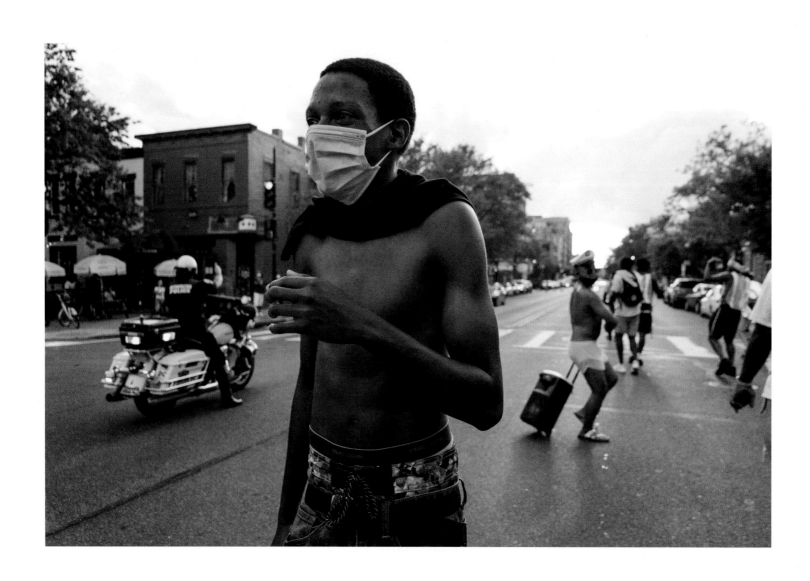

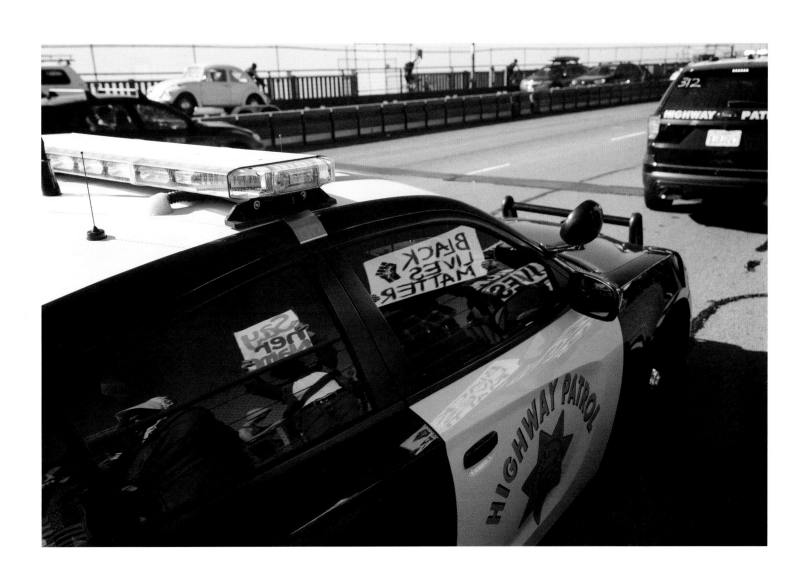

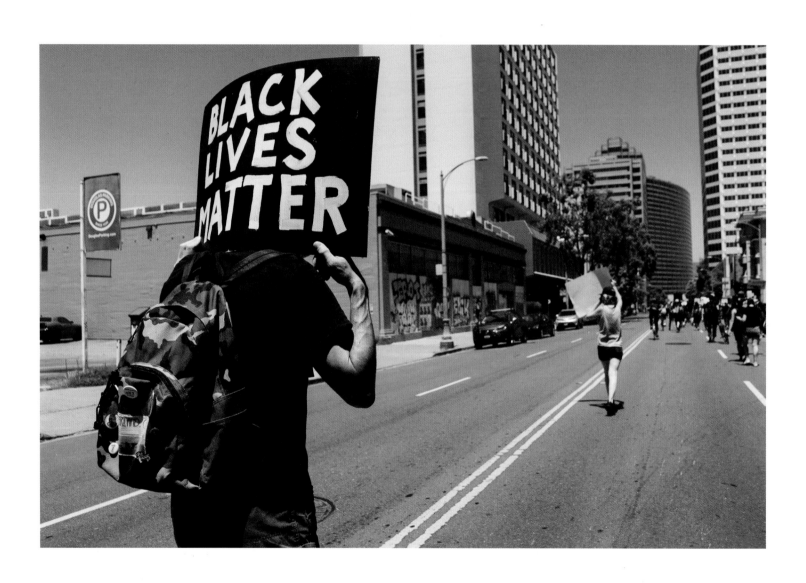

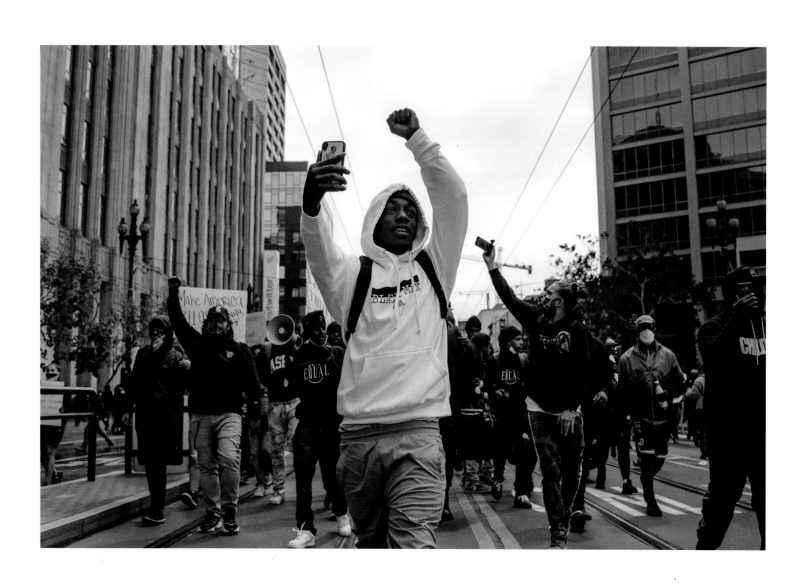

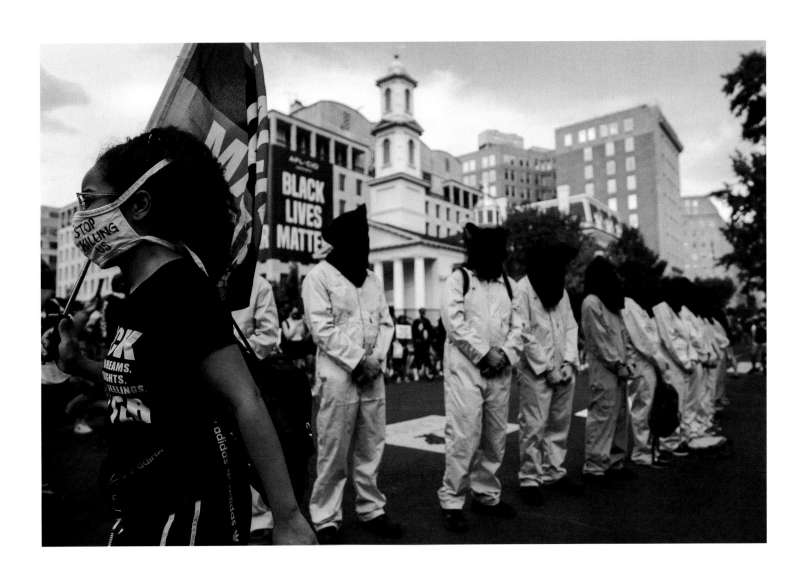

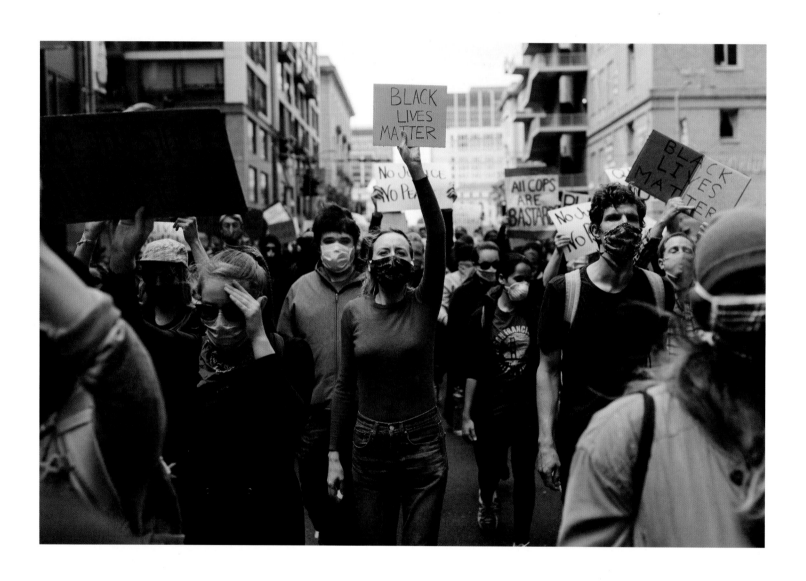

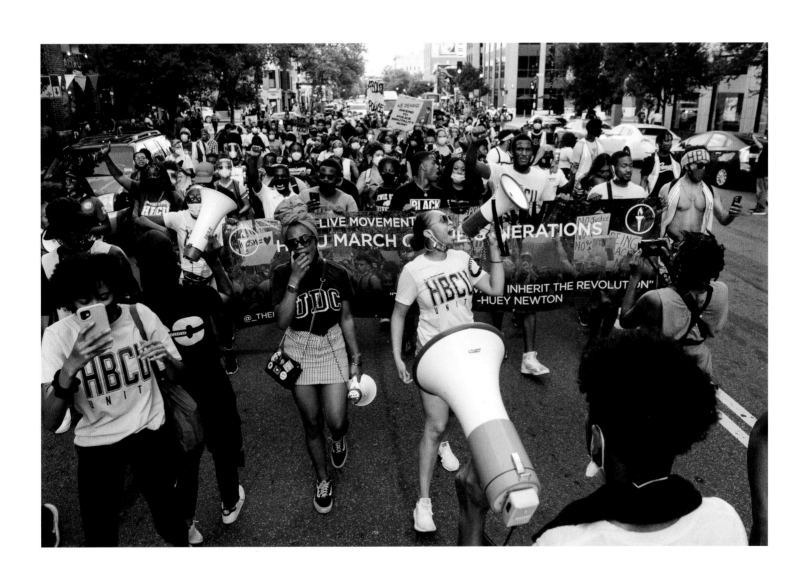

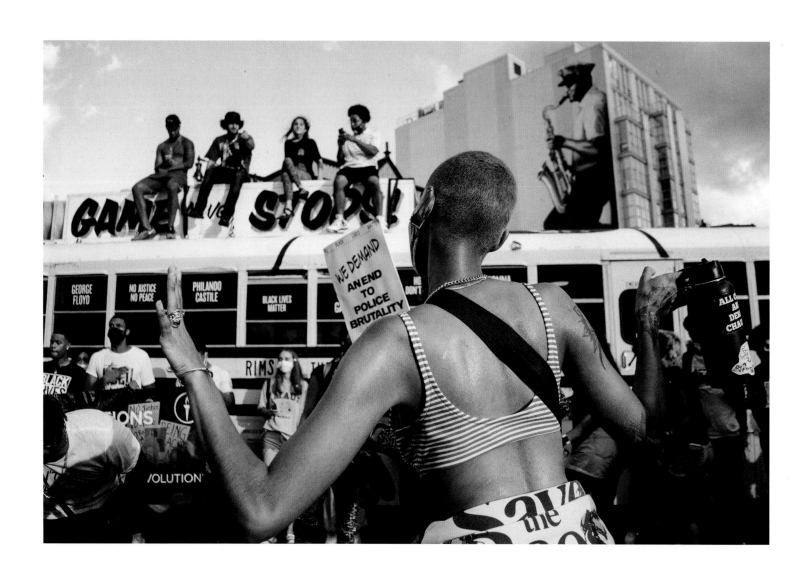

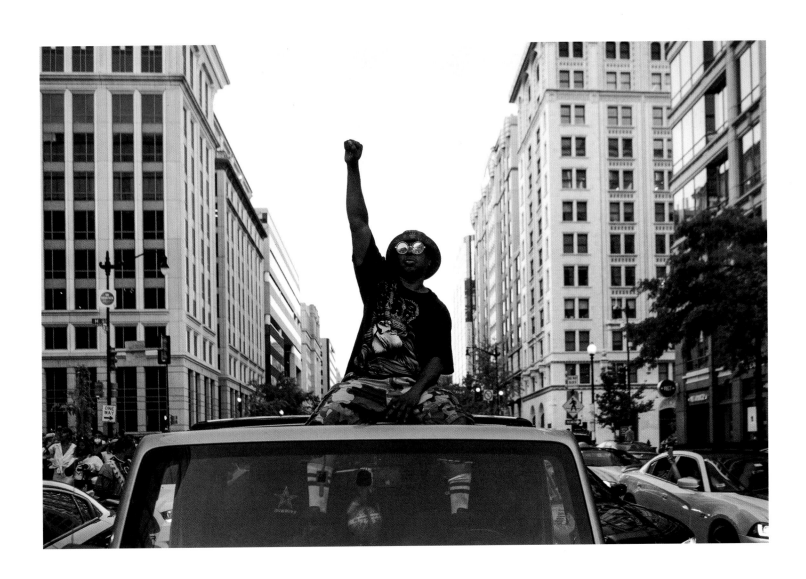

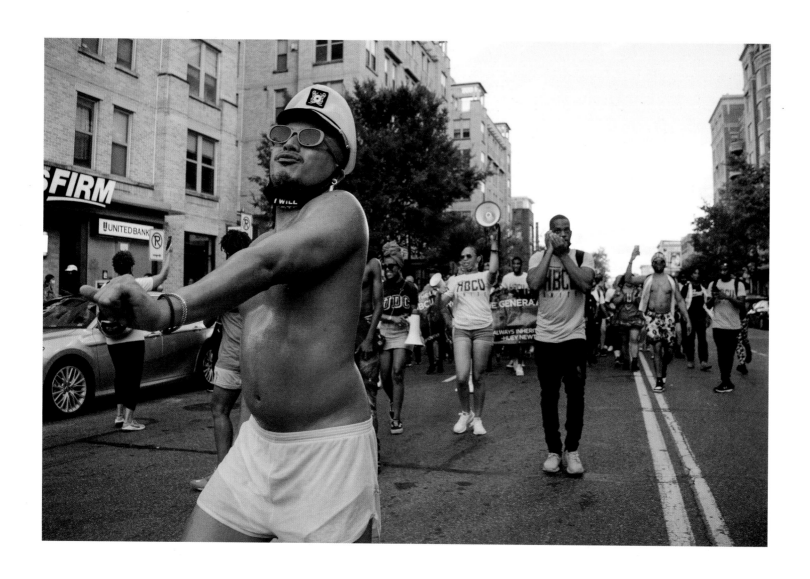

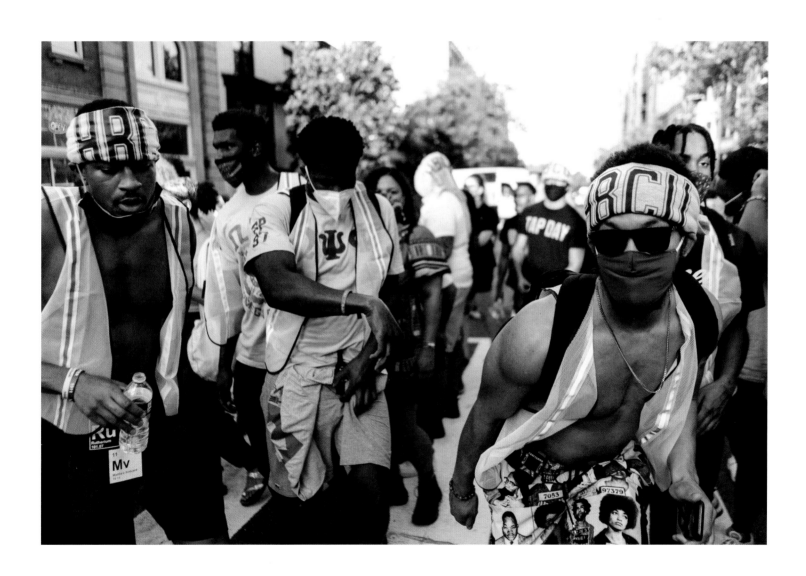

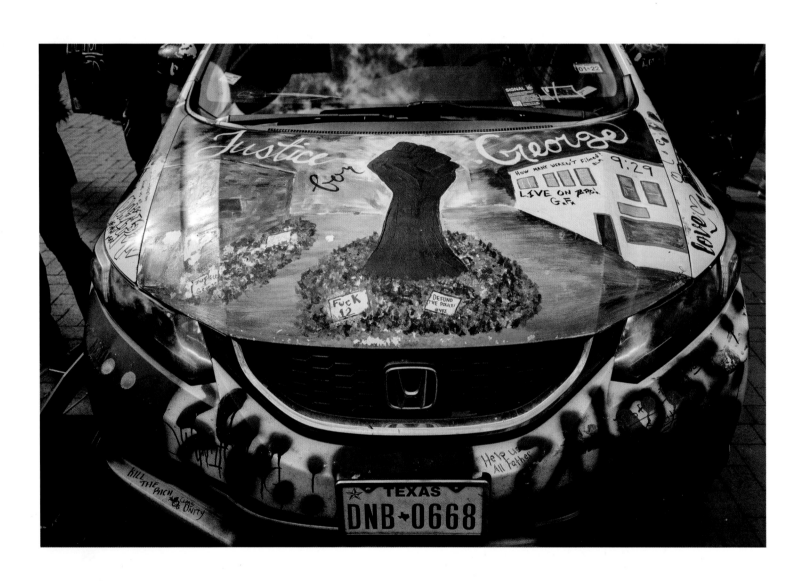

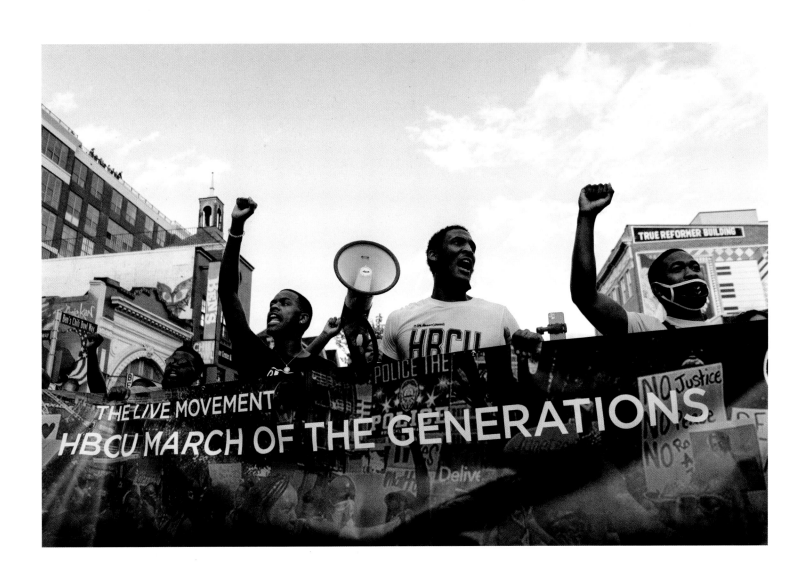

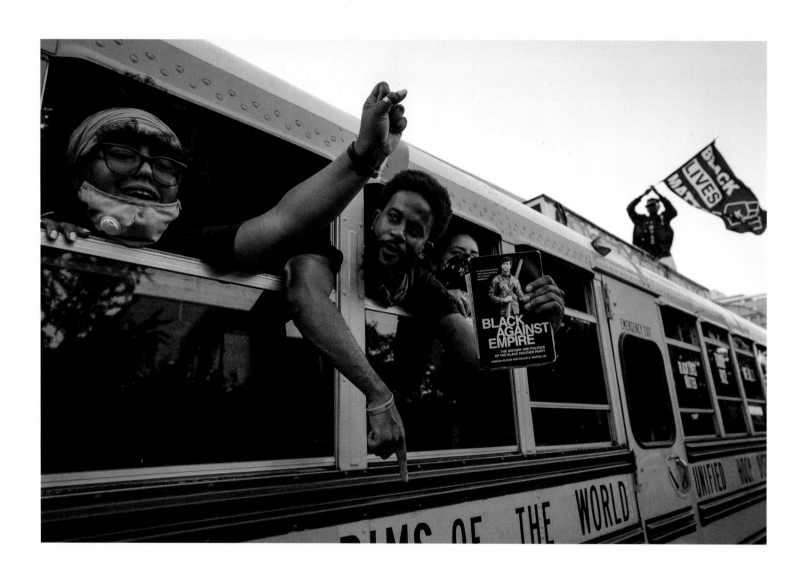

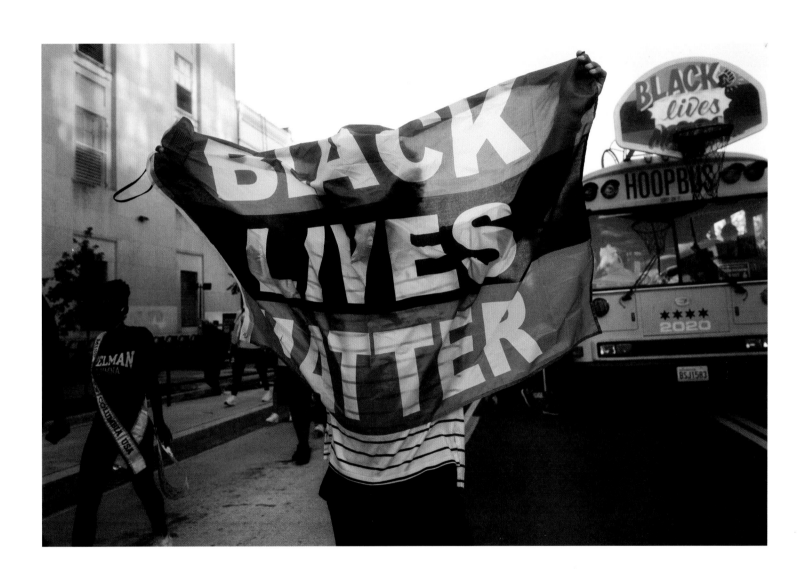

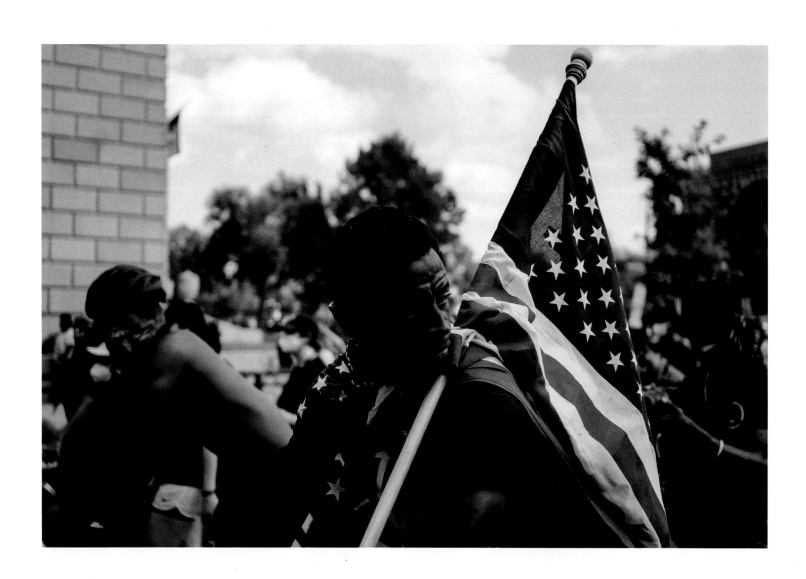

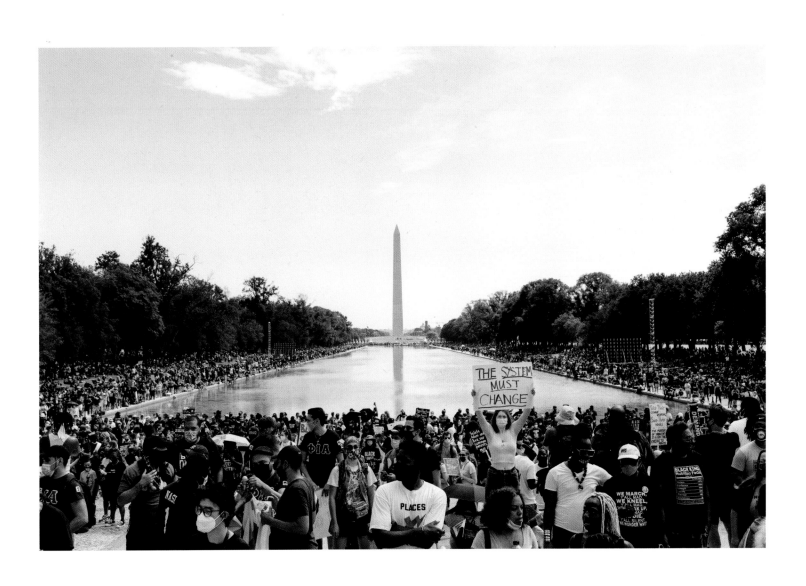

MINNEAPOLIS, MN
OAKLAND, CA
WASHINGTON, D.C.
ORLANDO, FL
ATLANTA, GA

GRAVITY

WHEN WE CLOSE OUR EYES

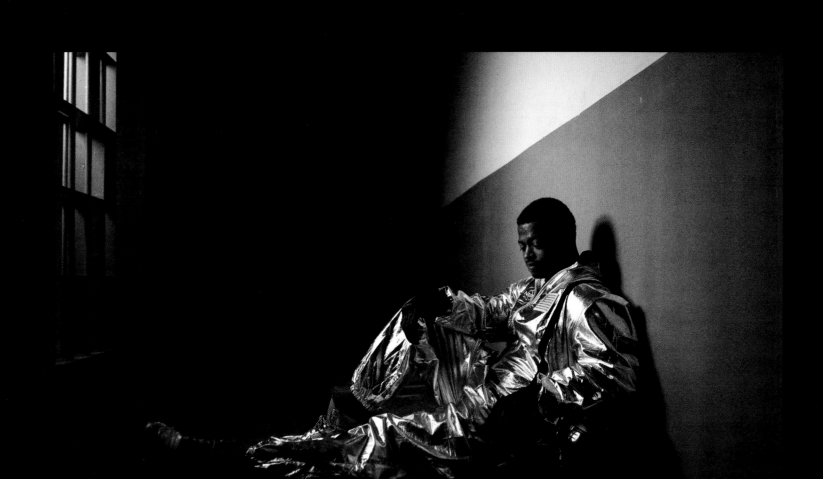

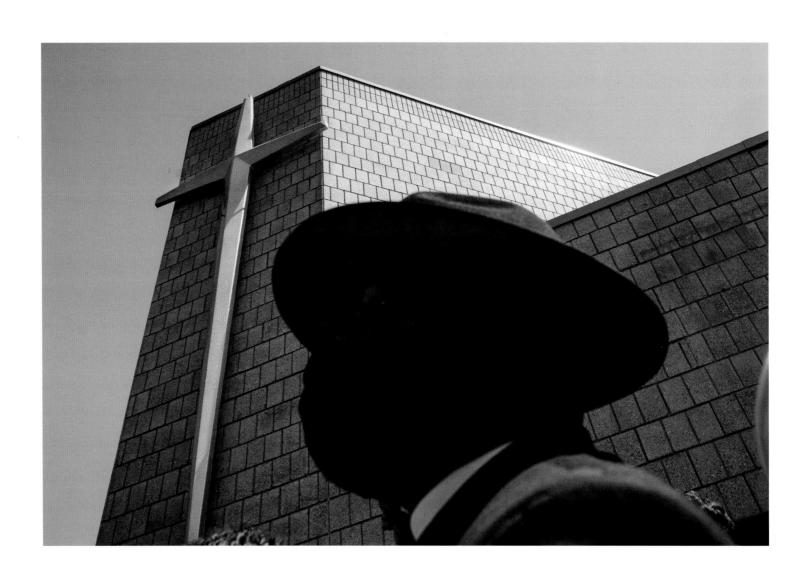

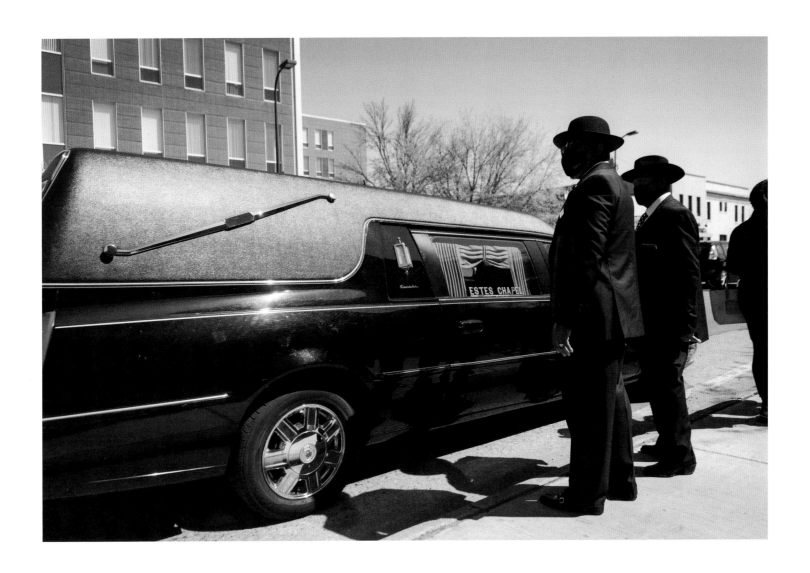

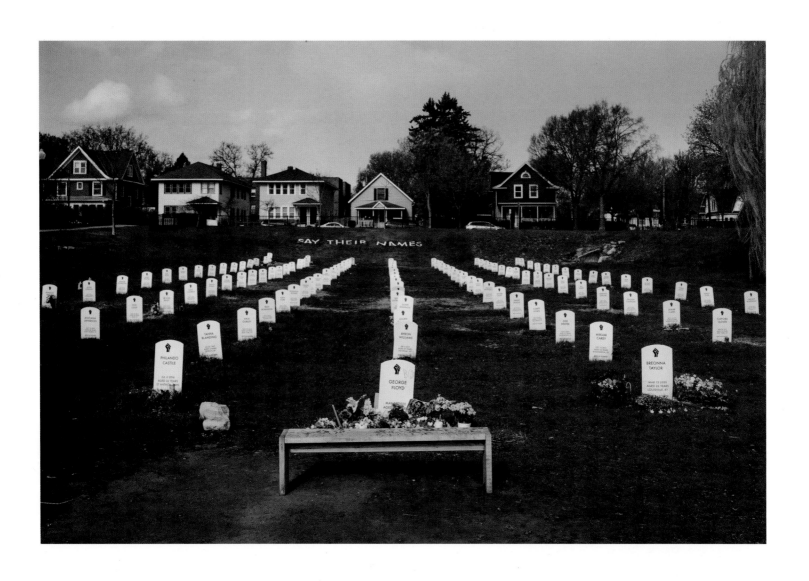

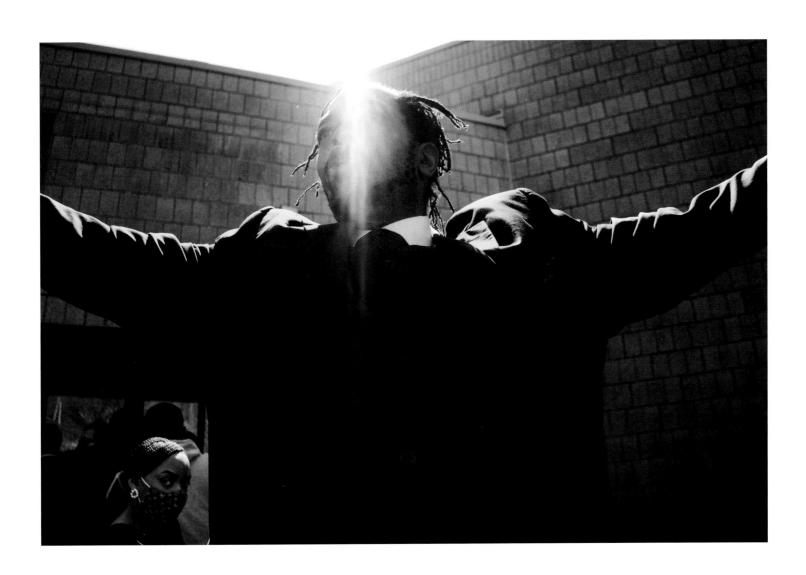

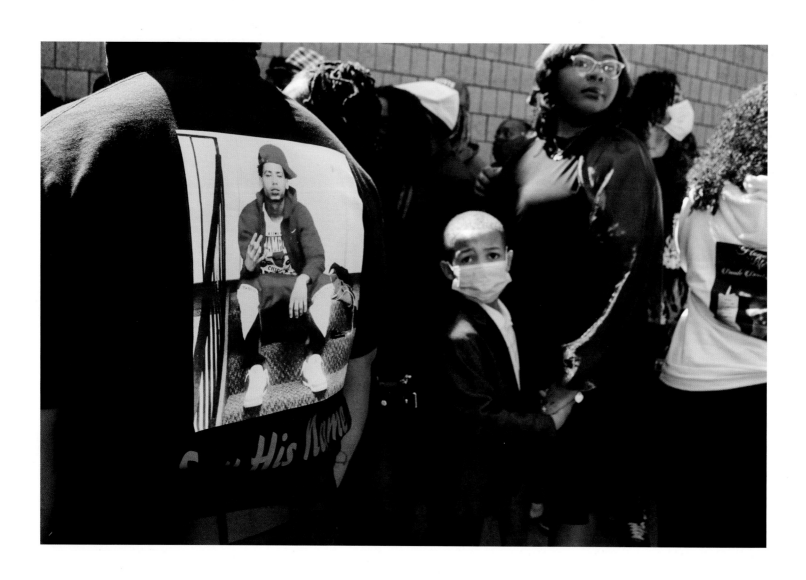

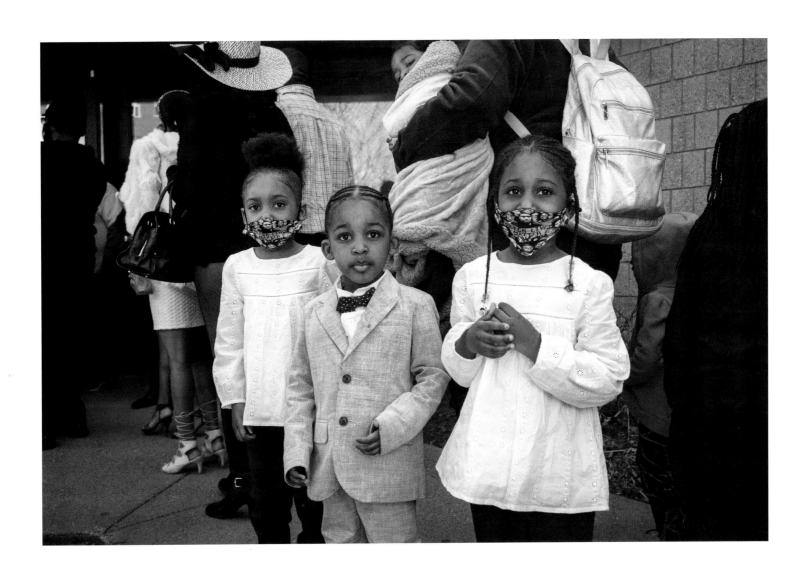

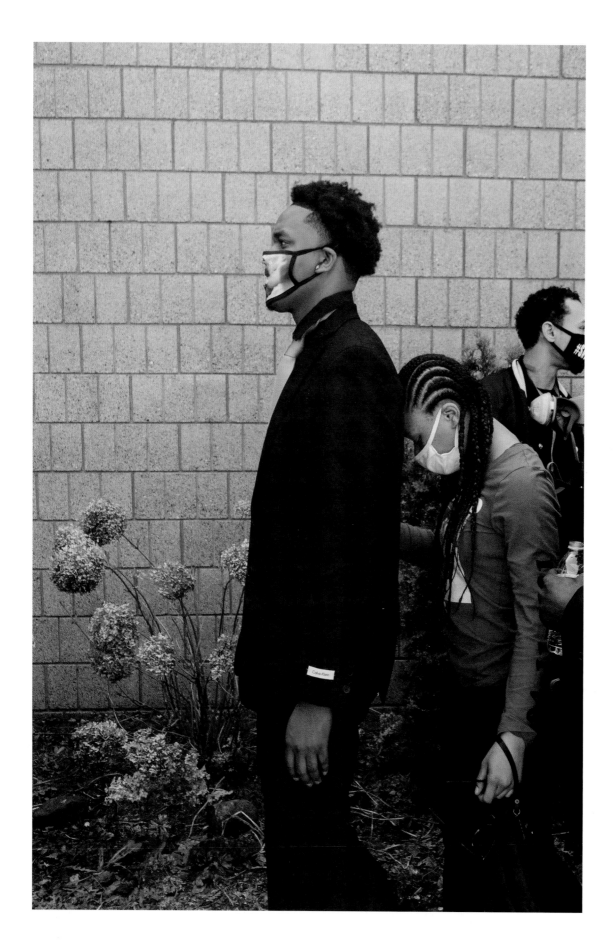

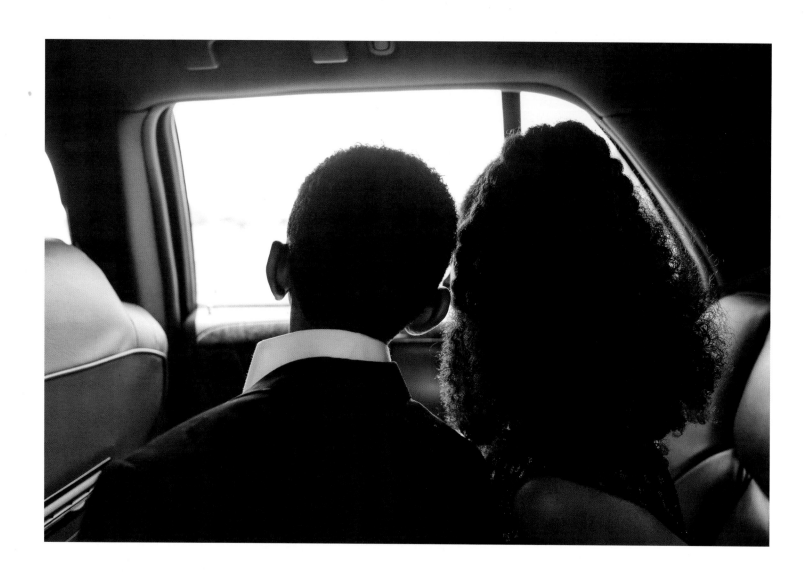

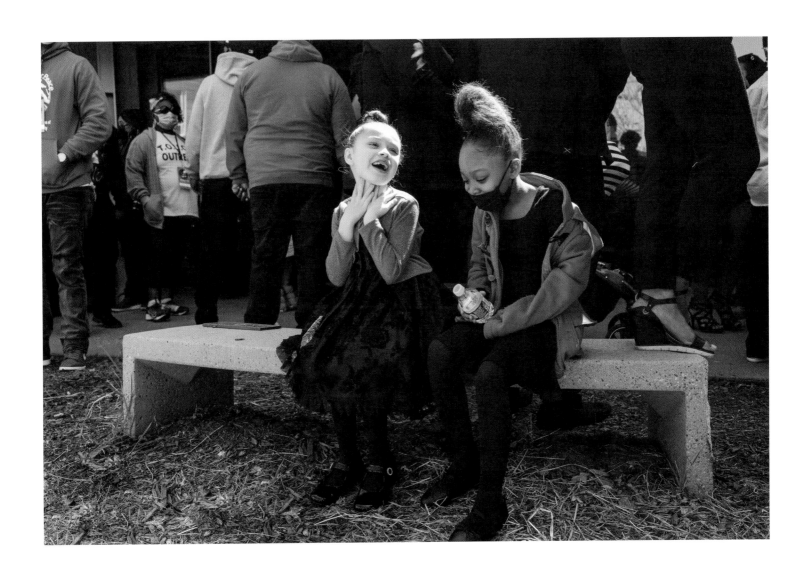

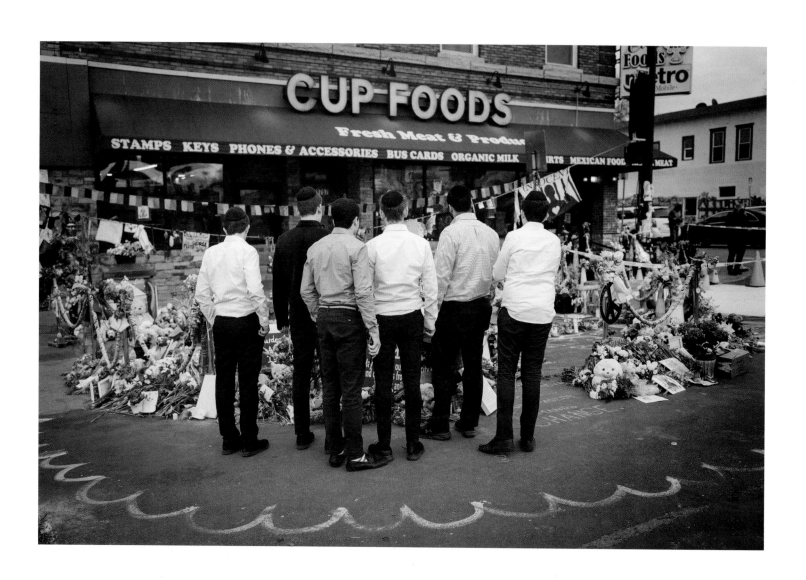

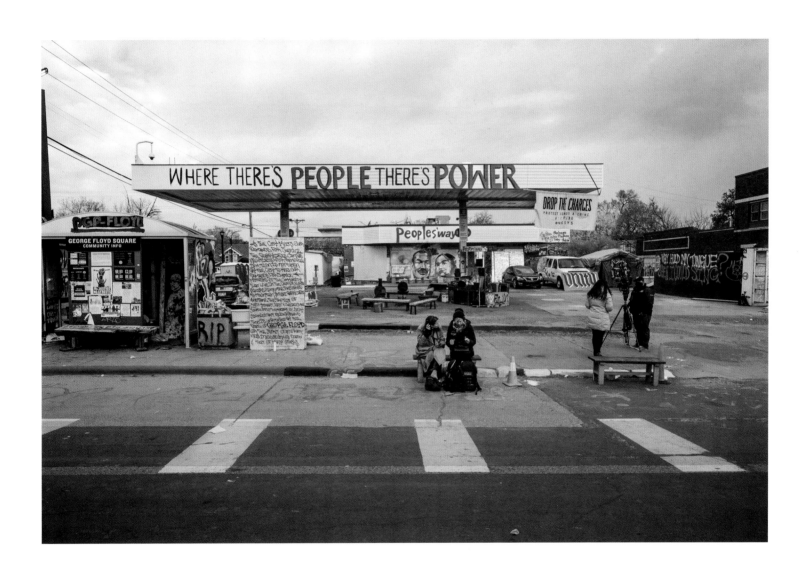

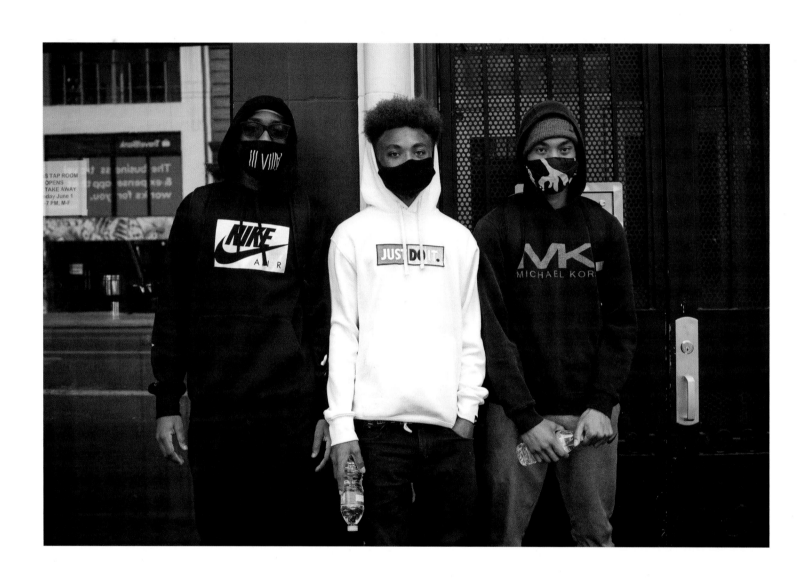

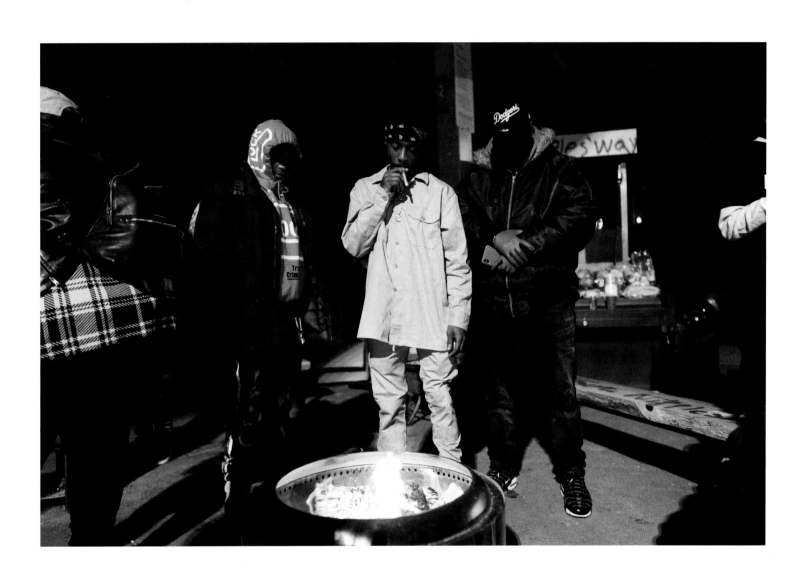

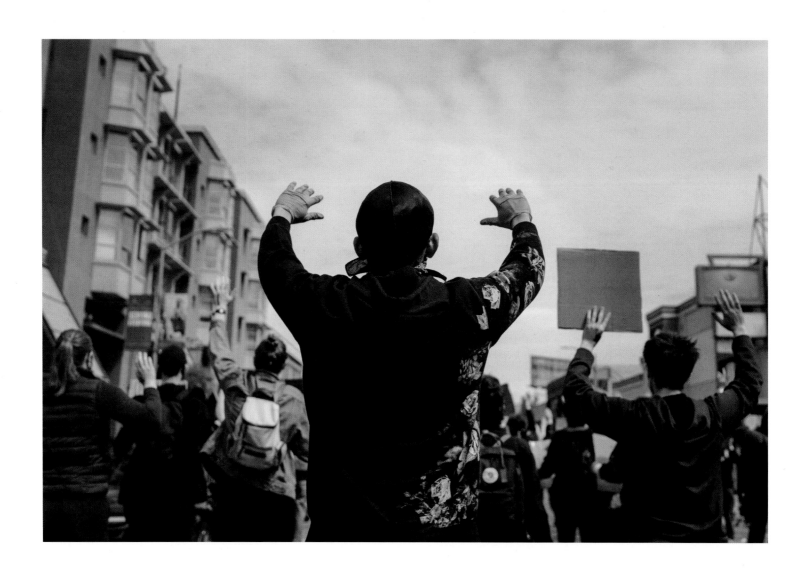

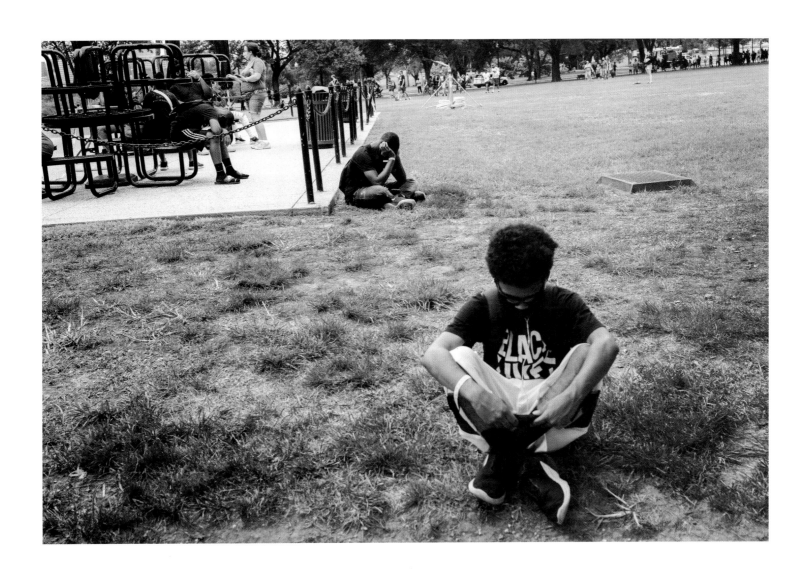

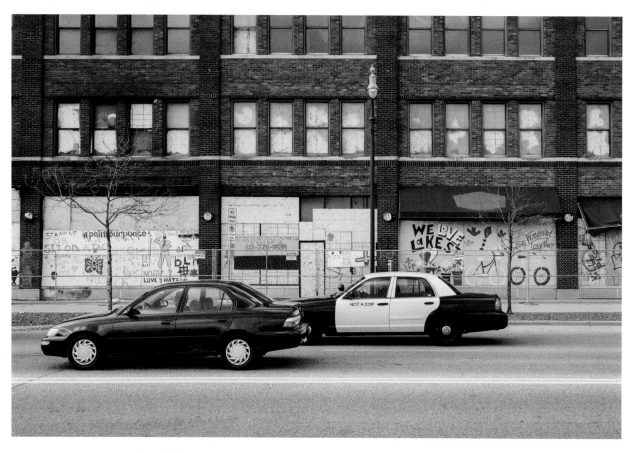

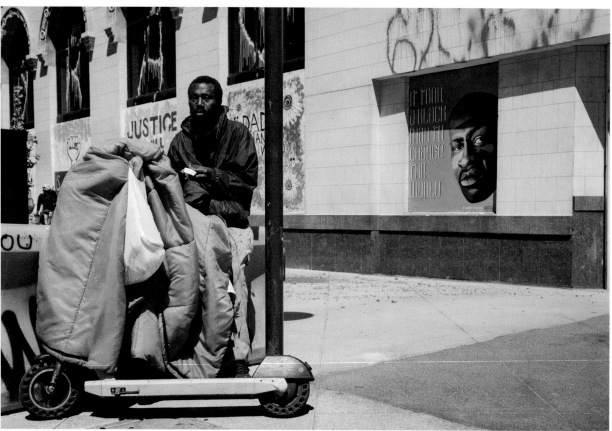

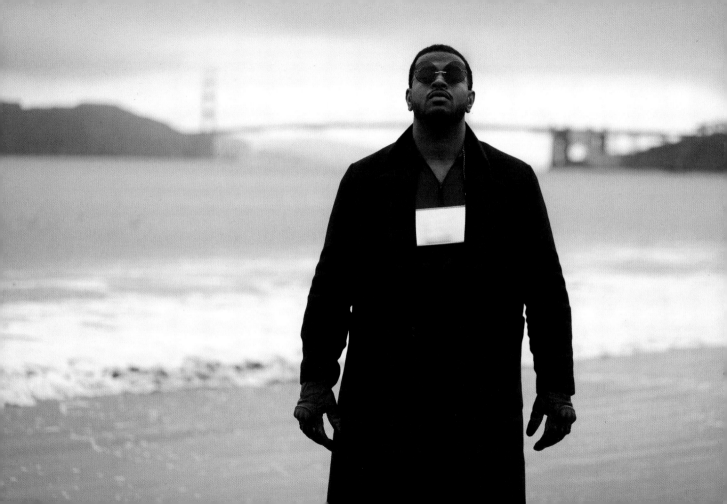

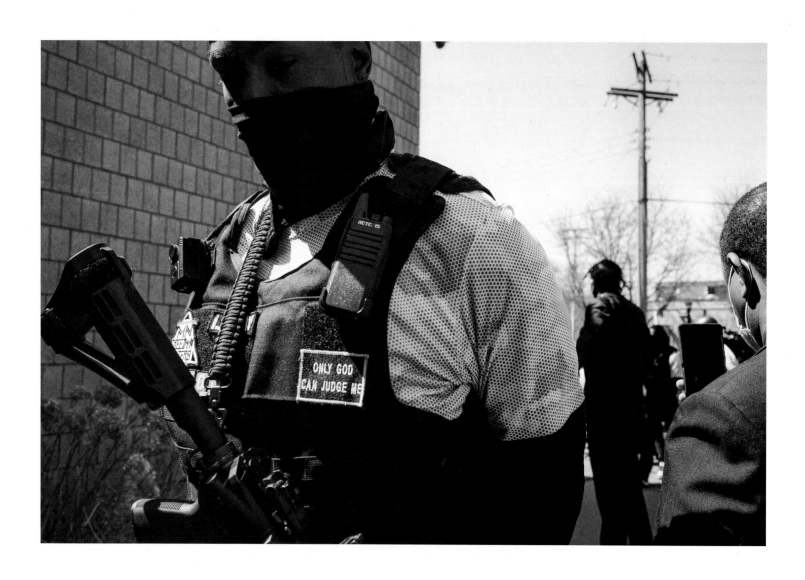

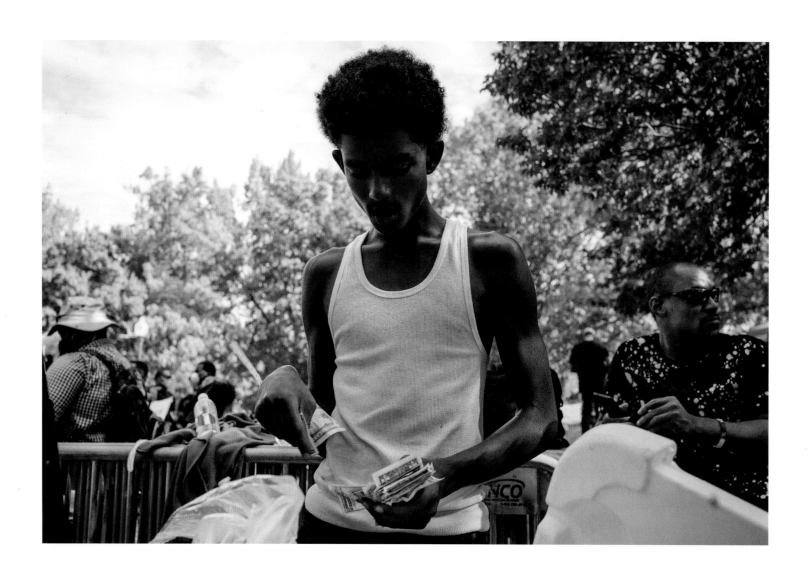

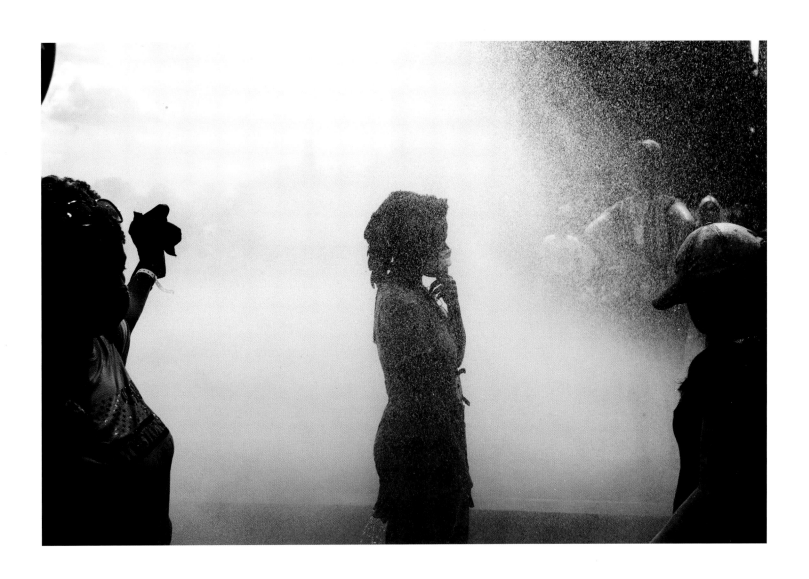

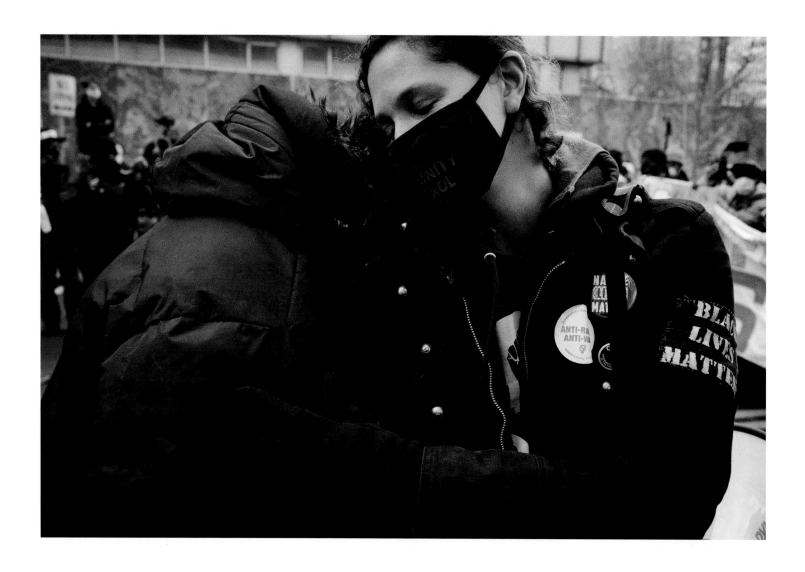

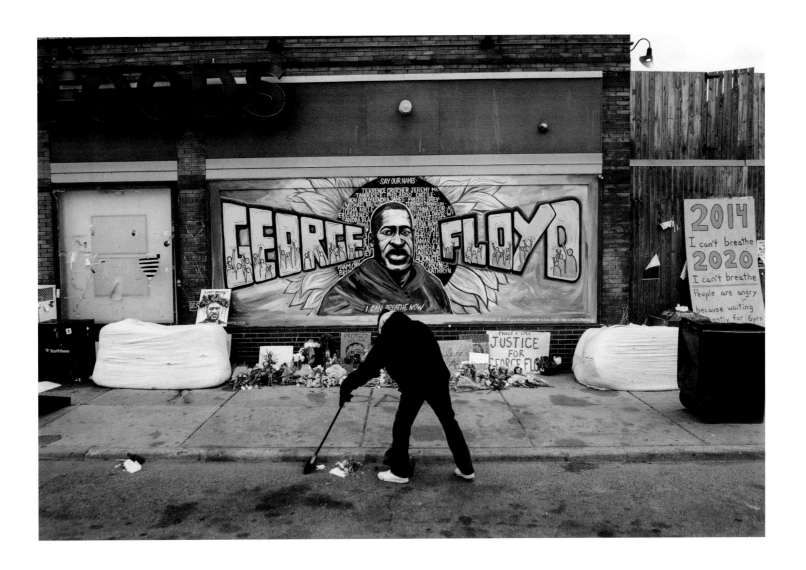

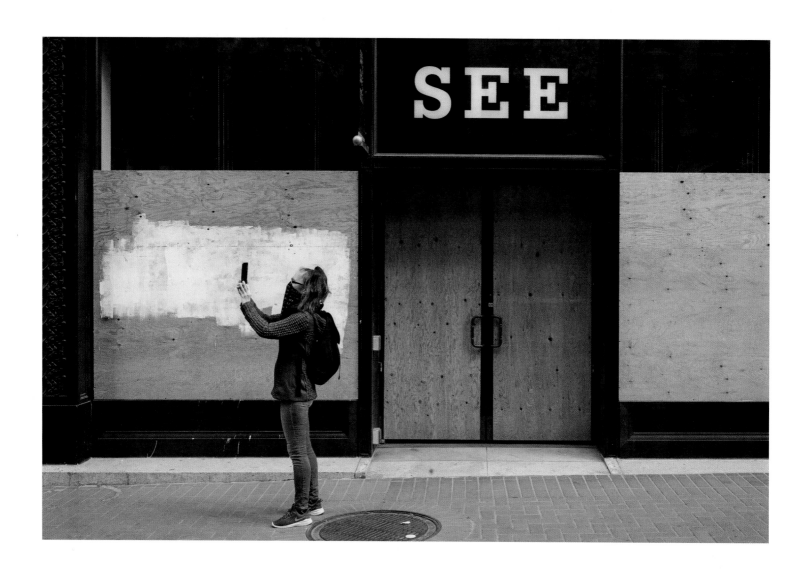

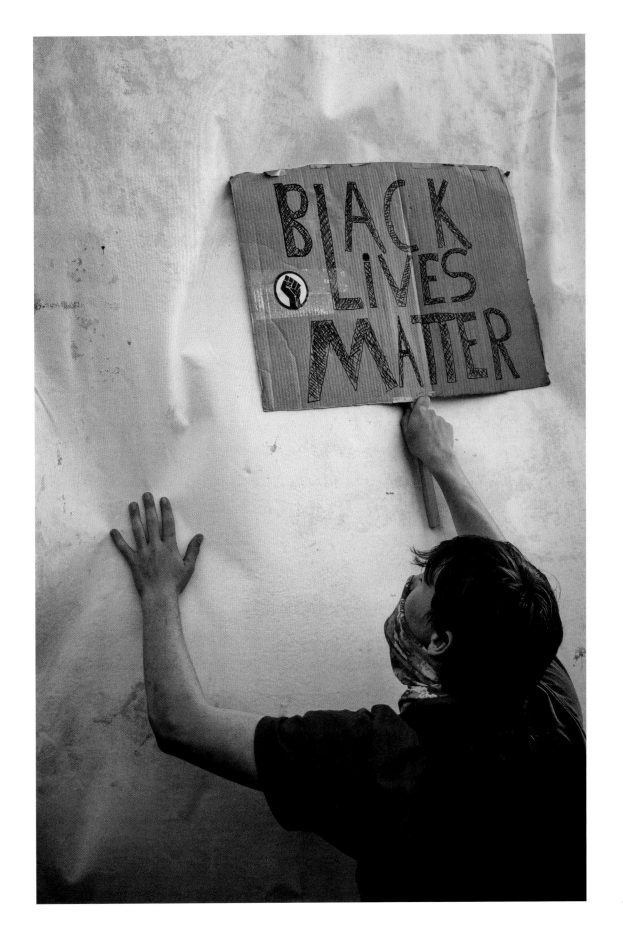

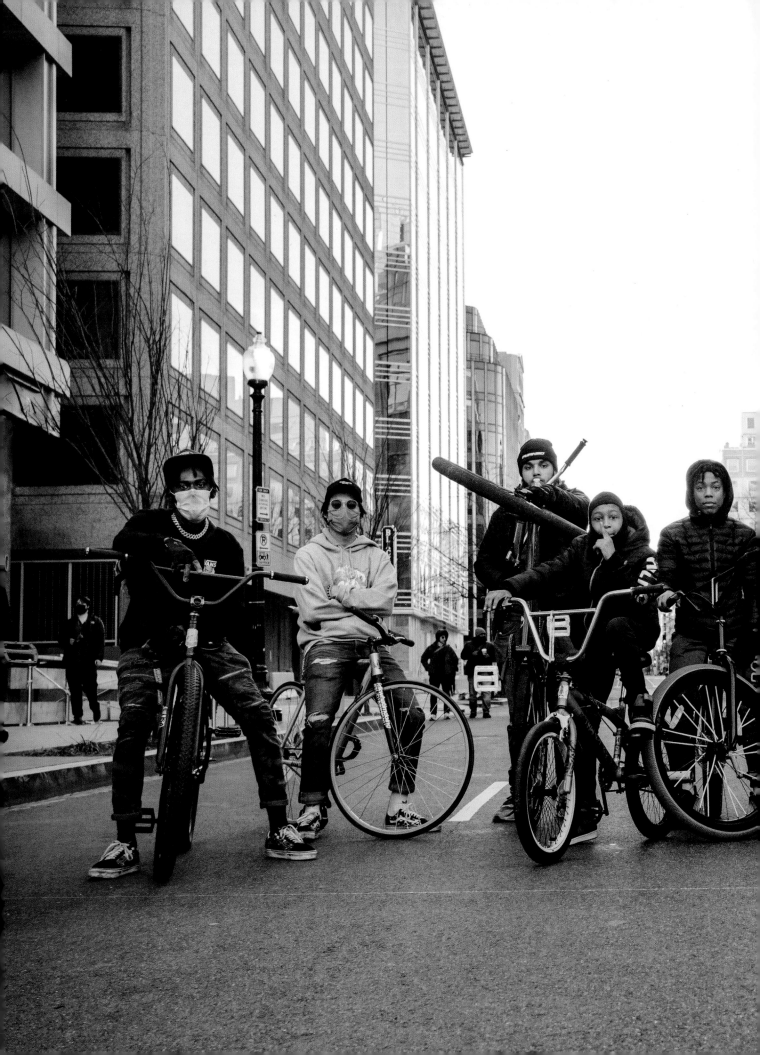

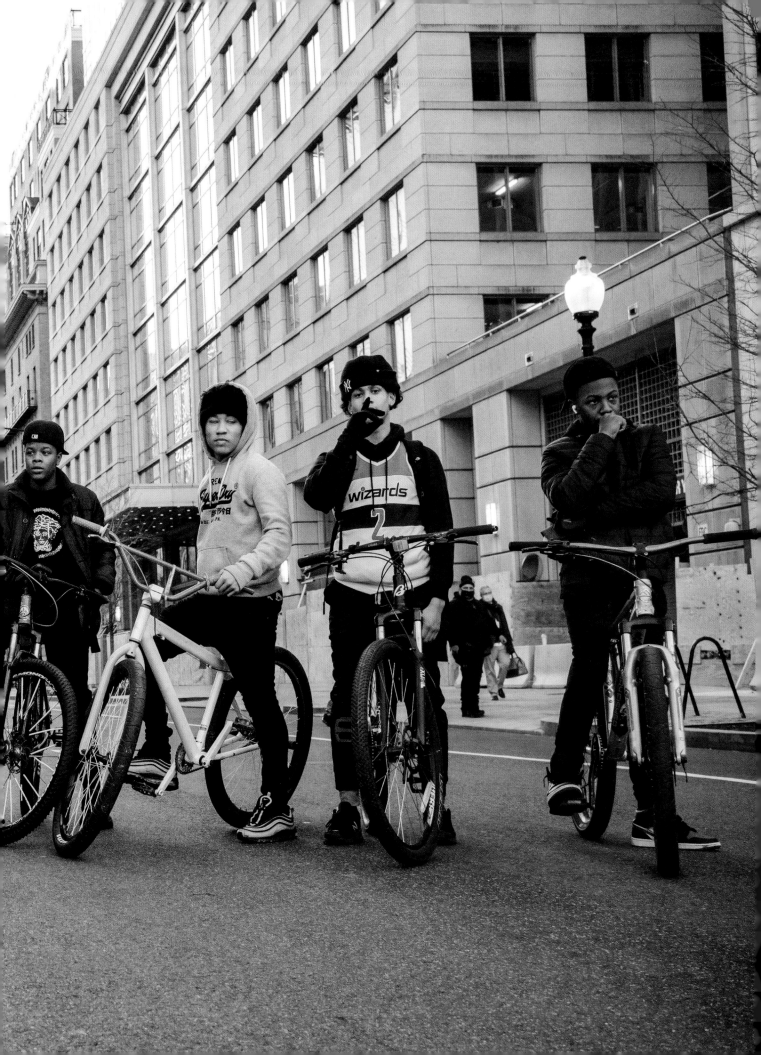

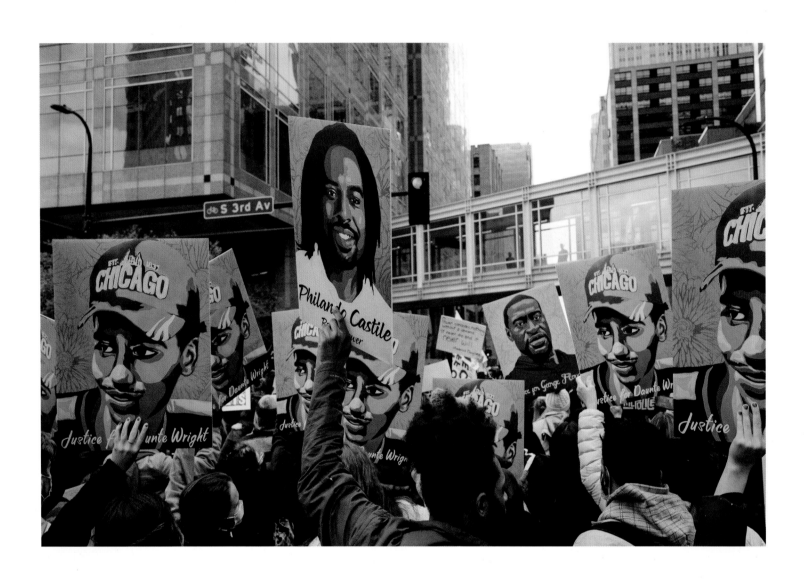

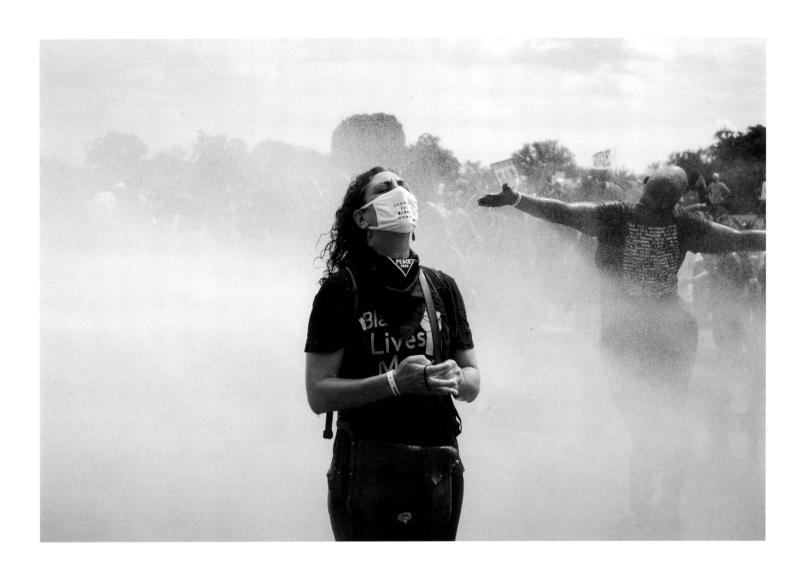

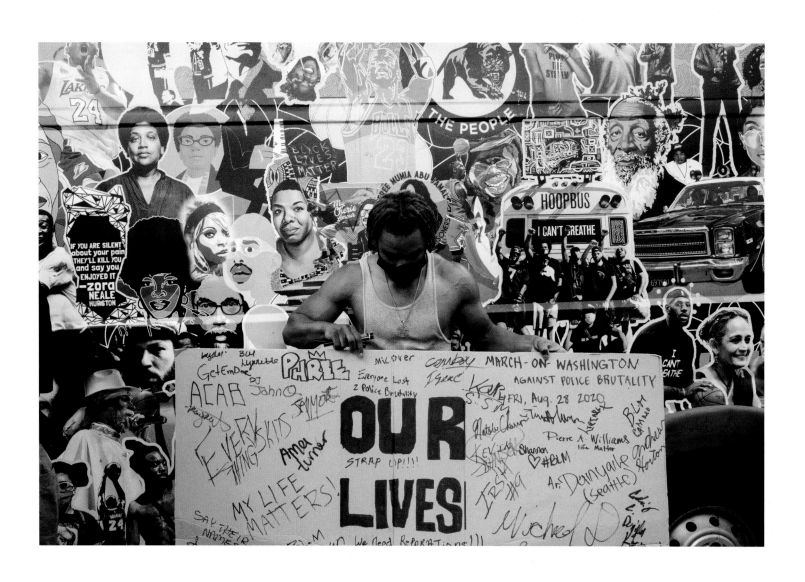

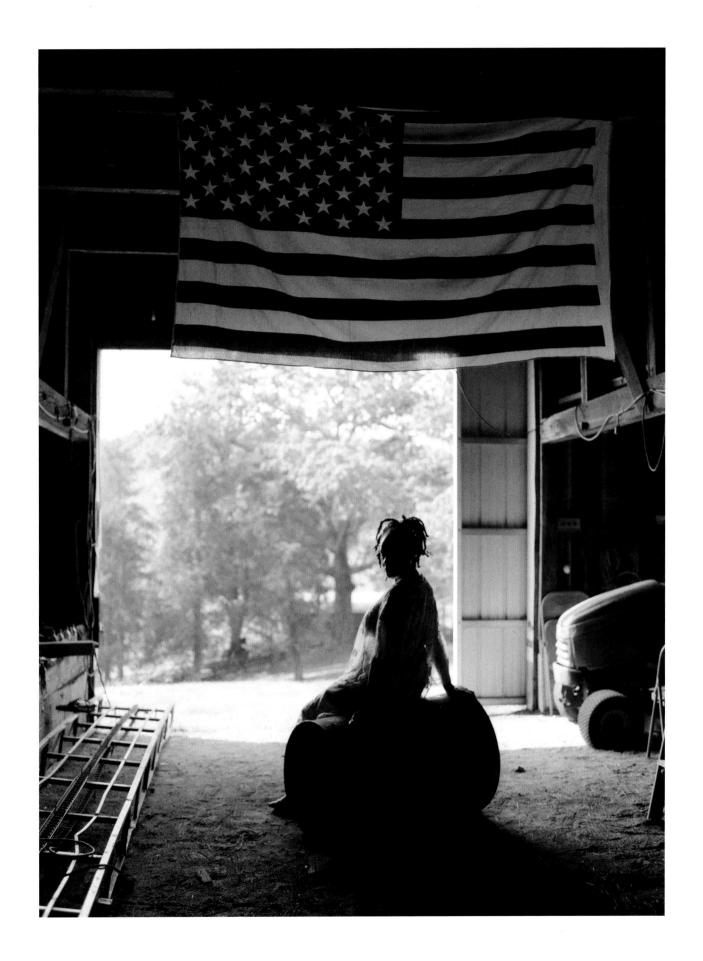

NEWARK, NJ
BROOKLYN, NY
OAKLAND, CA
DALLAS, TX
LAS VEGAS, NV
MIAMI, FL

DEEP SPACE

THE GREAT BEYOND

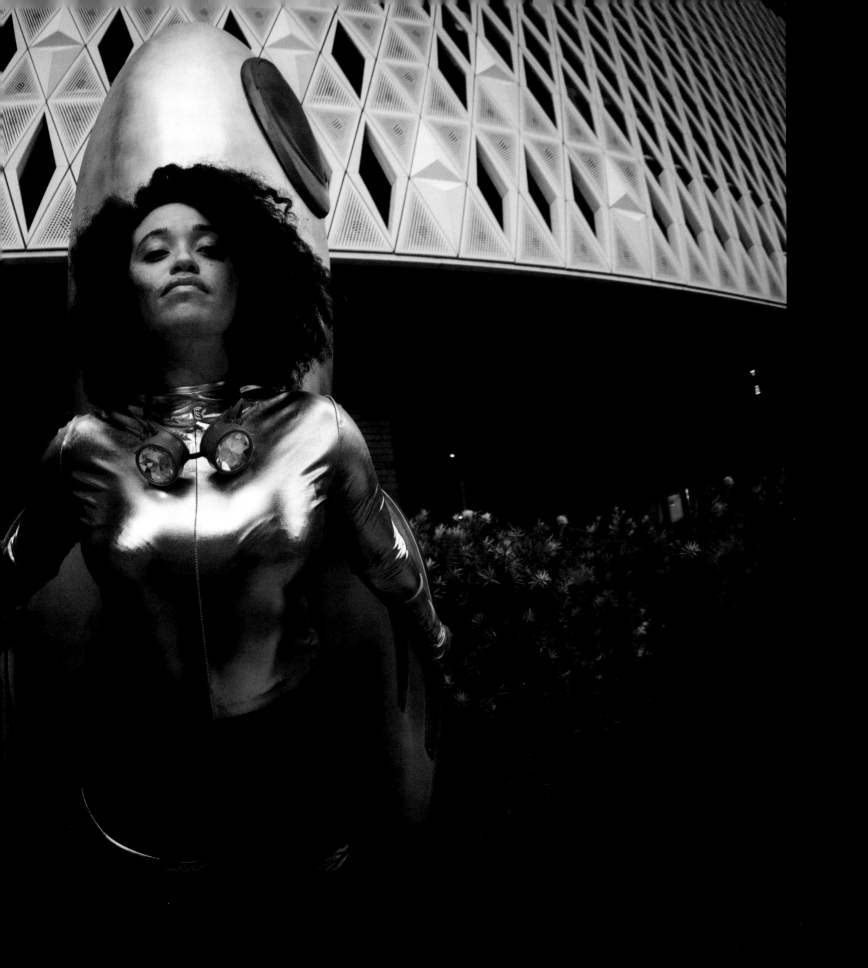

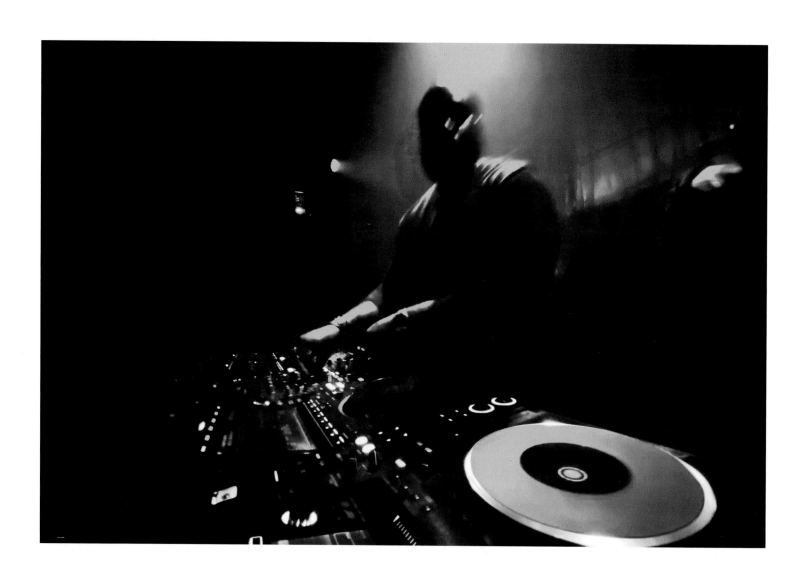

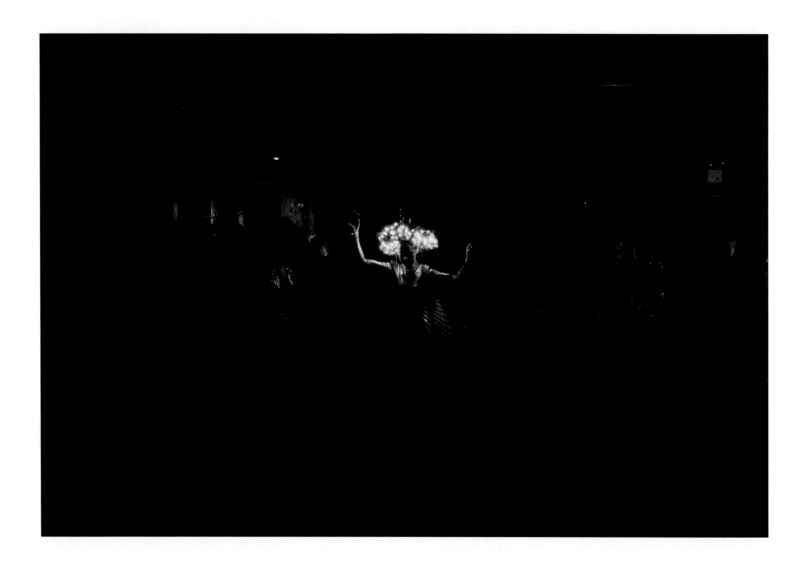

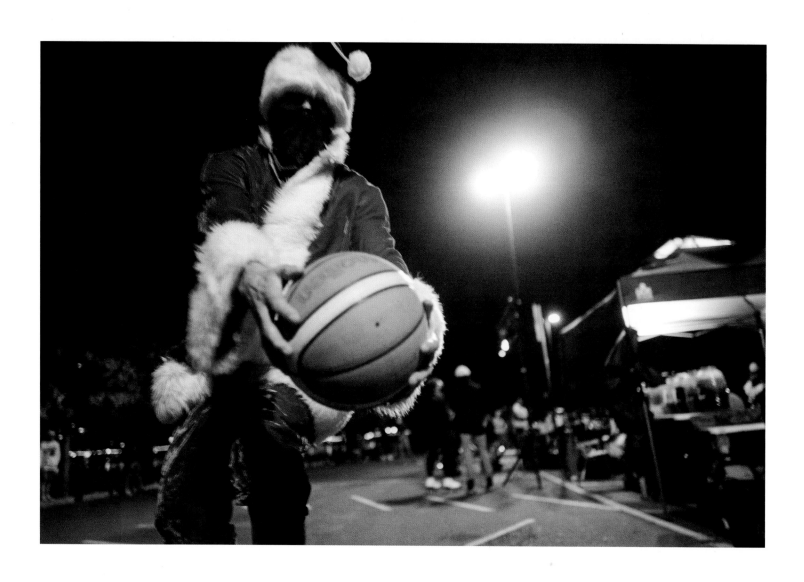

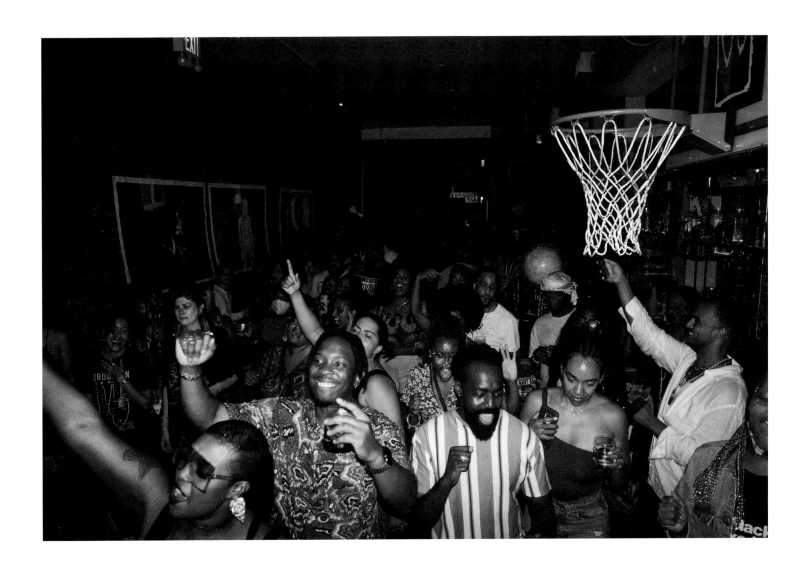

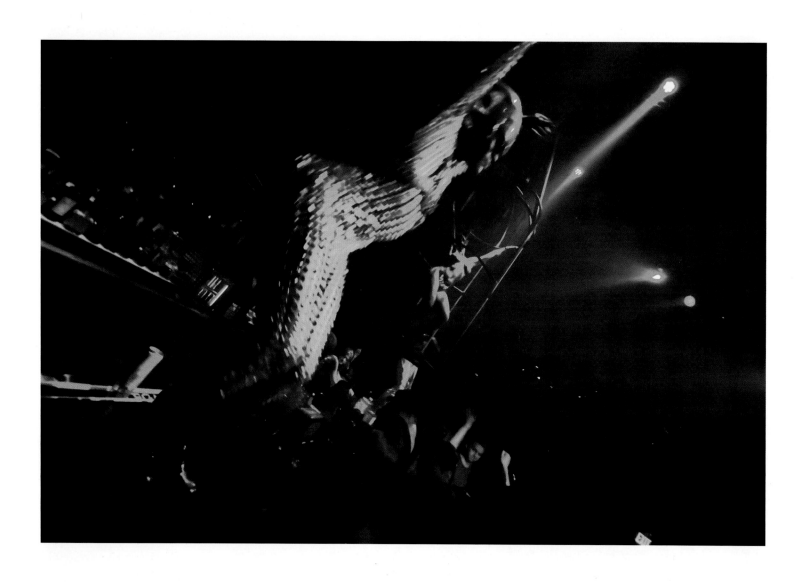

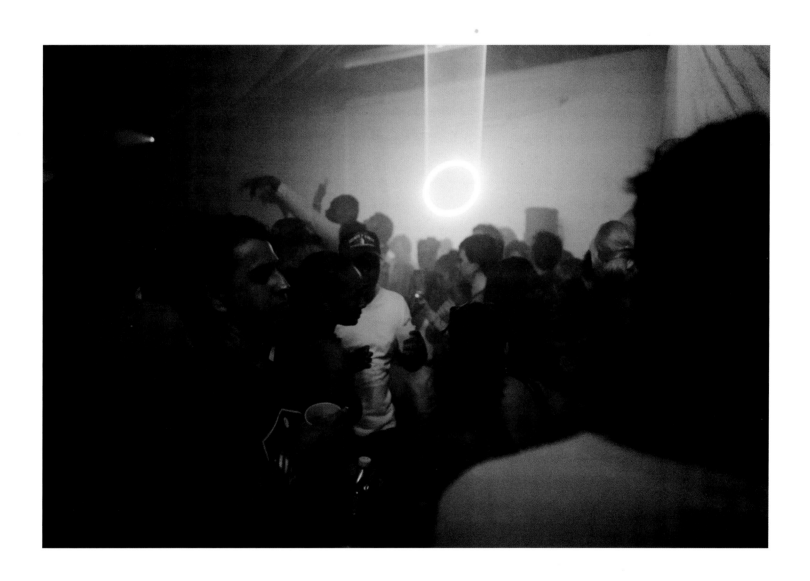

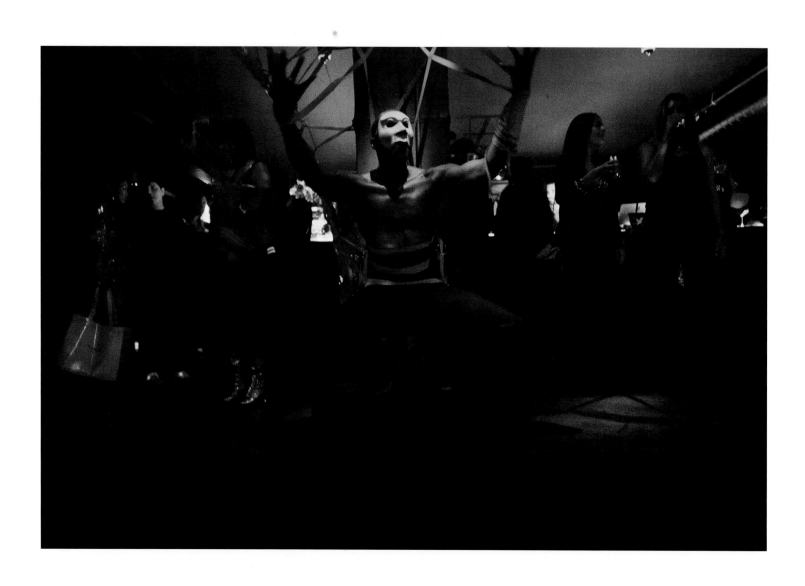

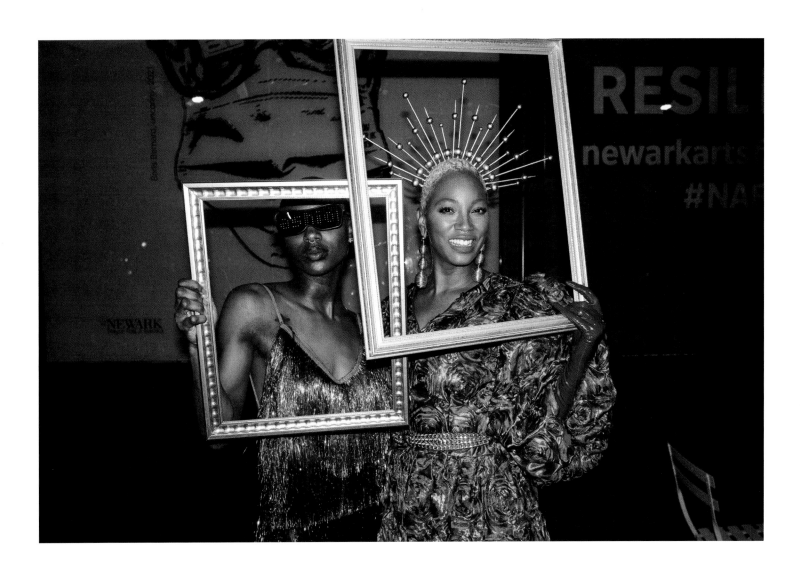

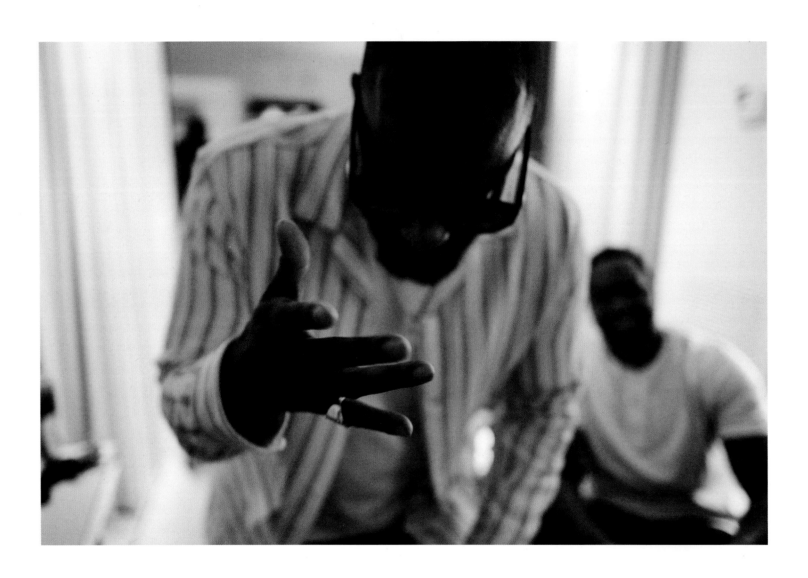

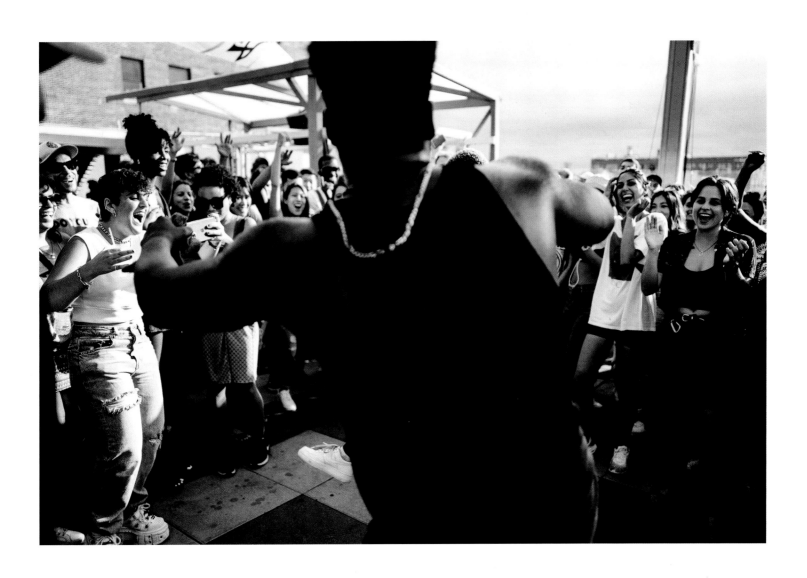

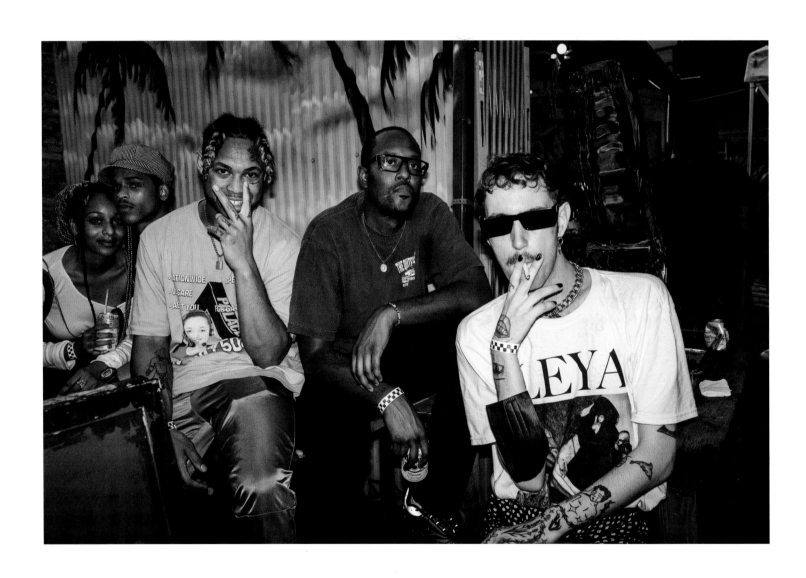

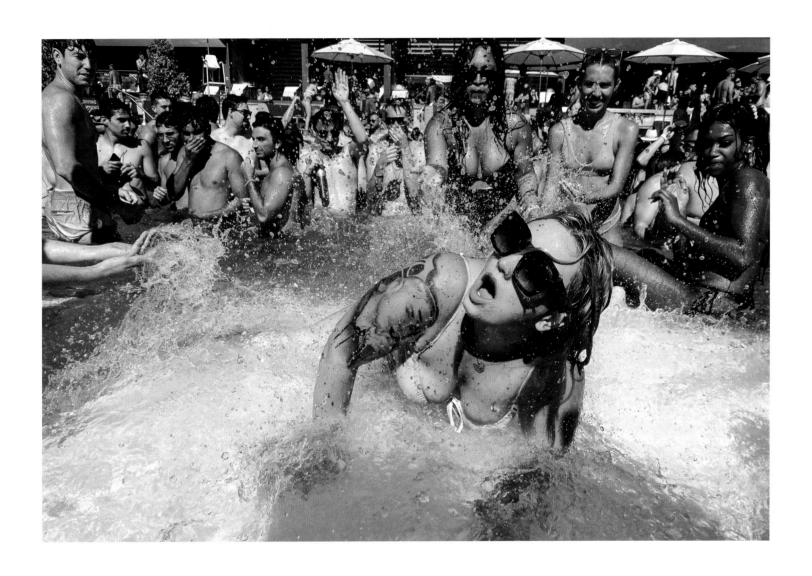

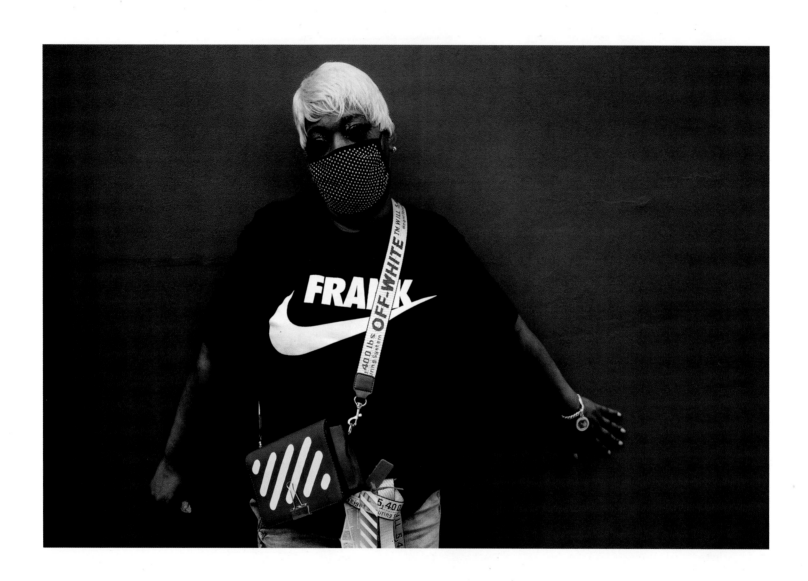

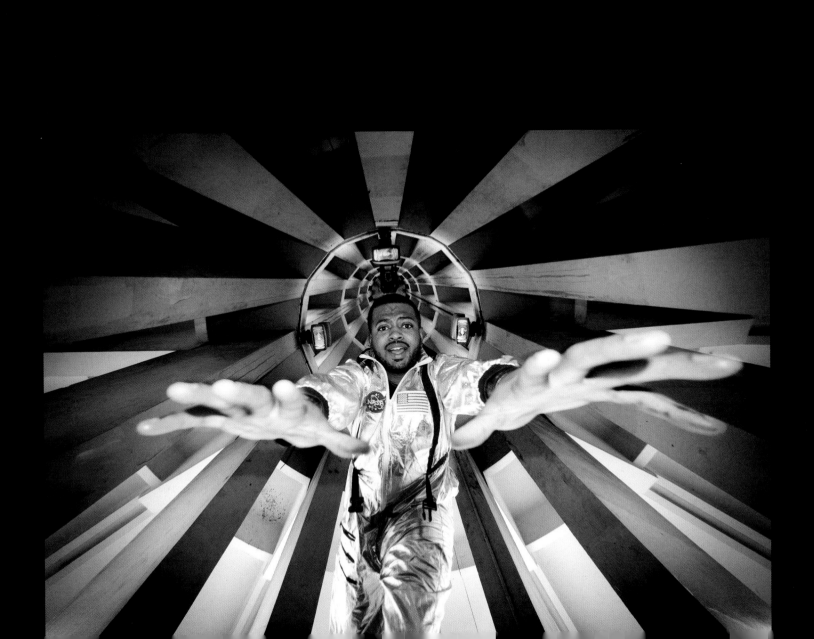

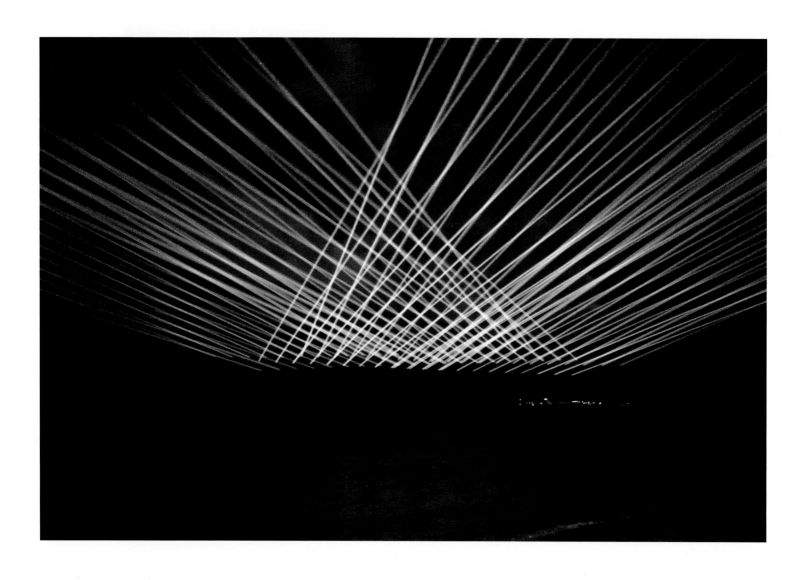

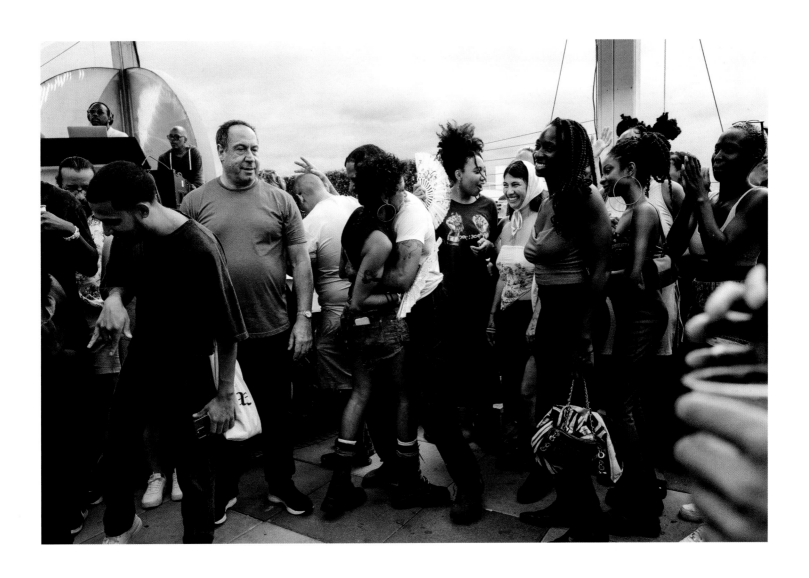

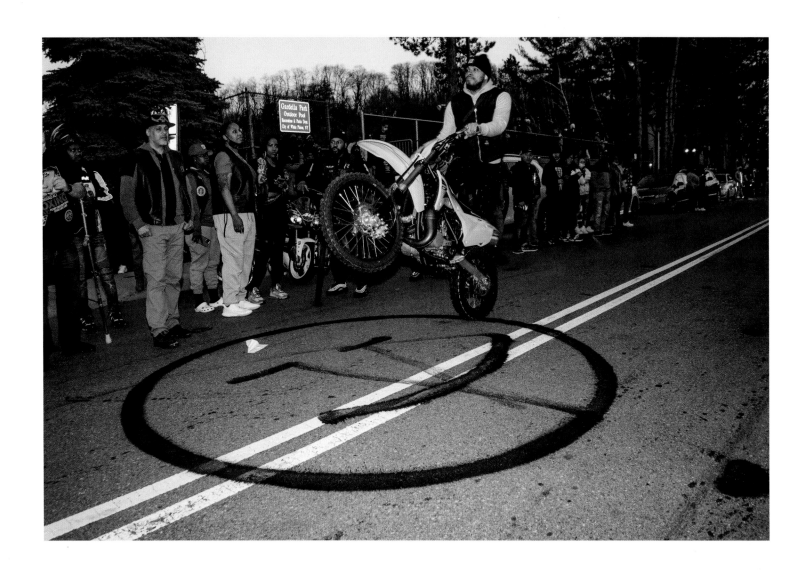

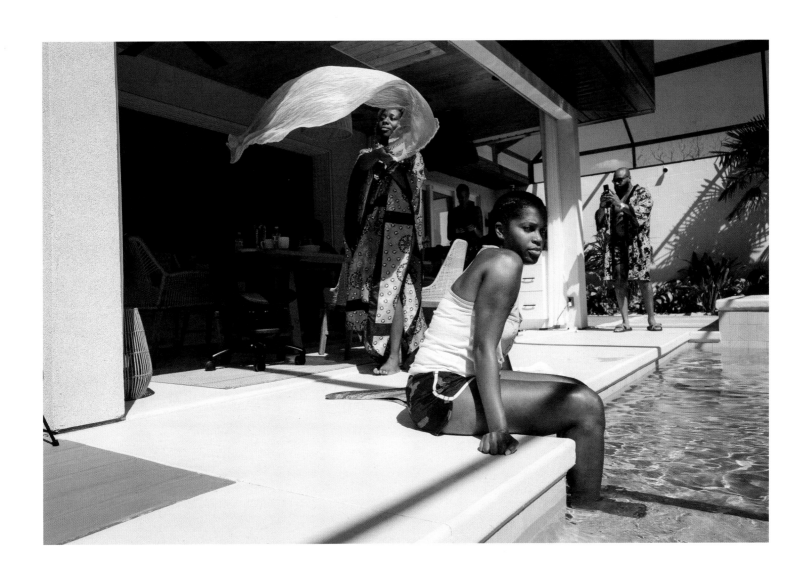

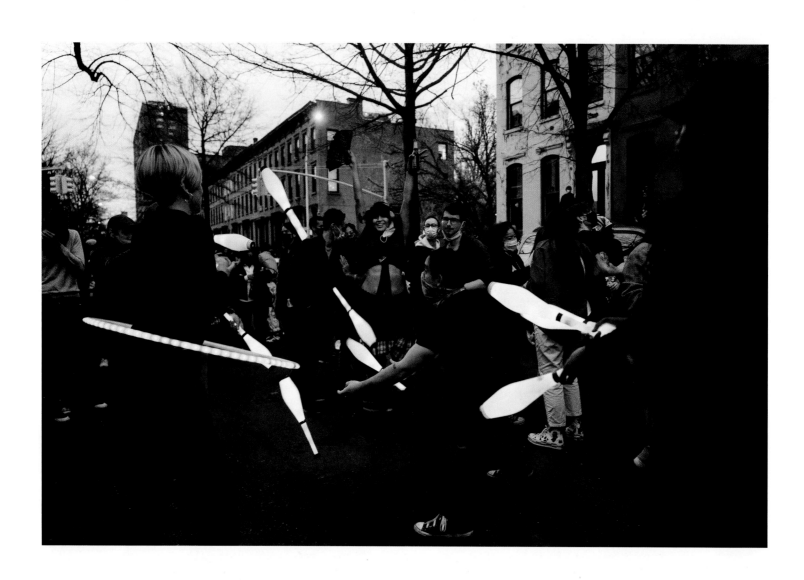

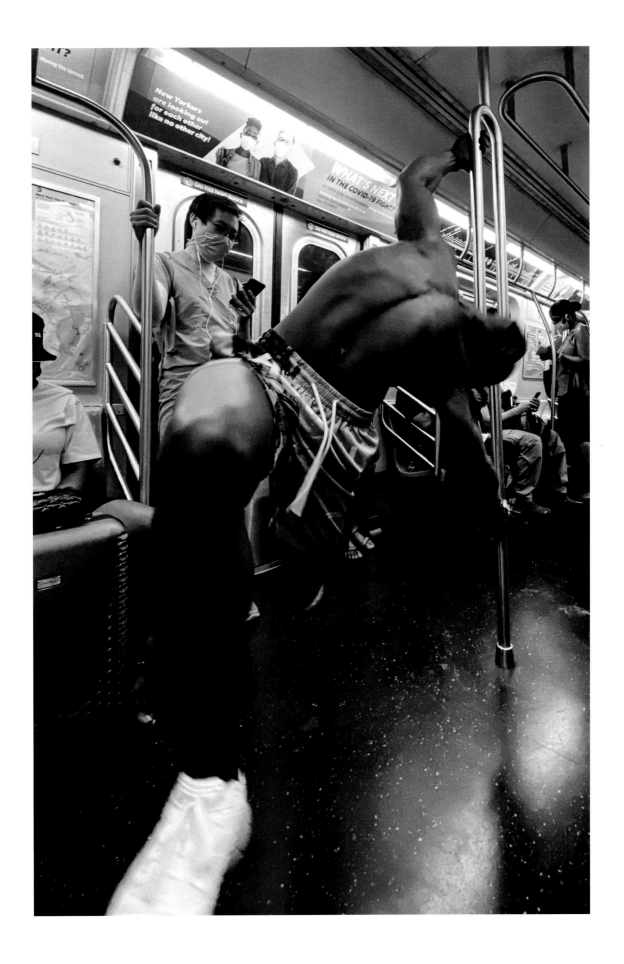

MINNEAPOLIS, MN
OAKLAND, CA
WASHINGTON, D.C.
VENICE BEACH, CA
HARLEM, NY

ANTIMATTER

INTERNET EXPLORER

DON'T
BE A
SLAVE
TO THE
ALGORITHM.

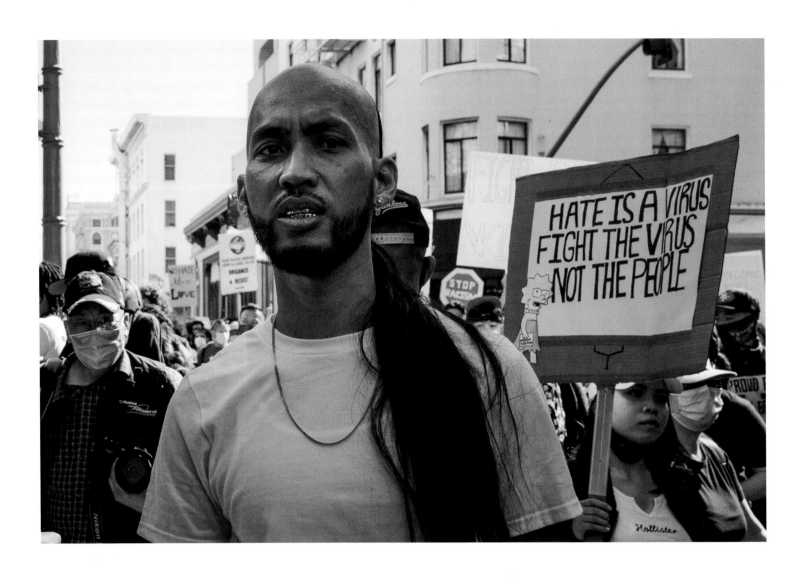

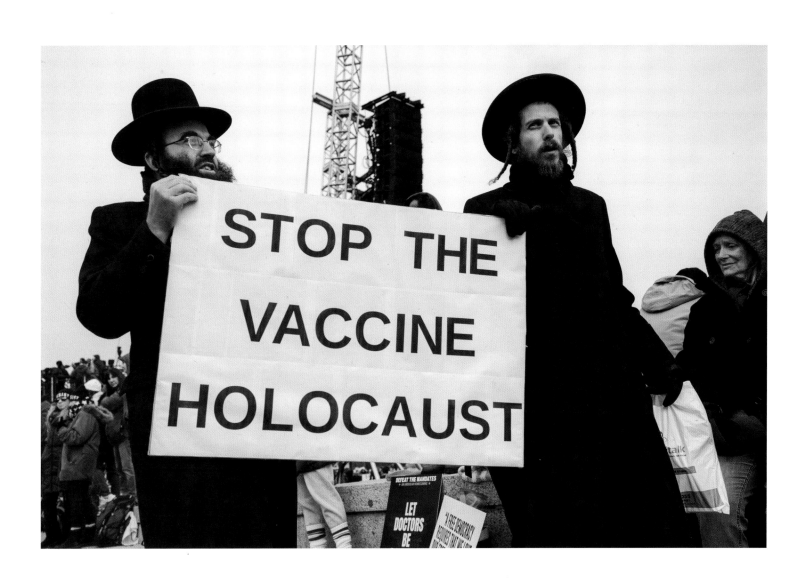

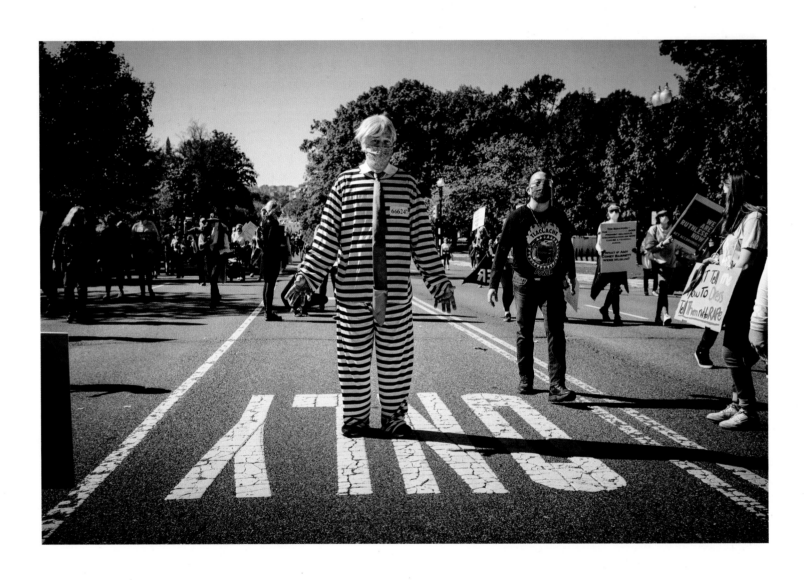

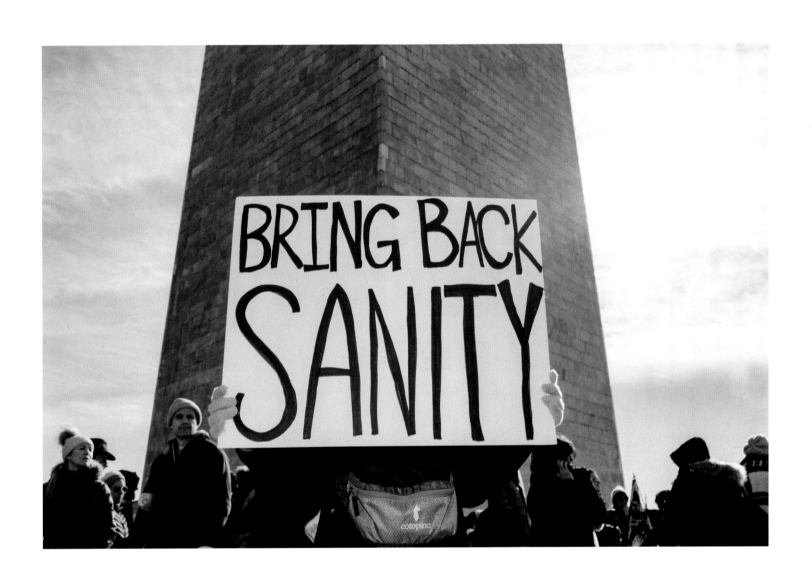

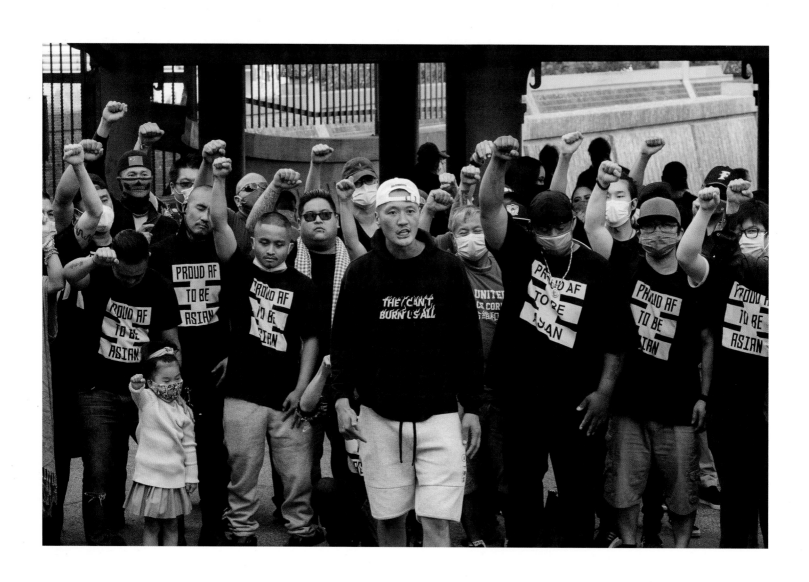

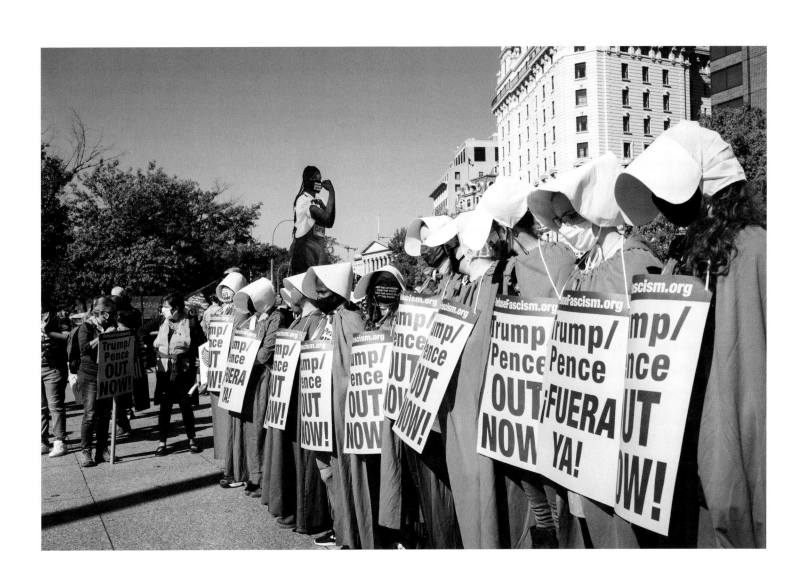

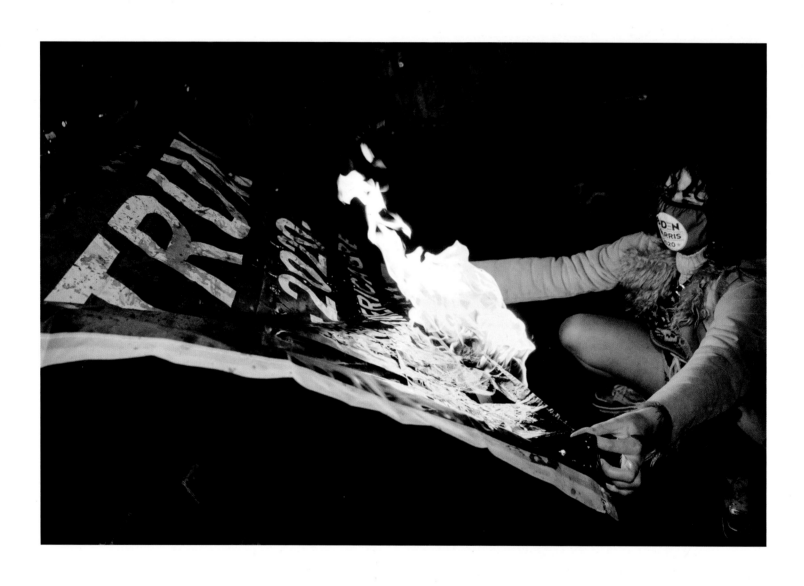

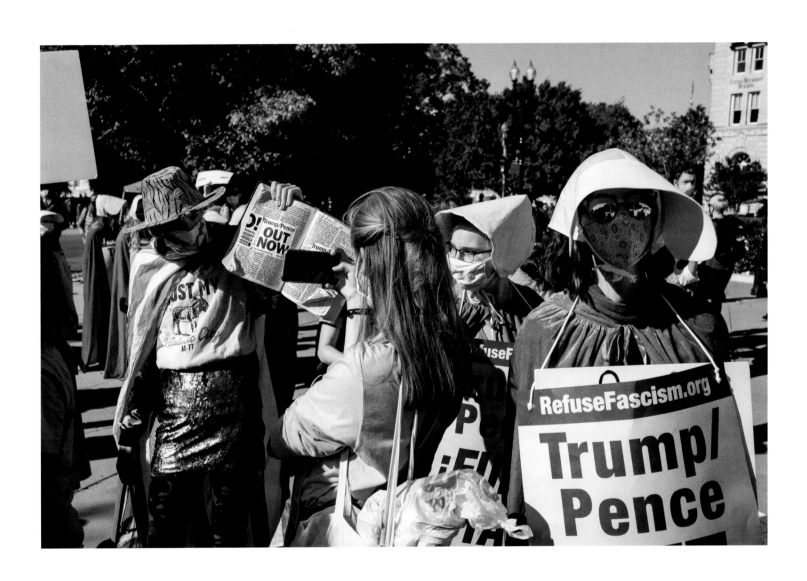

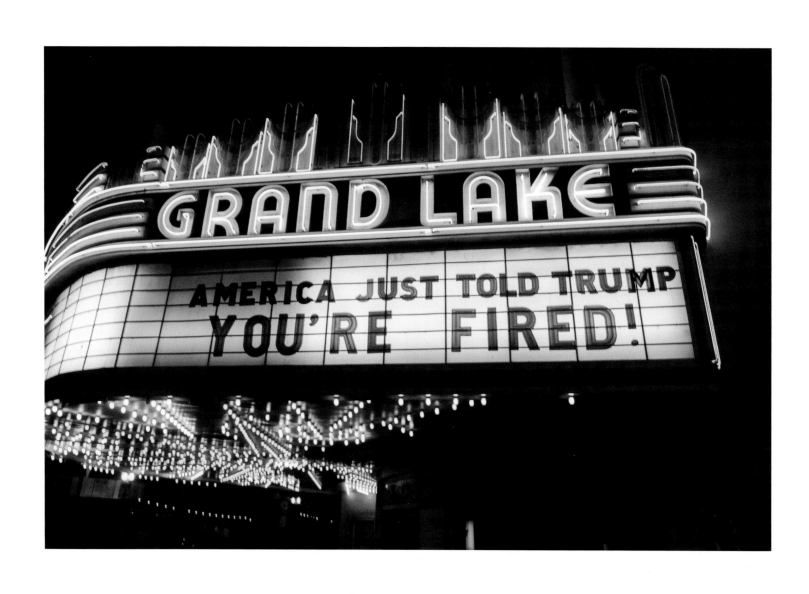

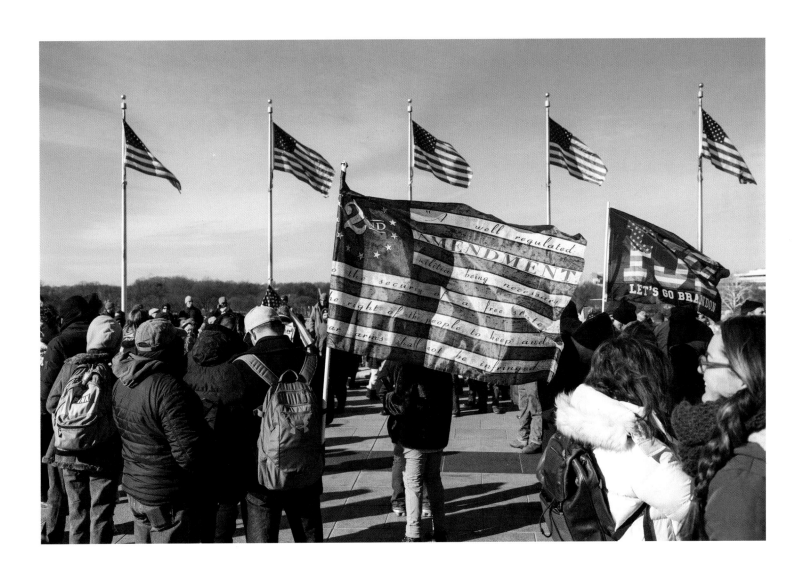

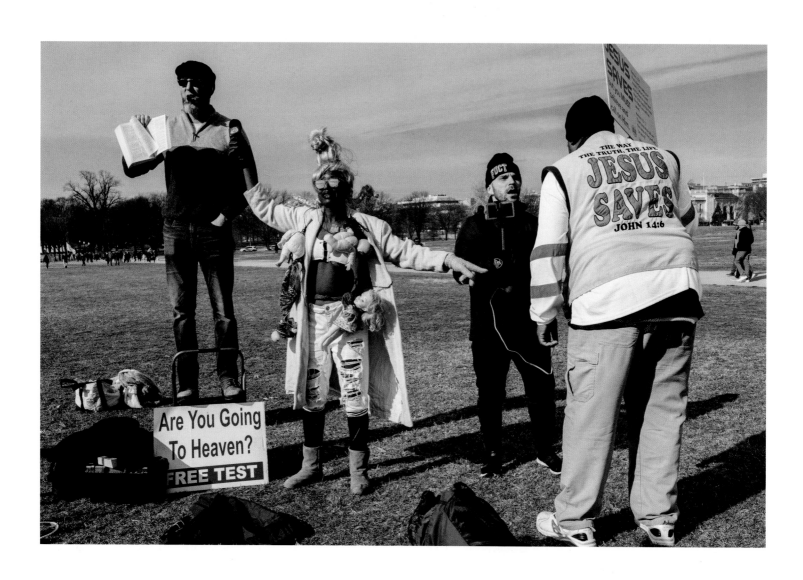

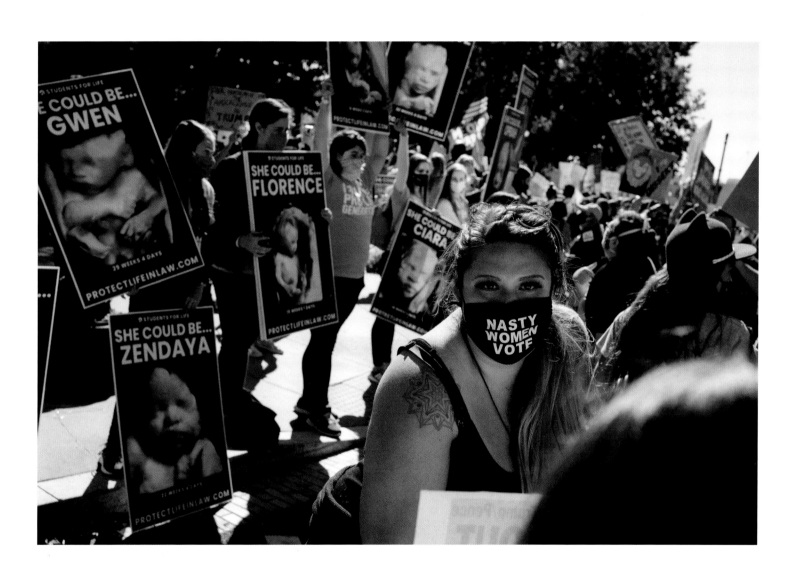

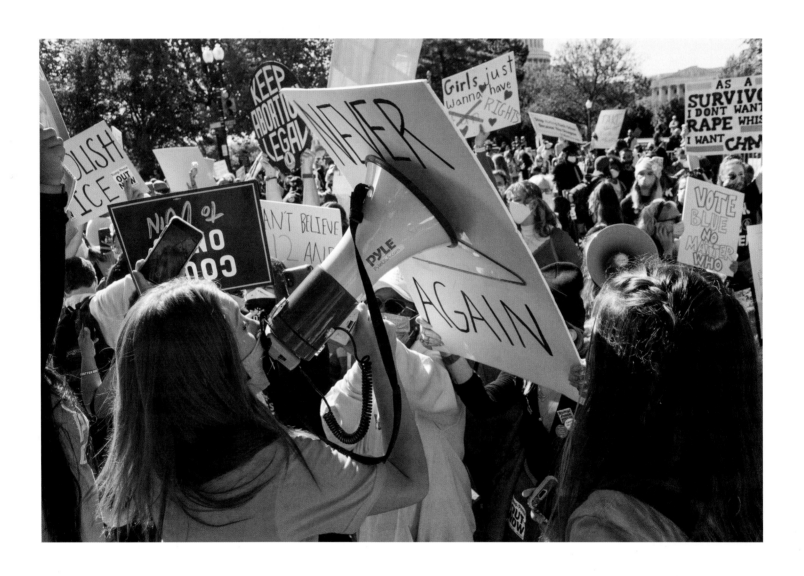

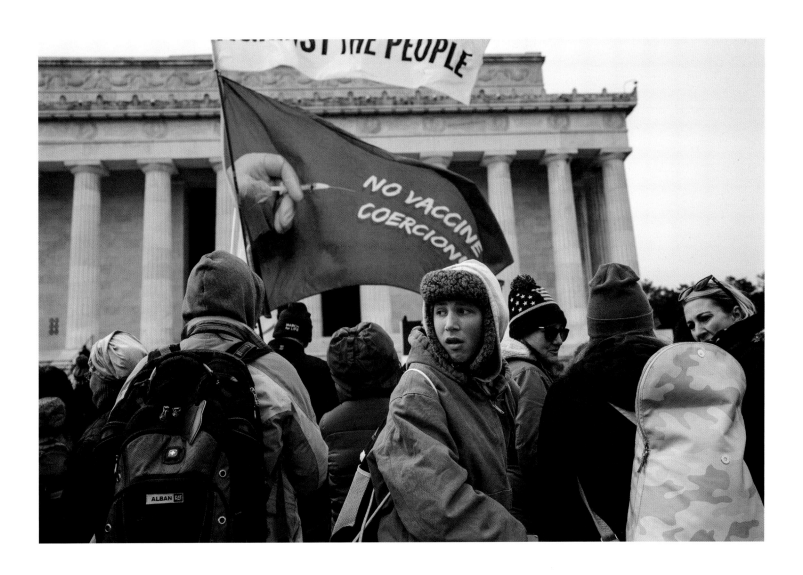

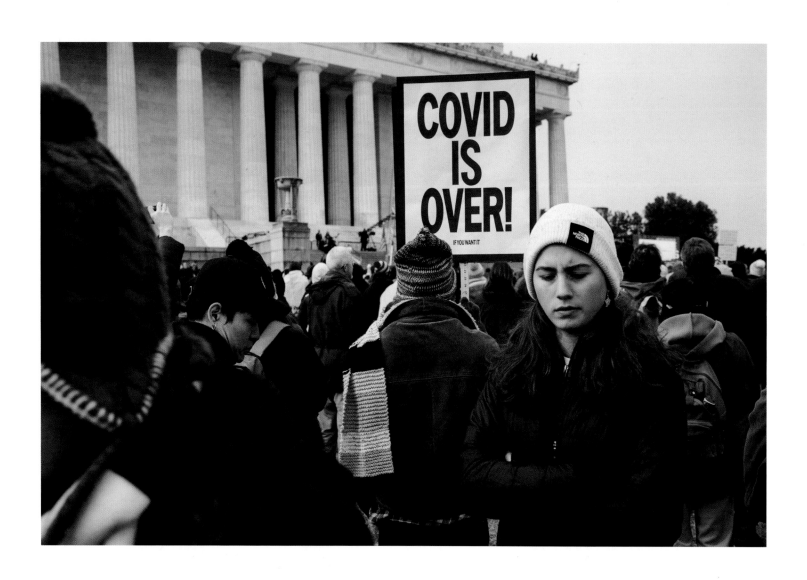

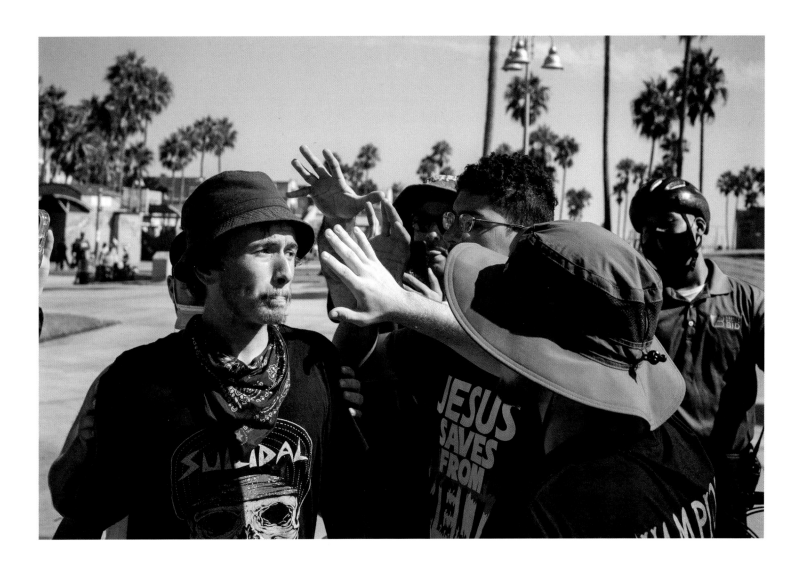

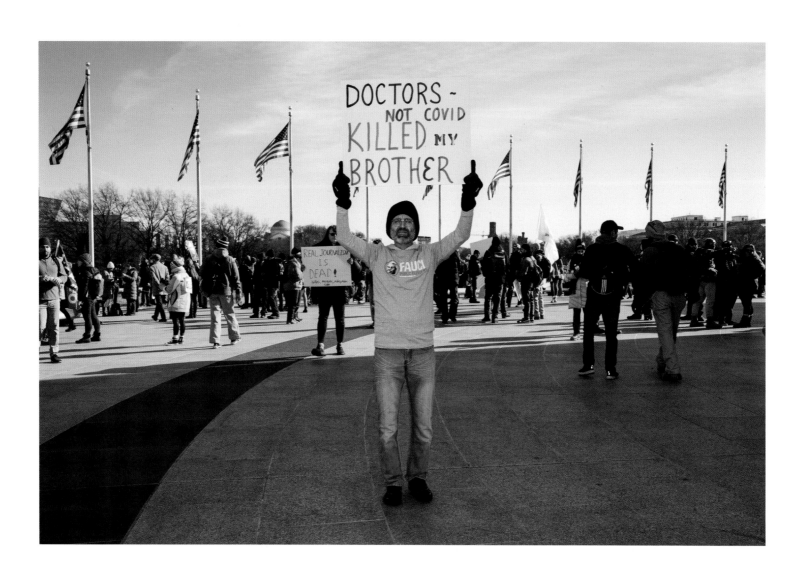

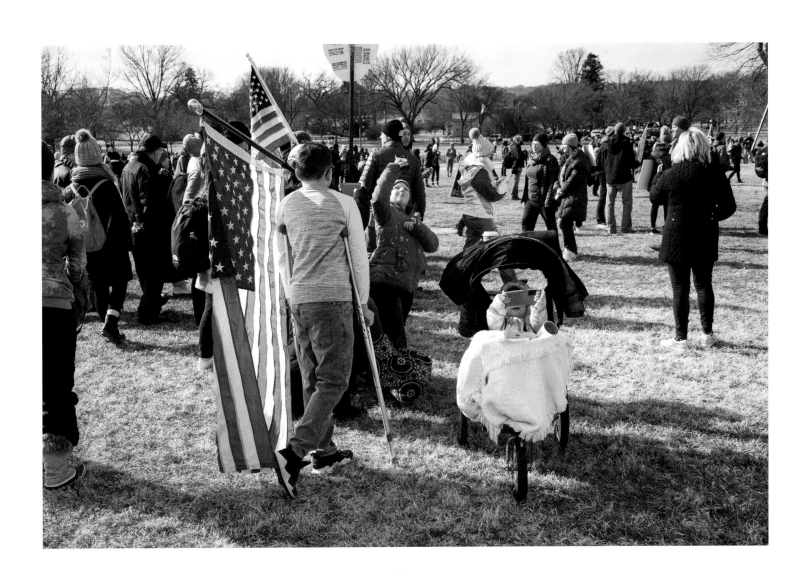

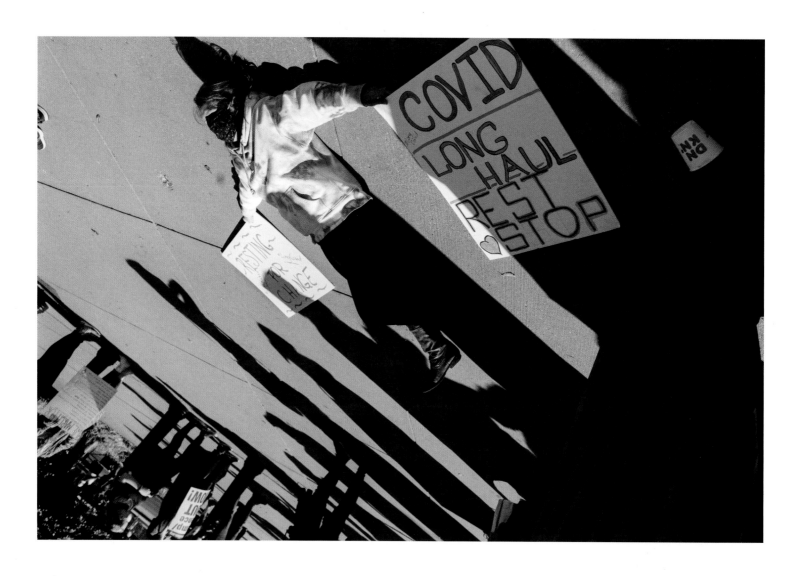

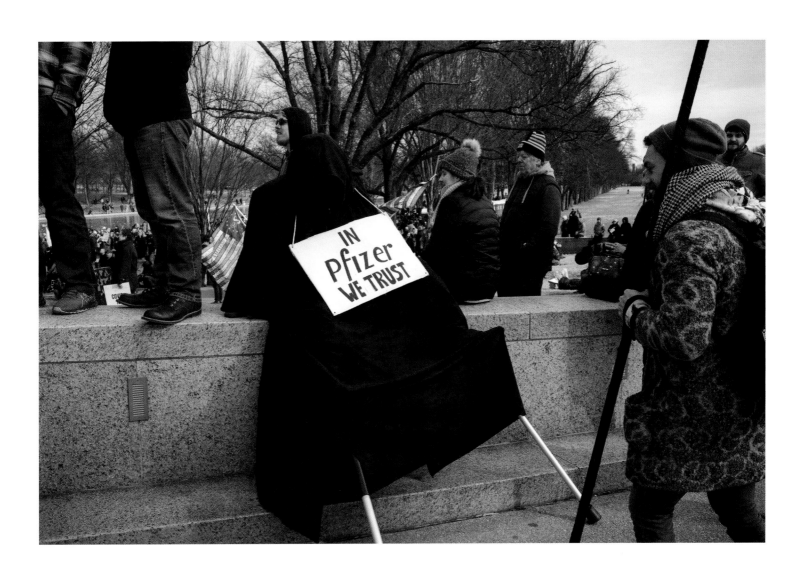

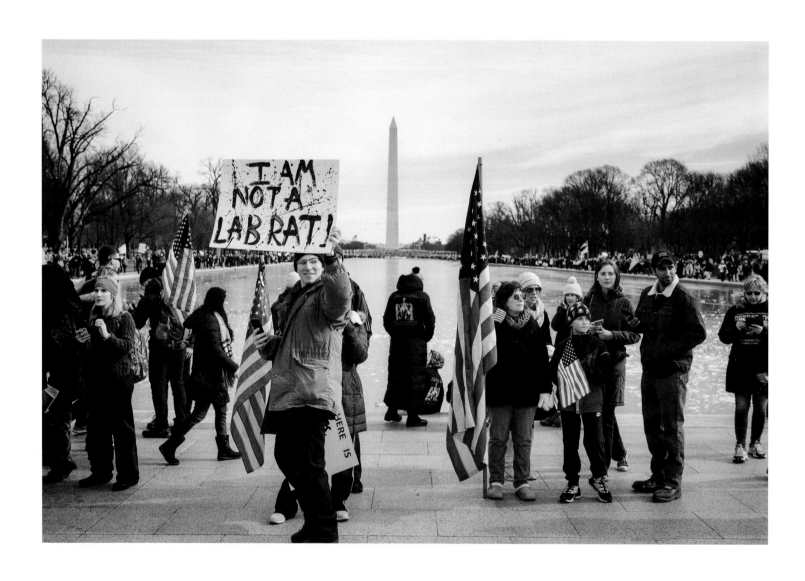

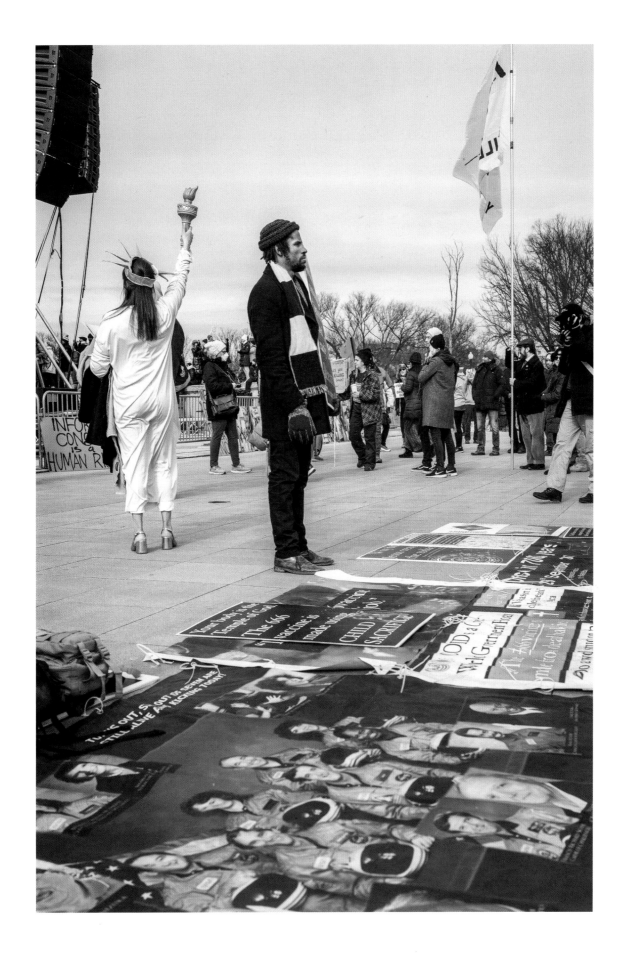

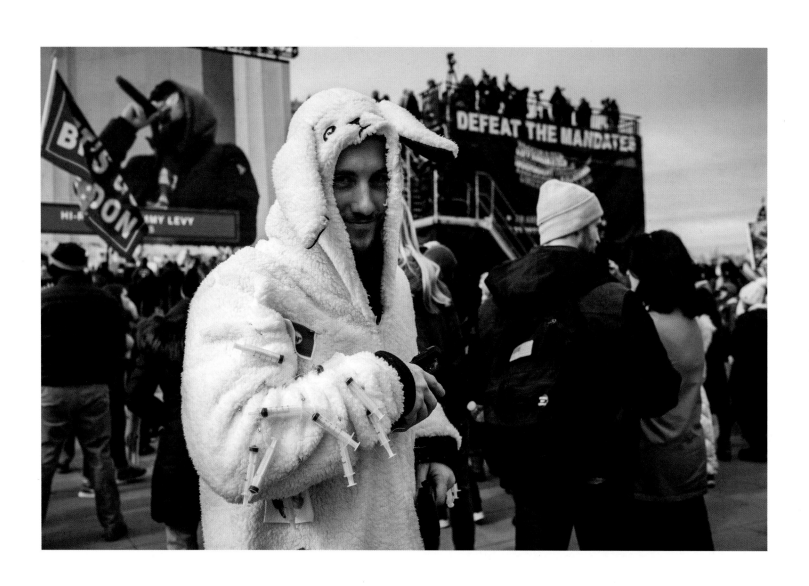

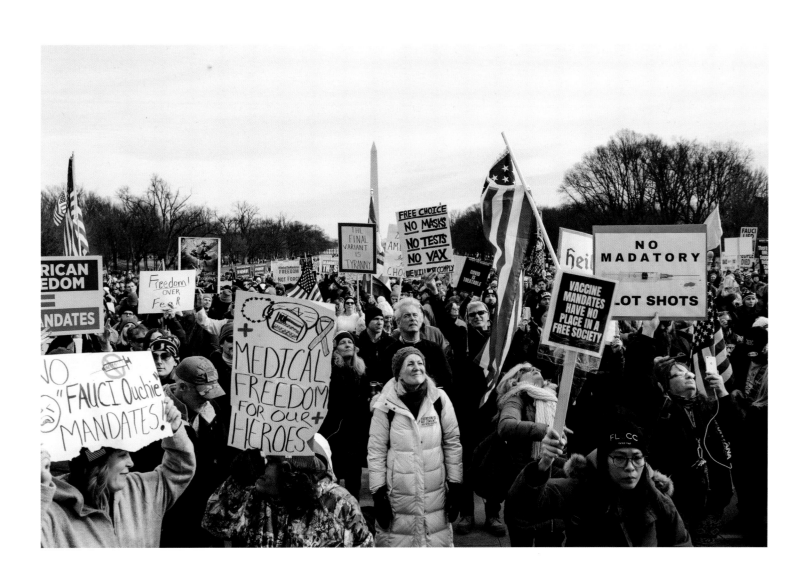

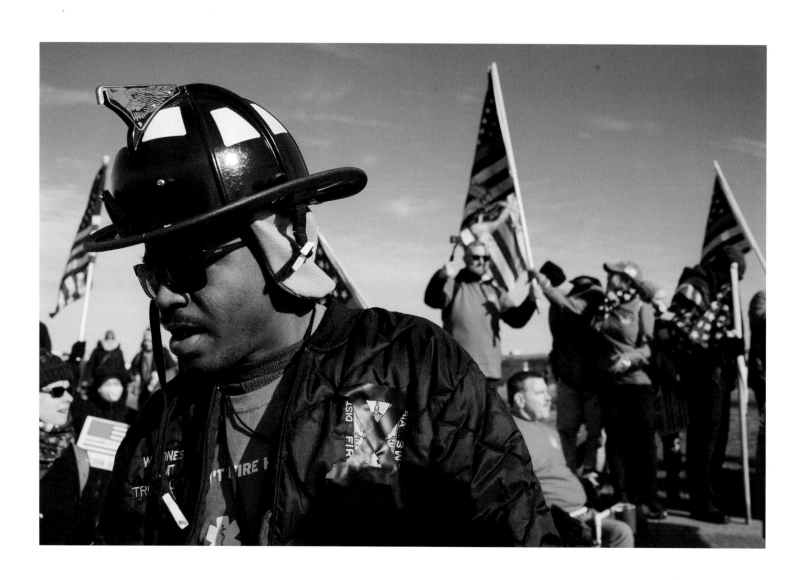

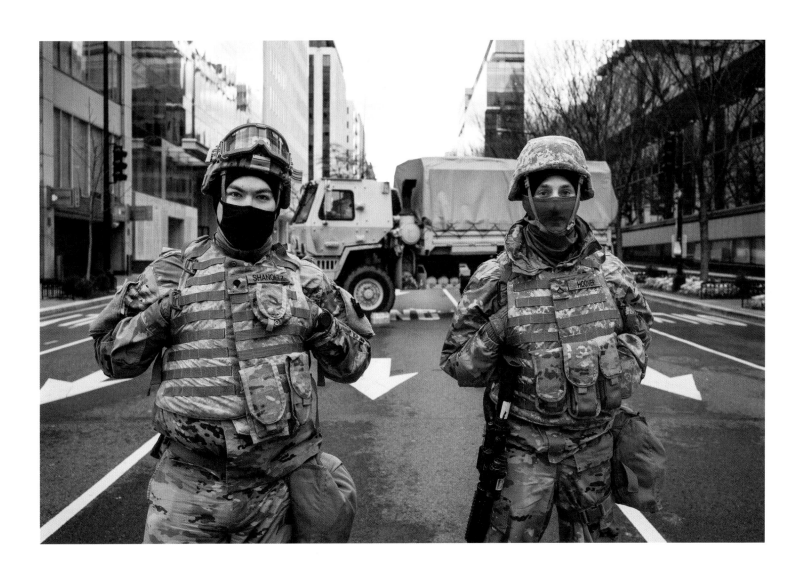

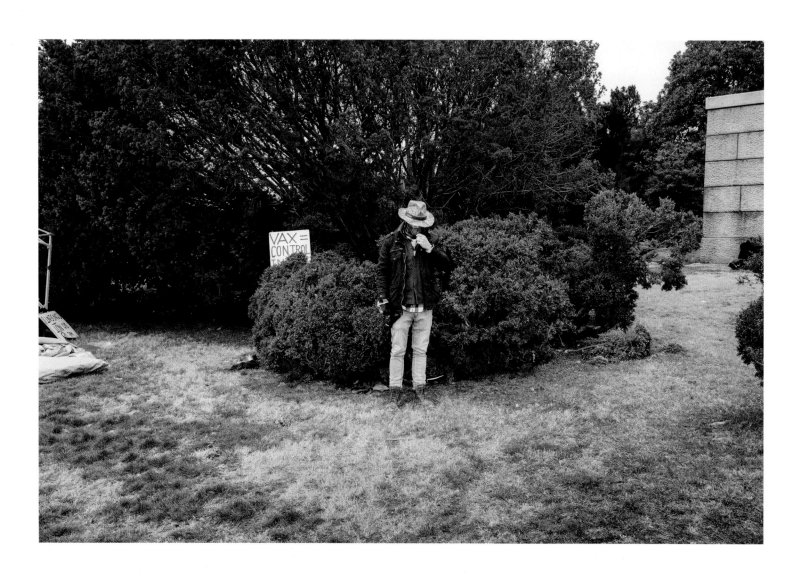

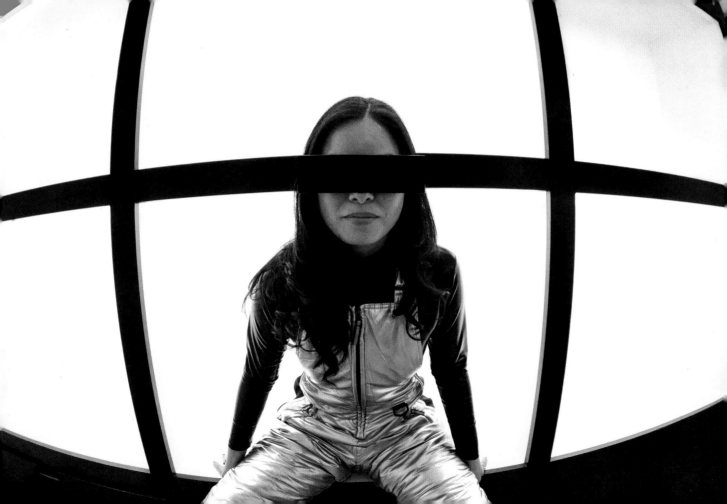

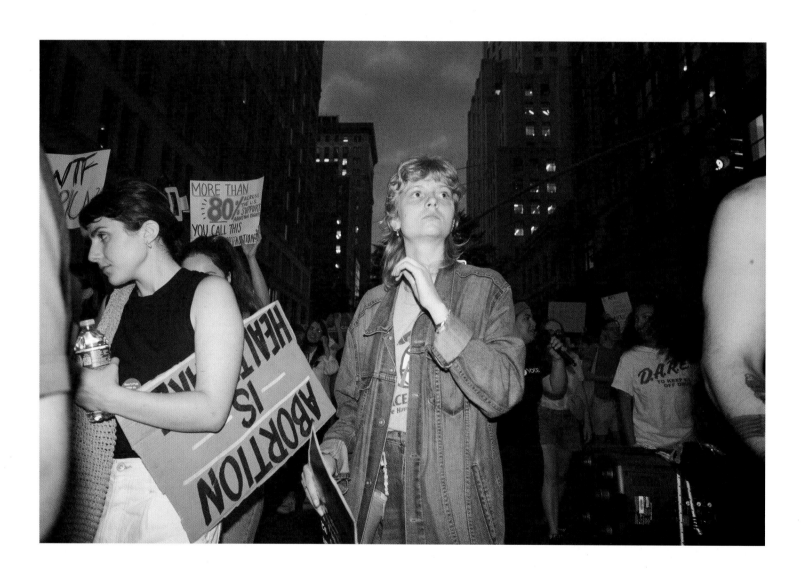

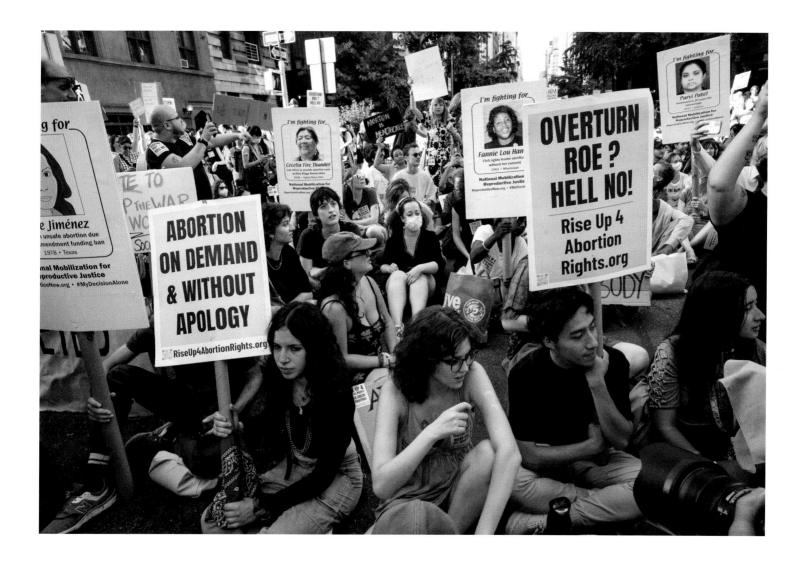

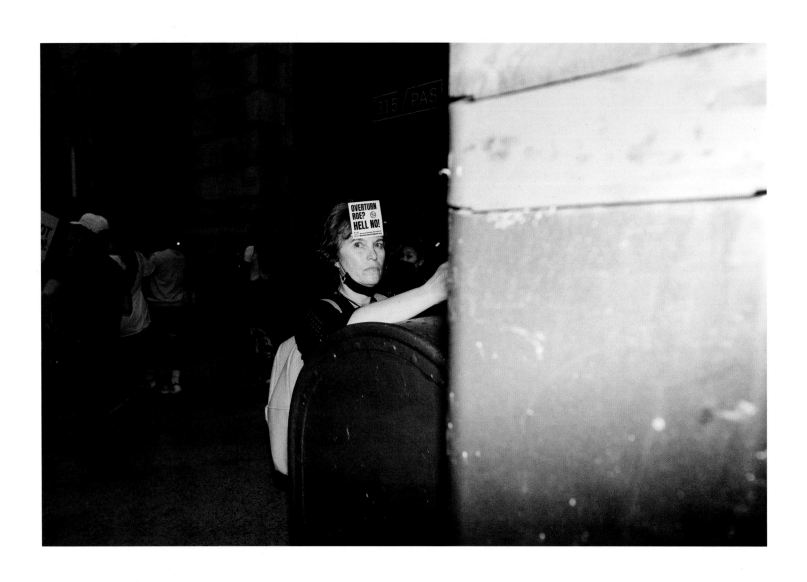

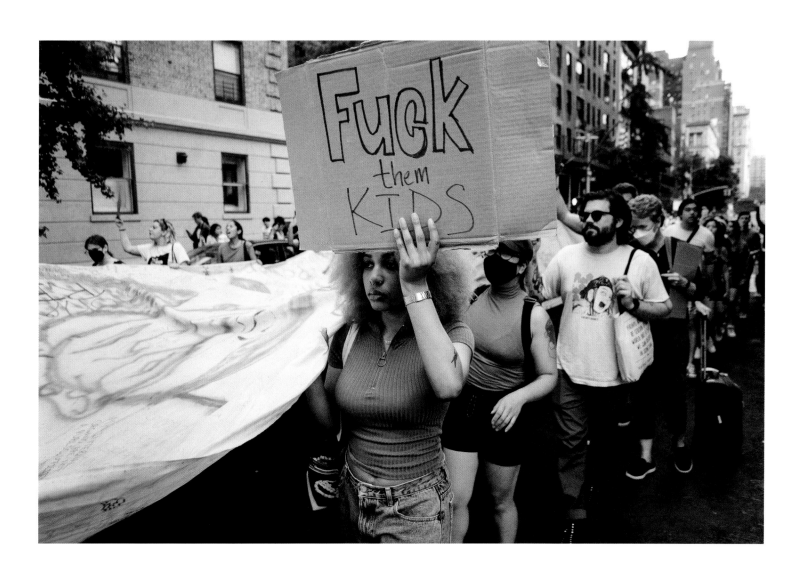

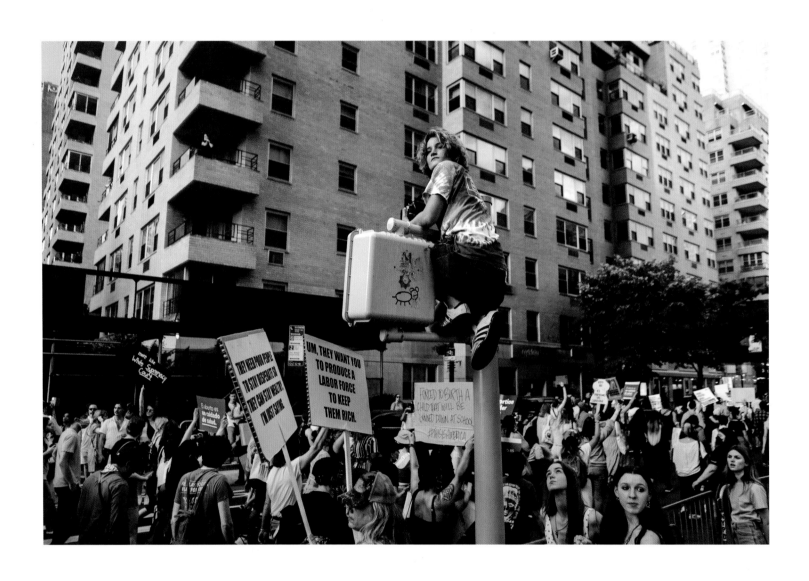

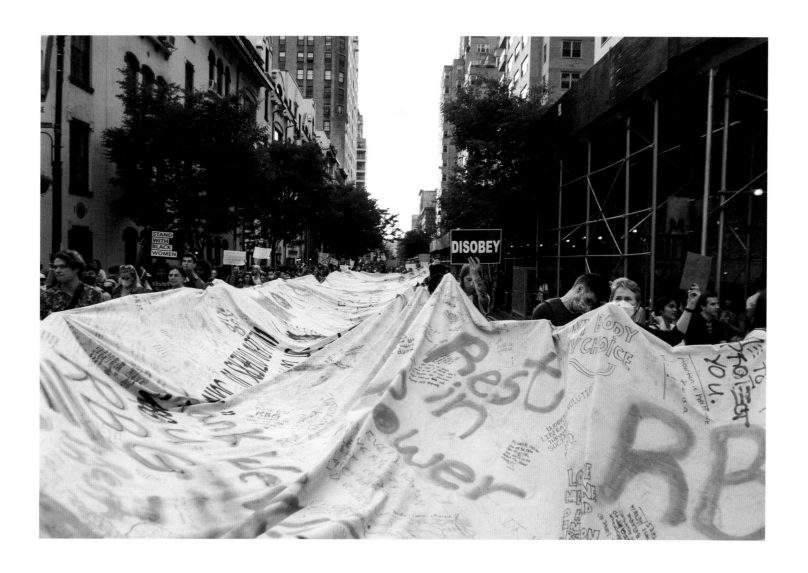

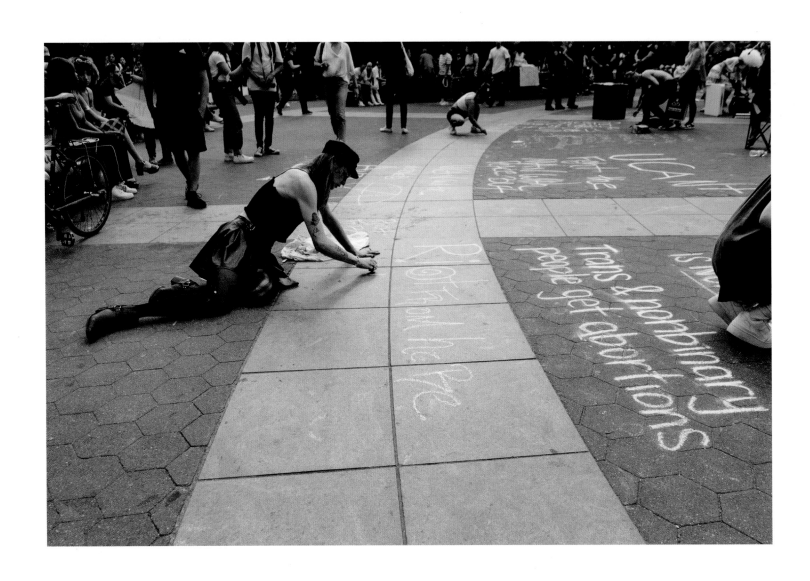

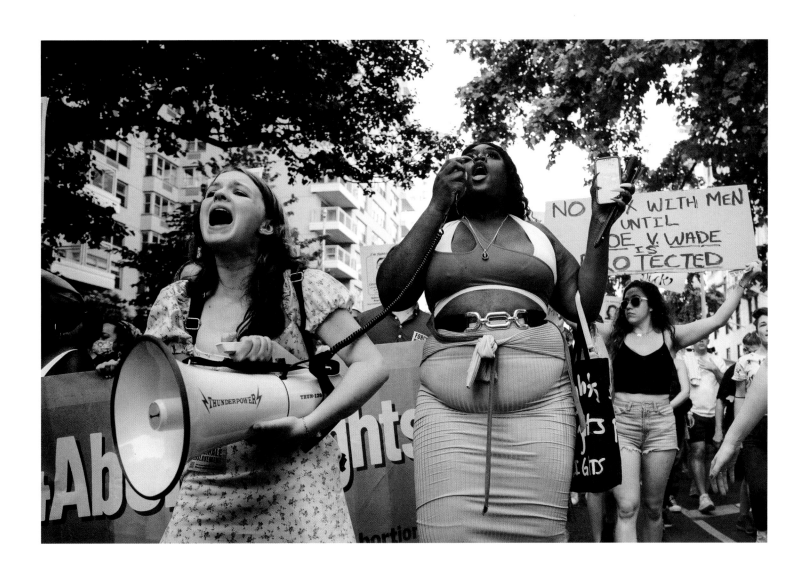

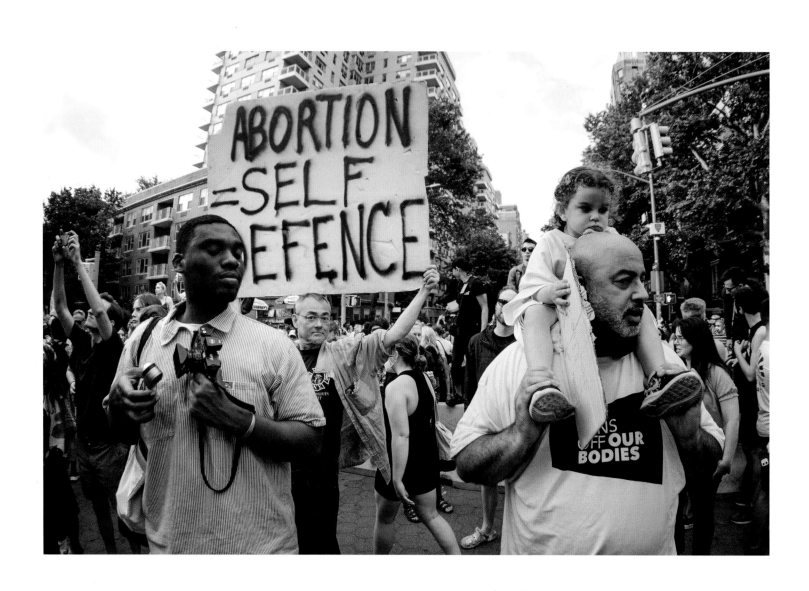

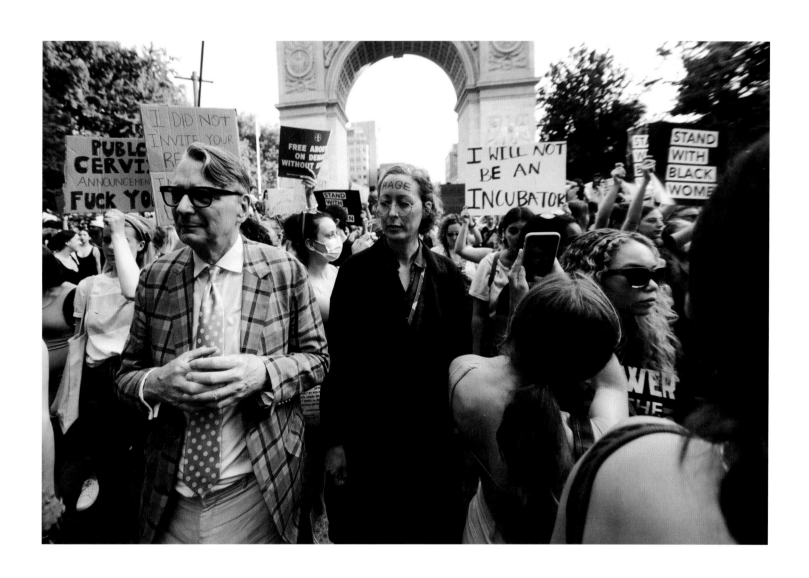

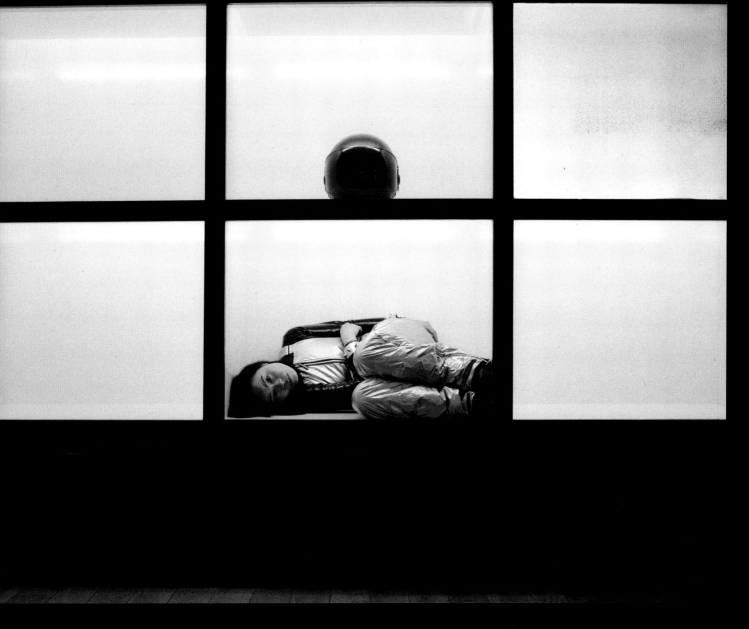

MINNEAPOLIS, MN
OAKLAND, CA

ZENITH

THE SPEED OF LIGHT

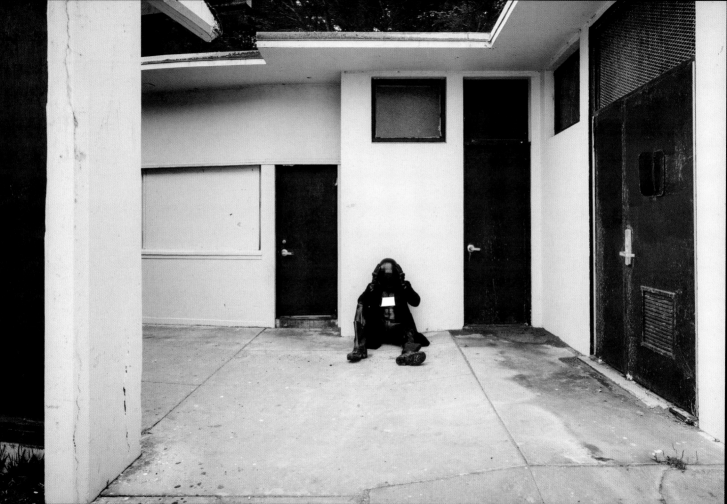

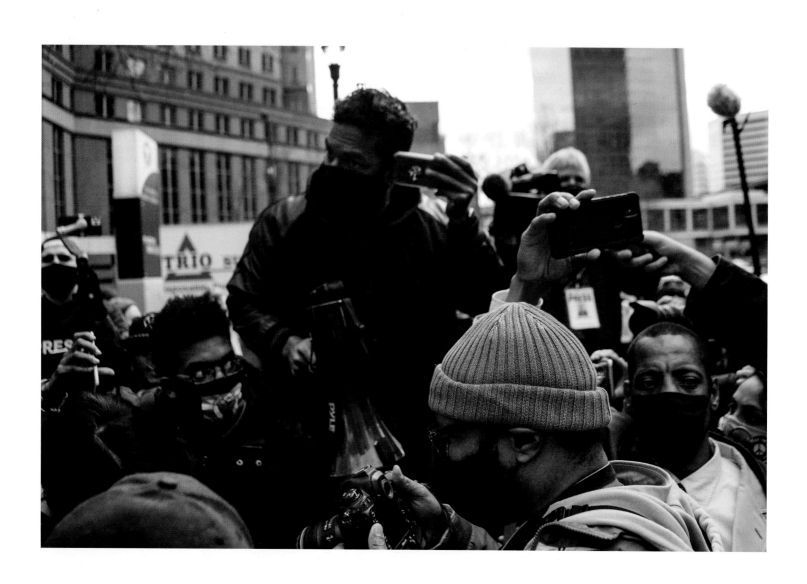

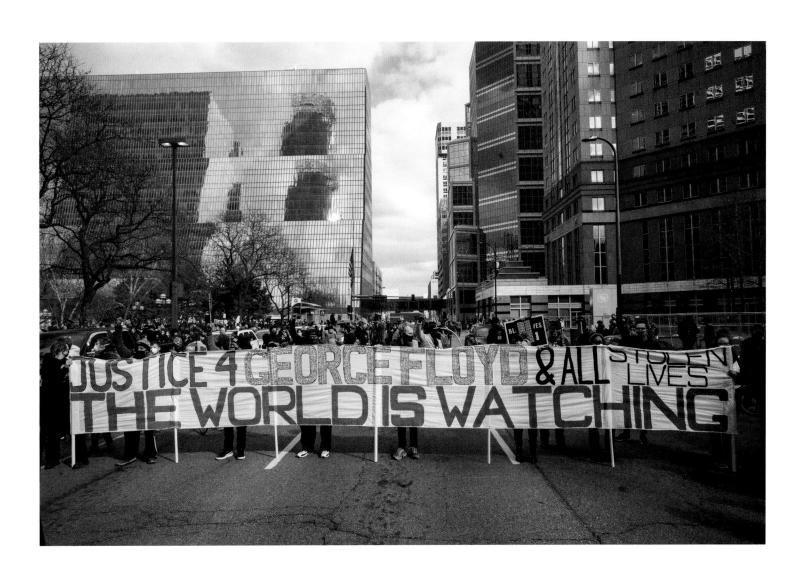

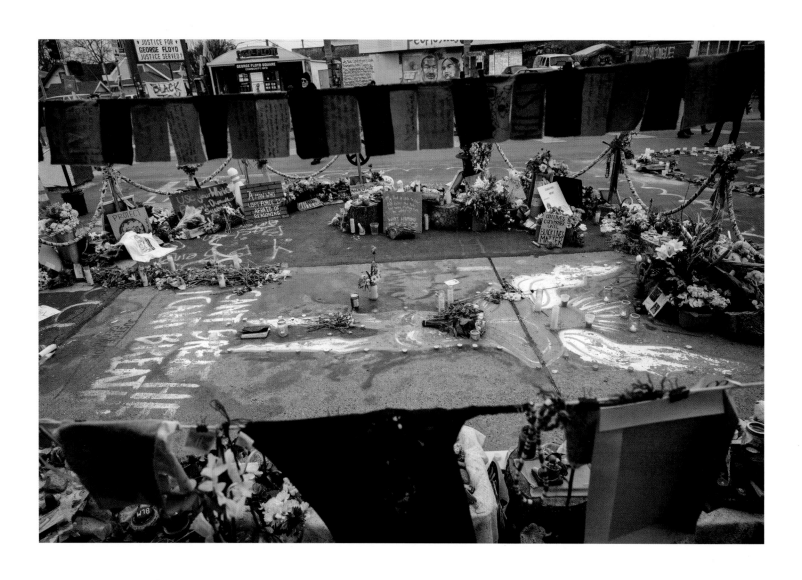

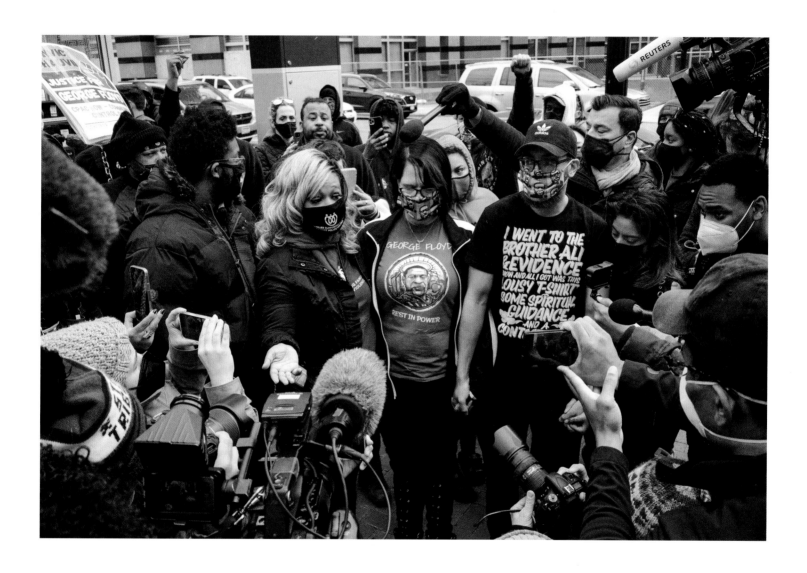

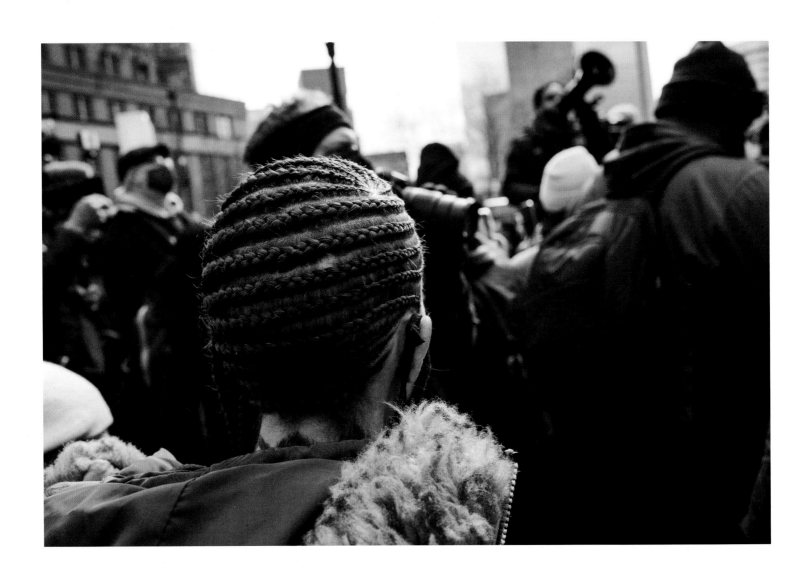

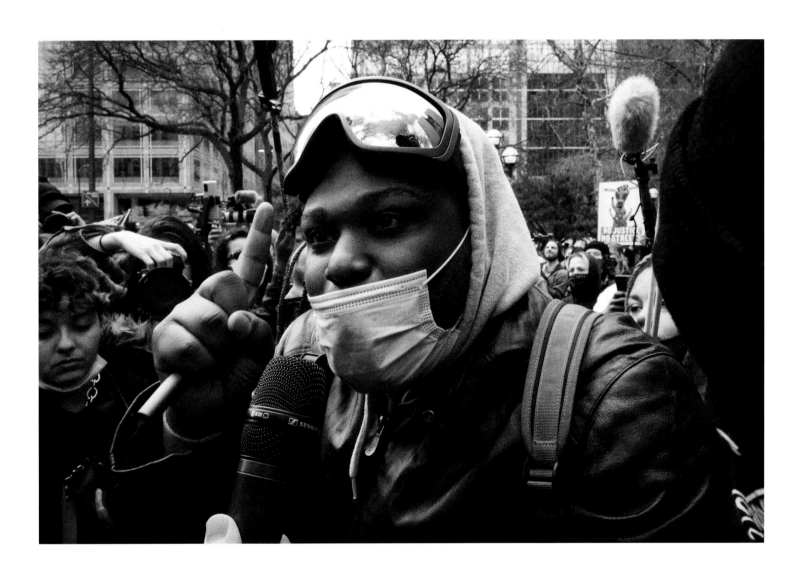

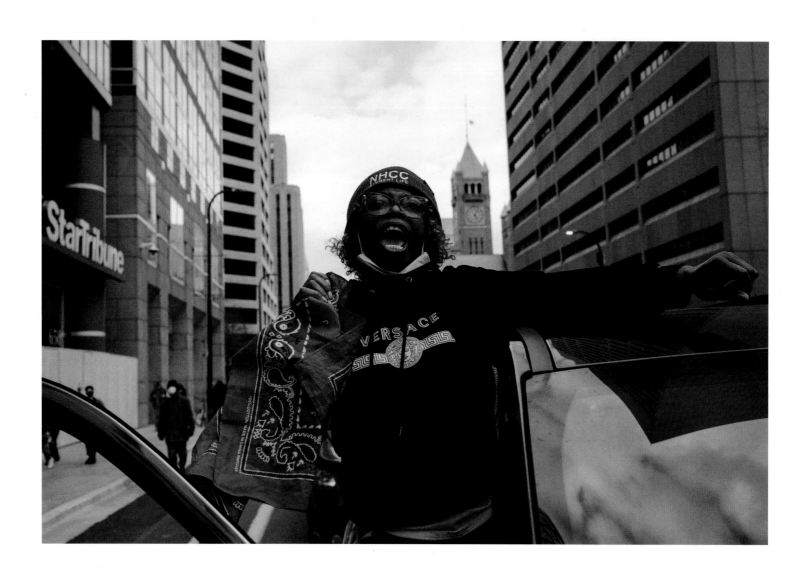

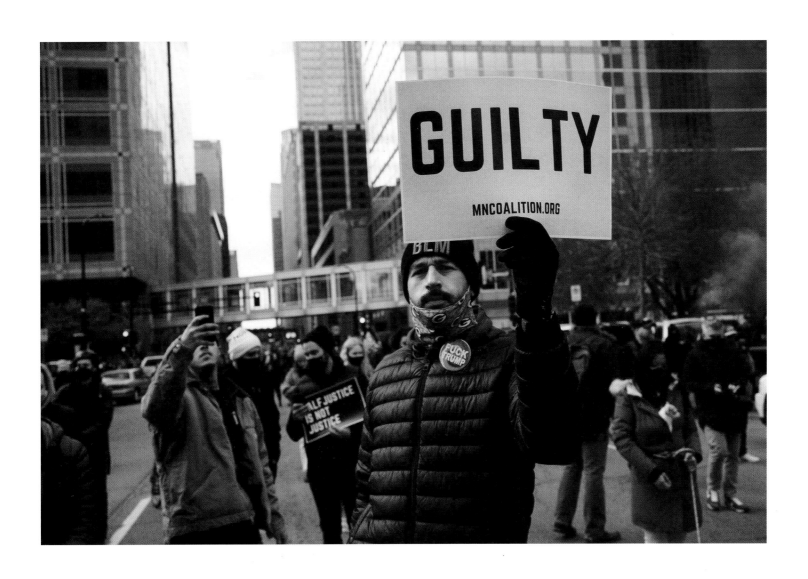

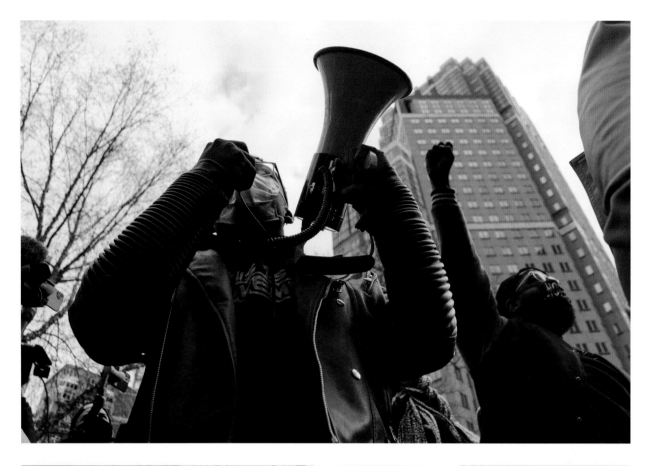

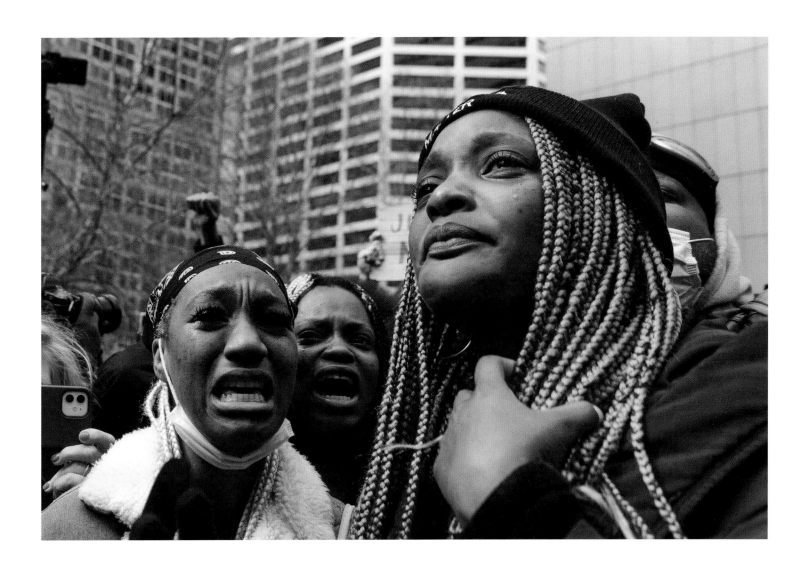

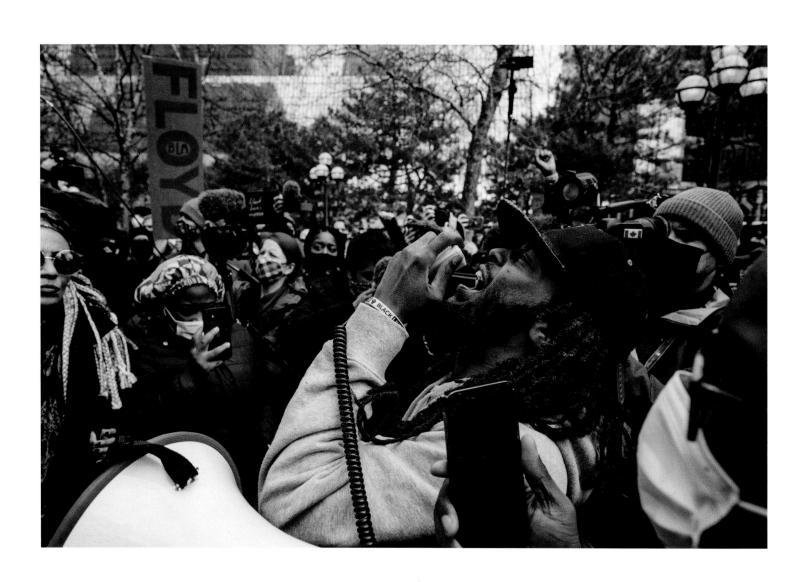

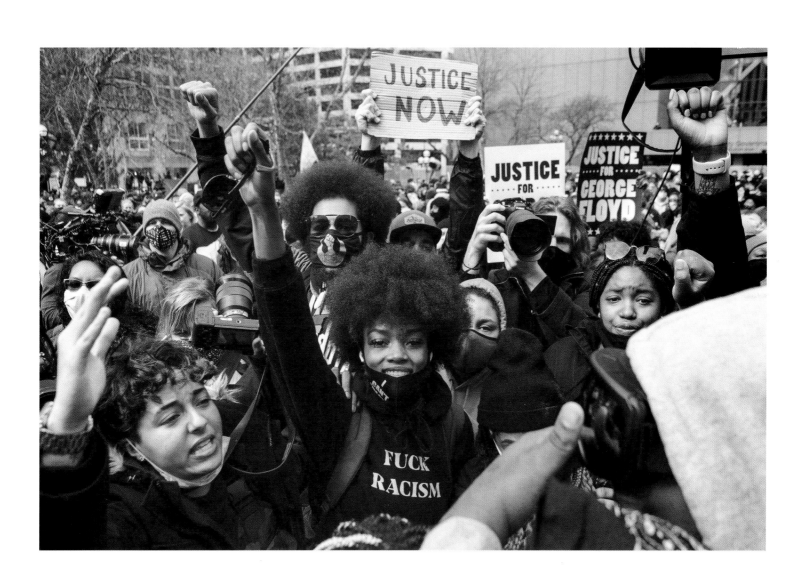

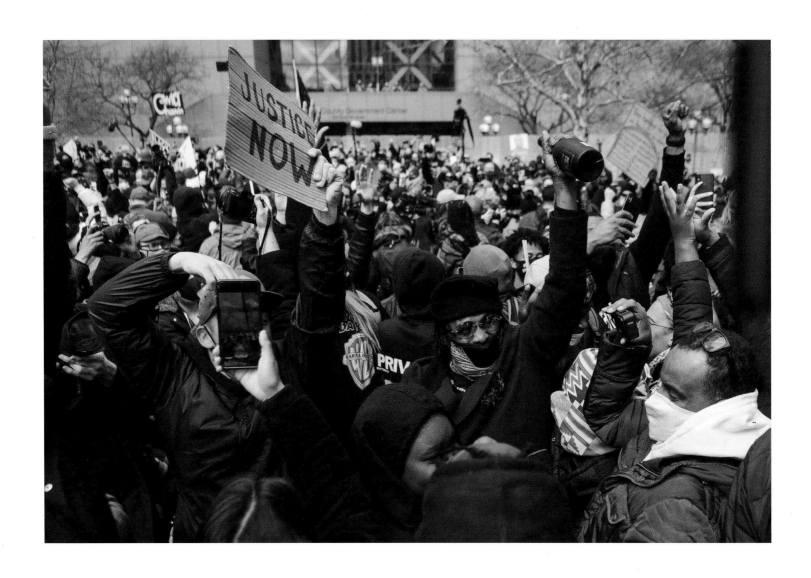

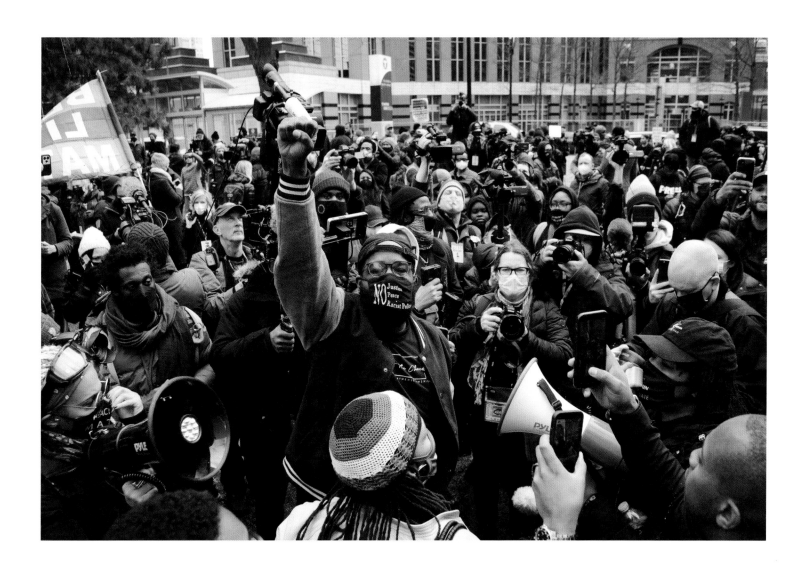

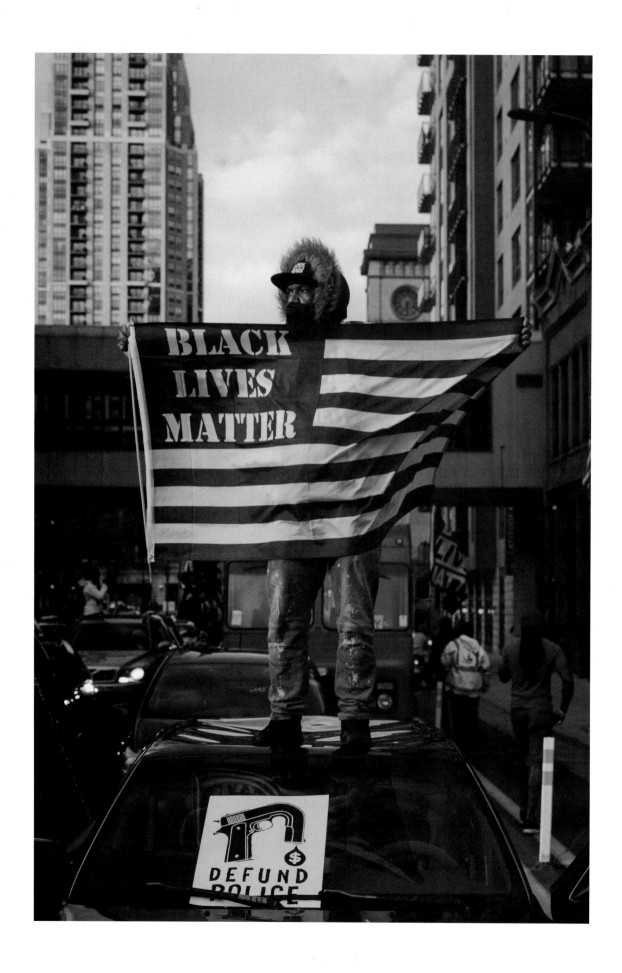

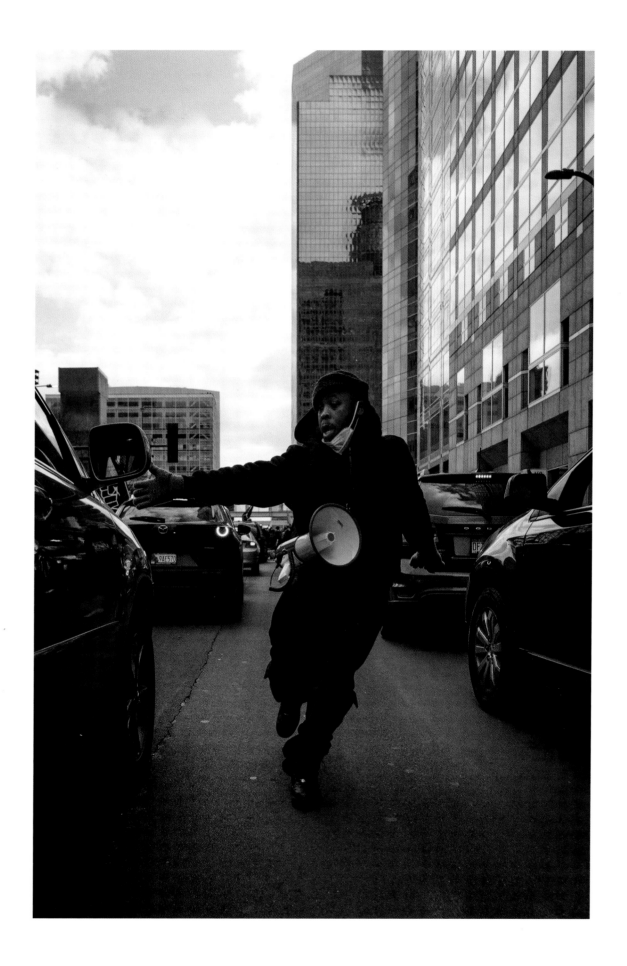

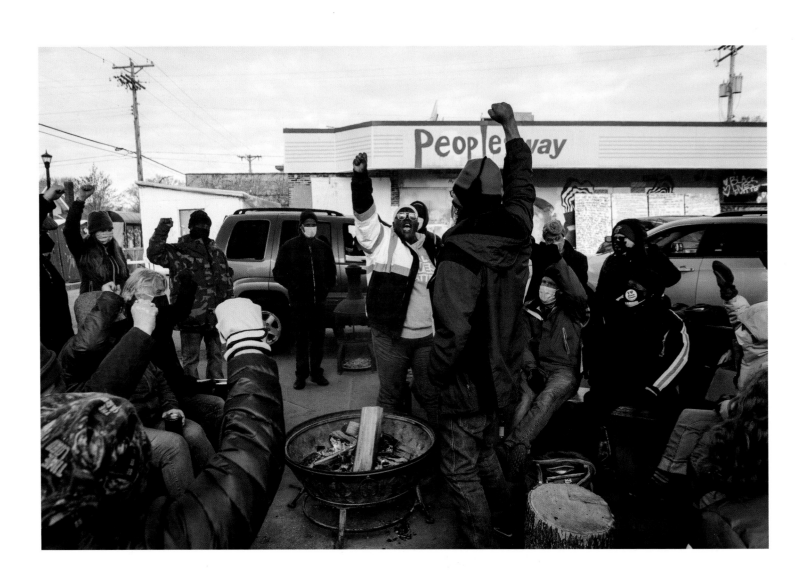

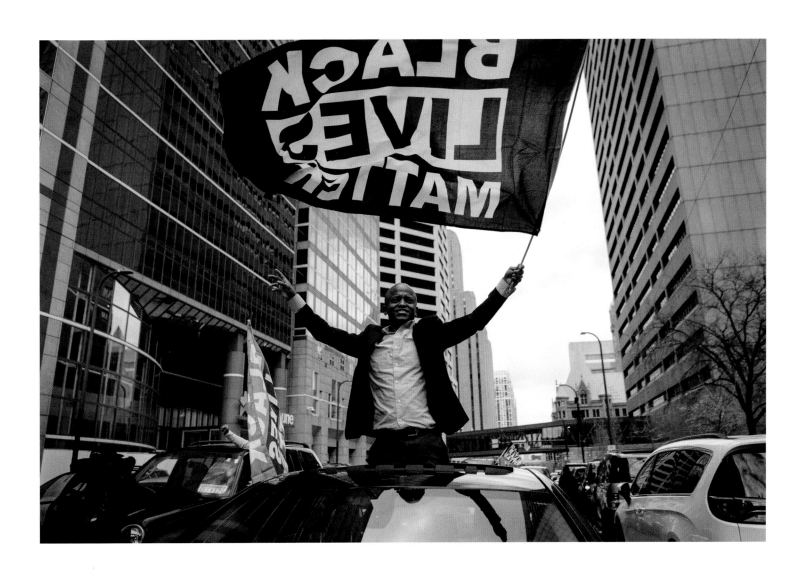

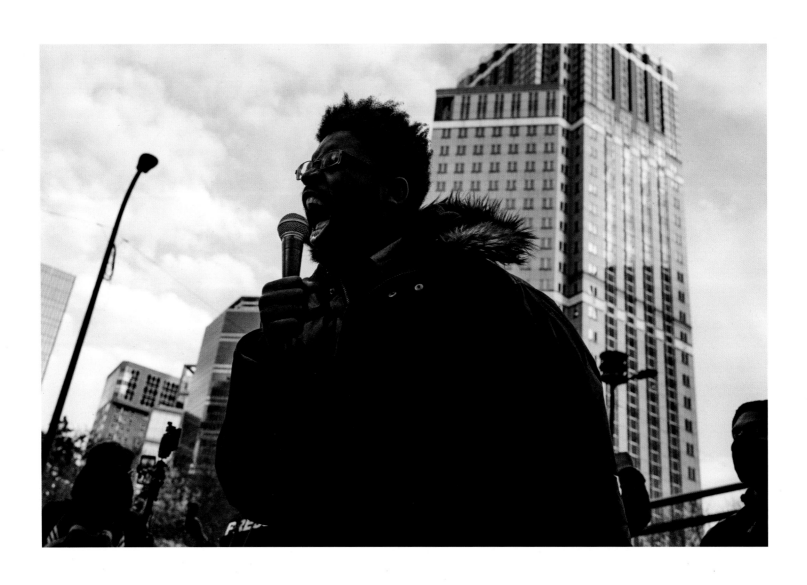

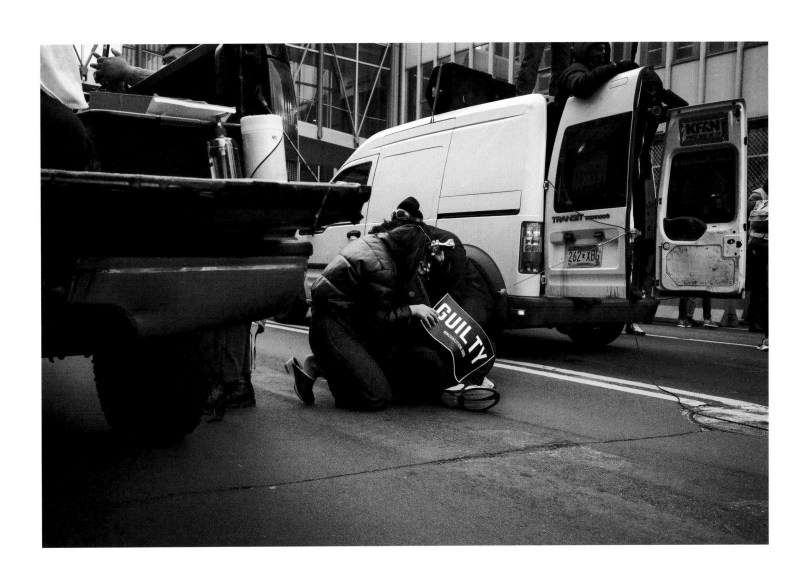

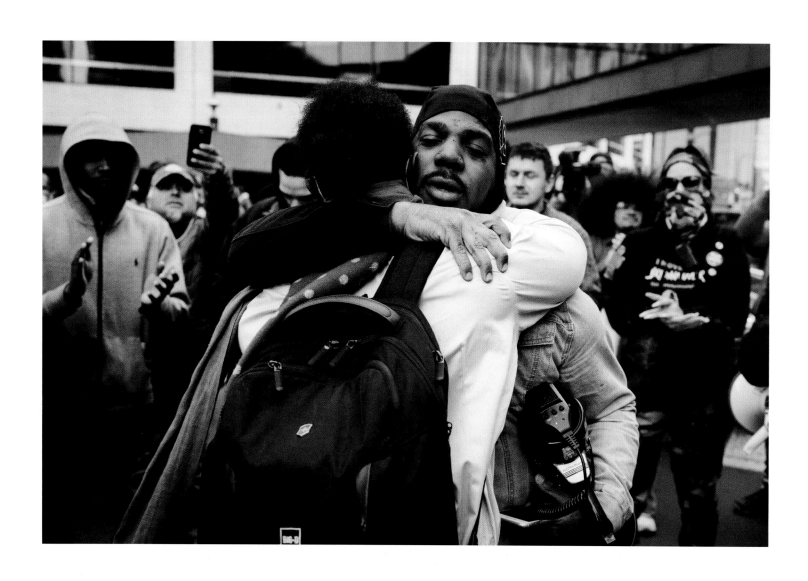

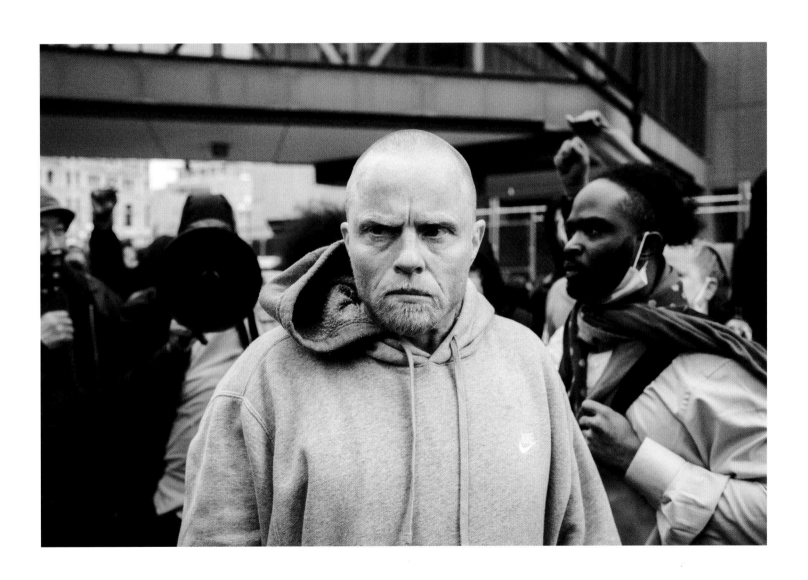

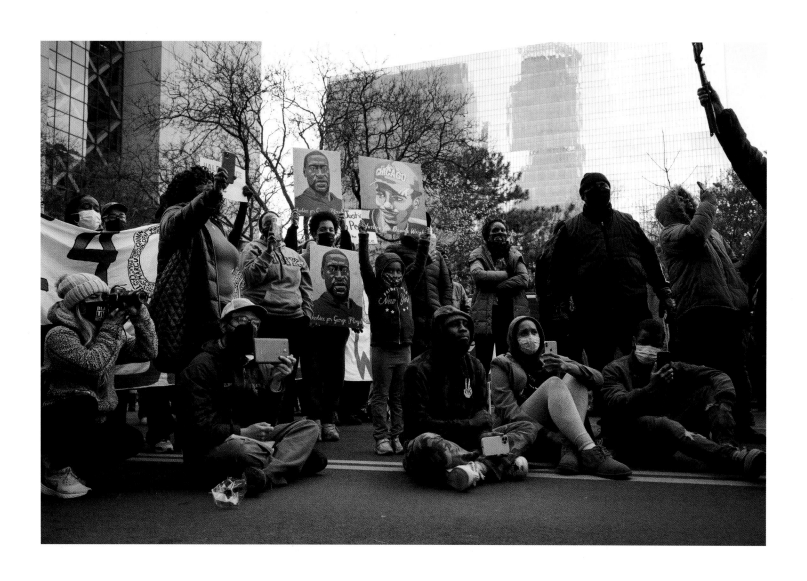

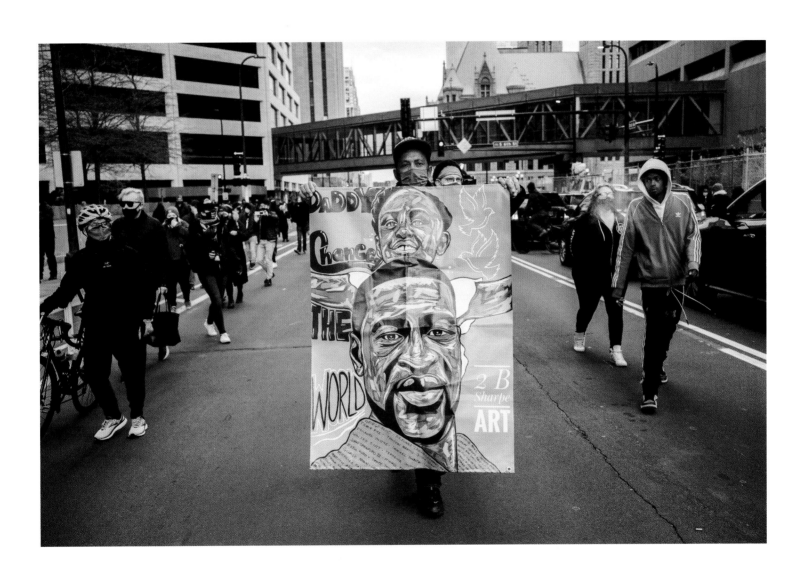

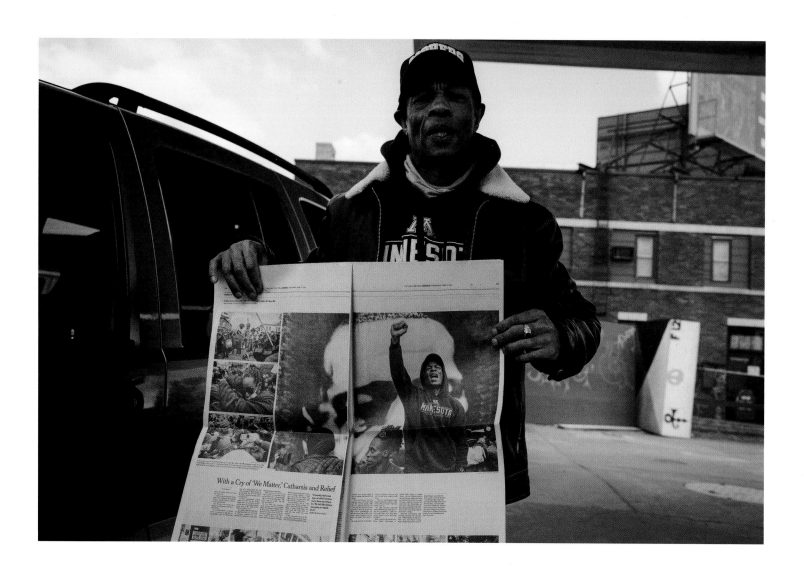

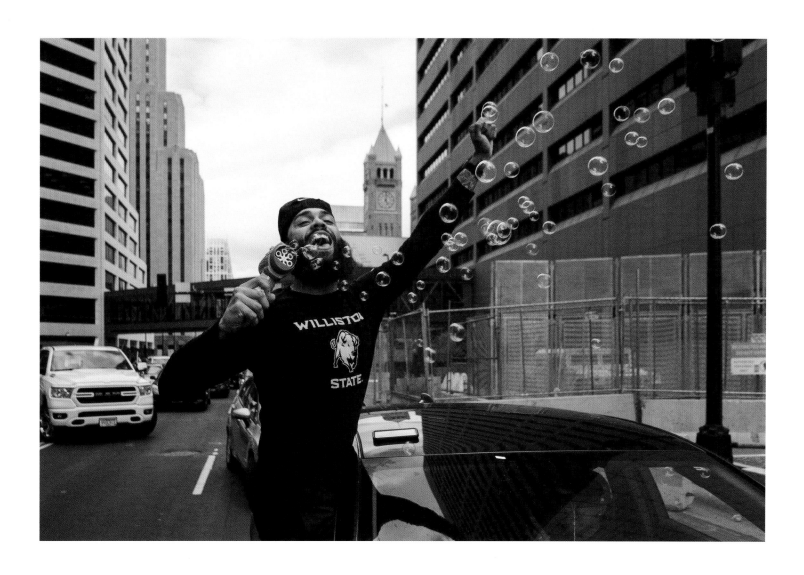

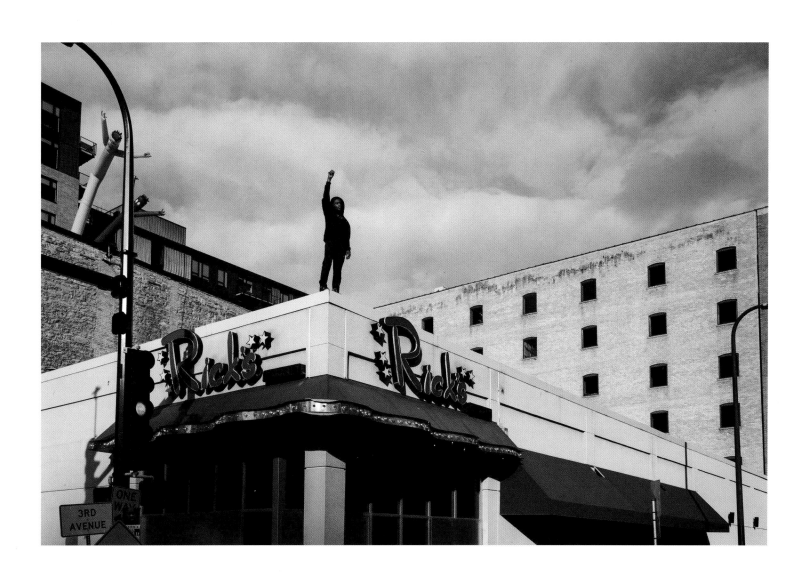

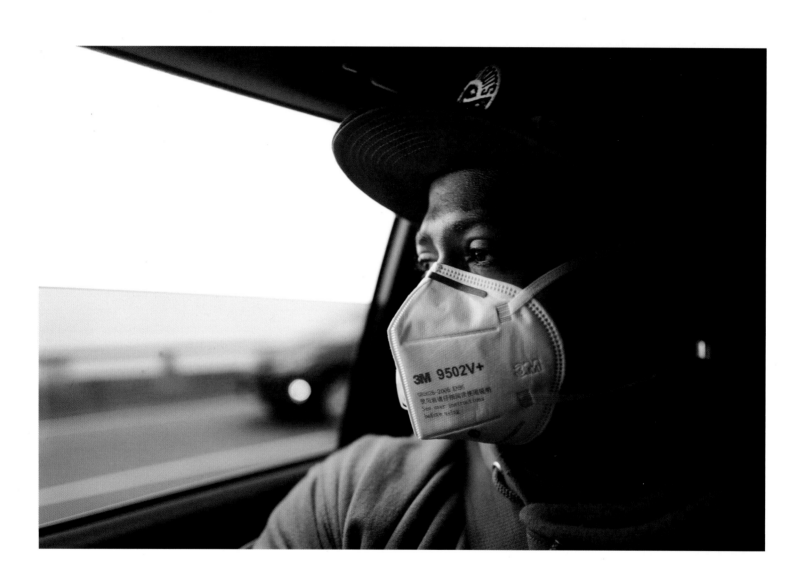

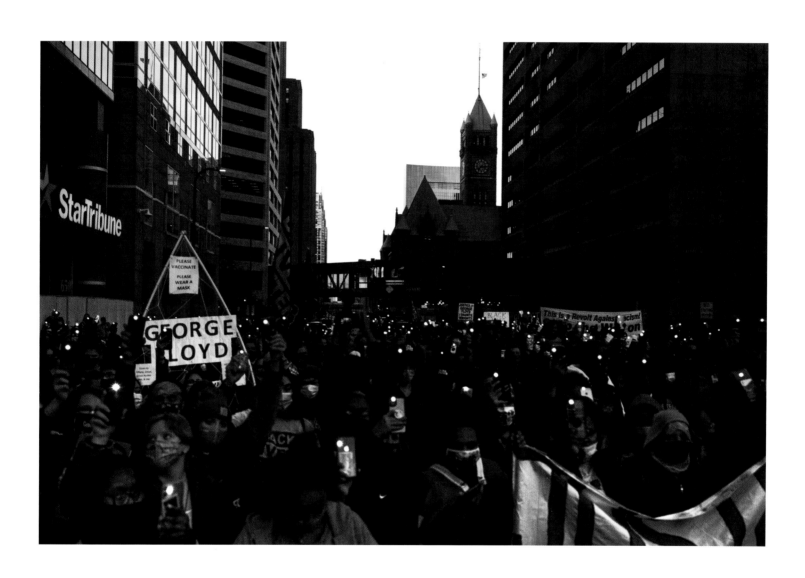

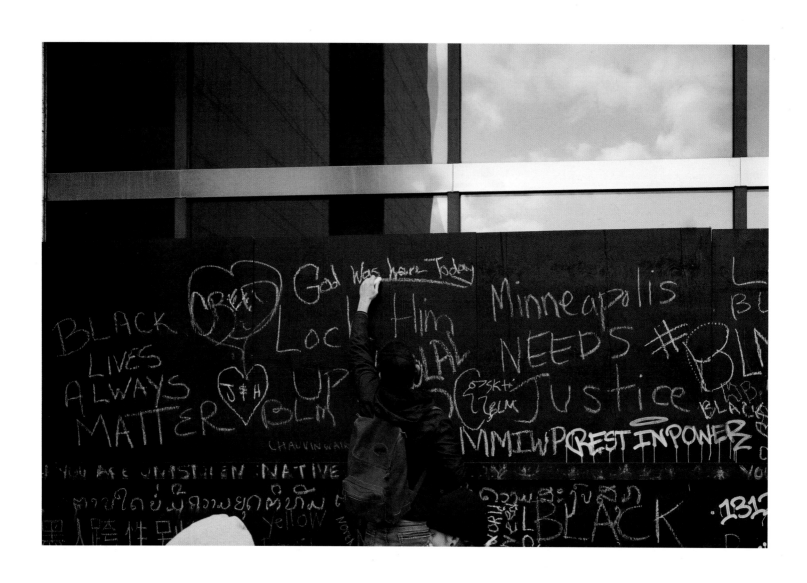

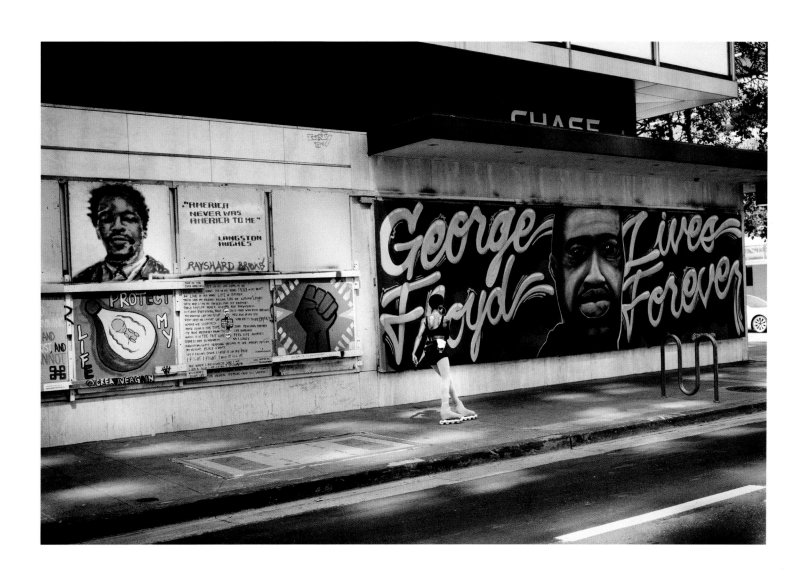

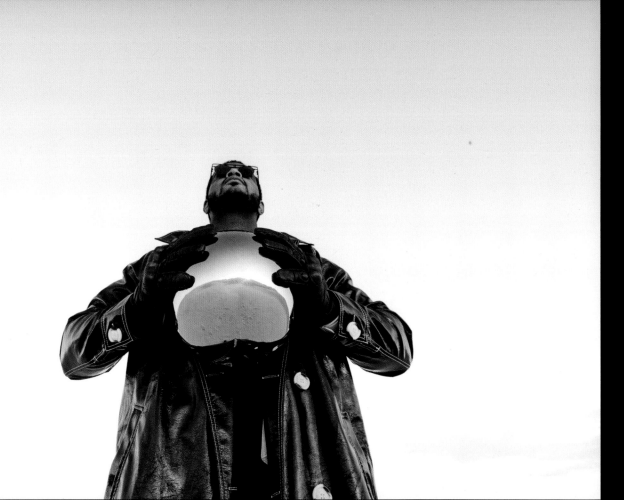